Snapshot Versions
of Life

Snapshot Versions of Life

of Life

Richard Chalfen

Bowling Green State University Popular Press
Bowling Green, Ohio 43403

Dedication

To Gladys and Sam, who saw to it that
I grew up in 16mm color.

Acknowledgements

The writing of this book has been a long haul. It has been through several reorganizations and rewrites. Some people, more than others, saw what I was up to and supported the effort. For help with early conceptual issues, I wish to thank the late Sol Worth, and Erving Goffman. For more recent consultation, thanks go to Larry Gross, John McGuigan, and Russel Nye. I am particularly indebted to the editorial assistance of Karen Donner. For struggling with the reading and typing of hand written manuscripts, I thank Linda Ecker, Laureen Rafalko, and Gloria Basmajian. Gratitude is extended to the College of Arts and Sciences at Temple University for granting me an academic study leave to complete the first draft of the manuscript.

Parts of several chapters have been published elsewhere. Original titles and sources of publication are acknowledged as follows:

Cinéma Naïveté: A Study of Home Moviemaking as Visual Communication, *Studies in the Anthropology of Visual Communication* 2(2): 87-103 (1975).

Photography's Role in Tourism: Some Unexplored Relationships, *Annals of Tourism Research* 6(4): 435-447 (1979).

I also want to thank the many non-professional photographers and family members who were willing to discuss their photograph collections with me. And for the support, patience, and understanding of Kirsten, Leah, and Claire, I am deeply grateful.

RMC
East Harwich, Massachusetts

Contents

Preface

We know that the majority of American families own inexpensive cameras, and that ordinary people use those cameras to take enormous numbers of pictures of themselves. People save, preserve, and treasure these pictures more than many of their other possessions. We know, too, that people take time and trouble to organize their pictures into various kinds of albums, sometimes sending special pictures to relatives and friends in all parts of the world. And, occasionally, they enlarge and frame individual pictures to be hung on household walls. While people commonly revere their own snapshot collections, they often express negative opinions about other people's pictures. (Being "invited over" to see someone else's travel slides or home movies is something to be avoided if at all possible.) The question I want to address in the following chapters is quite simple, namely "What's all the fuss about?"

My approach to studying amateur photography draws attention to a question that will be repeated throughout the book: "What are people *doing* when they make, appear in, or look at their own collections of personal pictures?" How do people know what to do? But I am not referring to technical information needed to produce photographic images. Camera manufacturers have historically taken care of that by continually developing more fully automated, error-free, inexpensive equipment. Commercial pressures and entrepreneurial initiatives have sought to guarantee that "every picture will turn out." And they obviously have done quite well. But questions addressed in this book have a different twist.

My studies have been directed toward understanding the knowledge that one must have in order to take "good" pictures—but what is a "good" picture? How do we decide? And how do we "know" all the things that we know about photos—how to take them, how to exhibit them? How do we know who should be asked or allowed to see these pictures, as well as when and where the pictures should be shown? What is taken for granted about this type of photography? And how is this knowledge used in everyday life?

I am also asking a set of questions about communication. I have been studying the kinds of personal expression and interpersonal communication that underlie forms of amateur photography. What are

people "saying" about themselves when they make snapshots and home movies? What are they expressing about their lives, their psychological, social, and cultural circumstances? What messages are being shared between photographers and viewers? What kinds of information are being transferred from generation to generation between the covers of a family album, in cans of home movies, or in videotape cassettes?

I have been investigating how this communication system works: what kind of communication is taking place when family members, relatives, or friends look at a family album, slide collection, or home movie? How does this form of communication compare with other forms of interpersonal or visual communication? Are these forms of photography similar to writing diaries, letters, or journals, or are they like sending tape-recorded messages between people or families? What does this communication system borrow from the mass media? Does it imitate, duplicate forms of photojournalism, of fine art, of documentary or popular feature films?

Some answers to these questions are more obvious and easily stated than others. This book provides less obvious answers—answers which describe the cultural dimensions of amateur photography. To this end, I have formulated the concepts of "Kodak culture," "Polaroid people," and "the home mode of pictorial communication." These concepts will be clearer after we explore how amateur photography is related to symbolic forms and symbolic environments, and how human life can be interpreted as a complex relationship between culture and communication.

Sources of Information

Findings and generalizations presented in the following chapters come from a variety of sources. I have examined approximately 200 collections of personal imagery at various times over the past ten years. The majority of the collections belong to white middle class Americans living in various locations of northeastern United States. Most of the pictures were made between 1940 and 1980. My comments come from the results of several studies, which include (a) an inventory of family photographic practices through use of a questionnaire (See Appendix for a copy of questionnaire); (b) a study of home movie viewing and interpretation through personally directed, open-ended interviews; (c) a commissioned study comparing conventional camera use with instant camera habits and practices; and (d) a study of the Polaroid Corporation's "Polavision" instant movie-making equipment. I have benefited from an uncounted number of inspections of photograph albums, collections of slides, and boxes of unorganized still photographs. I am also indebted

to over 60 papers written by graduate and undergraduate students at Temple University and by the students of several colleagues at other universities. I have reviewed innumerable popular publications for any mention of amateur photography—for intuitions, observations, comments, problems, and anecdotes that supported or disagreed with my thinking, or stimulated additional questions.

The resulting observations and generalizations describe structural features and social characteristics of amateur photography and pictorial communication. I have not attempted to complete a statistical survey of the photographic habits of sub-populations of American society, nor have I studied specific populations for definitive qualitative results. My hope is that others will pursue, refine, and clarify issues raised by this introductory study.

Chapter One

Kodak Culture and Home Mode Communication

When we try to examine the relation of photography to our culture—to examine the influence photography silently exerts on every person—we can make at least two assumptions. Photography has been little studied in a socio-cultural context and is little understood; the influence of photography... (is) clearly of great importance in shaping our relationships to the human world.[1]

The introduction of camera equipment for anyone's everyday use has been an extraordinary event, influencing the ways that people can keep track of who they are and how they have lived. The increasing availability of inexpensive cameras has made us the most-photographed people in the history of the human condition. This access to cameras has provided us with a modern expressive form that promotes the communication of information about ourselves to ourselves and future generations.

Three questions about the relationships between camera technology and social communication have stimulated this work and generated the material presented in the following chapters. First, we should ask how ordinary people have organized themselves in ways that make their pictures a meaningful part of social communication. Second, we should observe how ordinary people decide to use camera equipment while participating in leisure oriented activities, and, in doing so, make lasting and culturally significant statements about themselves. And, third, we should try to understand better how ordinary people learn to organize their thinking to make sense out of what they are doing when they view their private picture collections. We will first discuss the communication structures that make amateur photography meaningful and then a framework for understanding picturemaking as a culturally expressive form of communication.

Culture, Communication, and Symbolic Environments

The "culture and communications" approach used in this book focuses attention on social process, pictorial messages, and symbolic forms. This perspective implies that communication is inseparable from culture. Anthropologist Alfred G. Smith considers culture to be a code— better, a combination of codes—that are learned and shared; learning

4

and sharing also require *communication*. In turn, communication requires coding and symbols, the use of which must also be learned and shared within a *culture*.[2]

Scholarly explanations of symbolic forms (Cassirer), symbolic transformations (Langer), symbolic worlds and "worldmaking" (Goodman), and symbolic environments (Worth) provide the philosophical context for our theoretical approach to understanding photographic communication. The history of the human condition provides ample evidence of our continuing reliance on symbolically-mediated forms of information. Clearly we continue to develop new symbolic forms through which we express ourselves, solve problems, store information, and communicate with one another. Philosopher Ernst Cassirer noted that our symbolic universe comprises such systems as religion, myth, language, art—organizations of symbolic forms that we put to work for us to make our lives more comprehensive and intellectually more satisfying.[3] For purposes of this book, still photographs and motion pictures are being treated as a modern instances of symbolic activity—activity that creates the dense mesh of "the symbolic net, the tangled web of human existence."[4]

The accumulation and totality of these forms comprise what we now recognize as our *symbolic environment*. In this context, the philosophical concerns of Cassirer have provided a significant impetus to the communications scholarship of Sol Worth. Worth acknowledges past attention to three kinds of environments—the physical, the biological, and the social. He states:

It has become apparent that we live and function within a fourth major environment—the symbolic. This environment is composed of the symbolic modes, media, codes, and structures within which we communicate, create cultures, and become socialized. The most pervasive of these modes, and the least understood, is the visual-pictorial.[5]

Here, Worth sets the stage for additional research on how we construct, manipulate, interpret, live with, participate in, and generally use visual symbolic forms common to modern life.

Between Cassirer's concern with symbolic forms and Worth's notion of symbolic environment, we may introduce Nelson Goodman's constructivist philosophy called "worldmaking." Whereas the phenomenologist believes in multiple realities, Goodman's constructivist position believes in the multiplicity of *worlds*. He discusses the following kinds of questions: "In just what sense are there many worlds? What distinguishes genuine from spurious worlds? What are worlds made of? What role do symbols play in the making? And how is worldmaking

related to knowing?"[6] An underlying premise of the following chapters is that family collections of still and motion pictures comprise one of many constructed worlds. To understand this world, we need to explore how humans construct, encode, produce and reconstruct decode, interpret the pictorial symbol system that underlies the content, form, and use of snapshots and home movies.

We can conveniently tie Goodman's theoretical discussion of worldmaking to Worth's observations regarding what we "do" when making and/or viewing pictorial representations. Worth recommends that we study "peoples' use of the visual-pictorial mode as a symbol system that they could or did use in a variety of contexts *to structure their world, or their worlds,*" (emphasis in original) and, in turn, that "symbolic forms can be interpreted only in terms of their context, structure, and conventional usage."[7] Worth emphasizes an understanding of images as structured articulations, as assertions, as constructions, and as "statements about the world."

In this perspective, "copies of reality" do not exist; all drawings, paintings, photographs, films are considered visual *statements.*[8] They may, or may not, be similar to other constructed realities. Worth adds:

Understanding that photos and films are statements rather than copies or reflections forces us to ask how the statements were made. In what context. For what purpose. Under what rules, conventions, and restrictions. It enables us to look... at various ways of picturing the world.[9]

In this book, his set of questions is being asked of the pictorial communication that results from ordinary people's use of cameras and photographs. Snapshots, home movies and home videotapes are being examined as more than "mindless copies" or "simple documents" of what's "out there." These kinds of images have been made by humans— not by cameras[10]—by people who have made many decisions about camera use and about producing particular arrangements of the symbolic universe. Here pictures must be understood as evidence of the structure of observation-with-cameras, and of how people have structured a particular view of the world.[11] Collections of personal pictures can also be considered as juxtapositions and sequences of symbols, as texts that have been produced as interpretations of life.[12] In this perspective, we are seeking to understand the meanings people build into their photographic renditions of their own lives—to see how "claim," "statement," "interpretation" are translated into visual terms. Few people have been conditioned to think of amateur photographs as claims about life, as attempts to make sense of human existence, as interpretations,

or as constructions of reality. The following chapters offer certain conclusions about the claims that ordinary people make about life as they continue day after day, year after year, and, now, generation after generation to take and save pictures of themselves.

Developments in communications technology have greatly enlarged the symbolic universe and increased the density of our symbolic environment. It is often said that we "swim" in floods of pictures and audio-visual messages that now dominate parts of our everyday lives. Modern methods of mass reproduction of information have contributed and, indeed, increased our participation in symbolic environments. In turn, an increasing number of studies show how we construct particularized views of ourselves, and tell us what we are saying about ourselves through "programs" that fill modern channels of mass communication. For instance, we have studies that focus on the structure of life seen in television programming—in daytime soap operas and the evening news, in prime time drama and situation comedies, in talk shows as well as commercials.[13] Similar studies have been done of photojournalistic images and photo essays, of cartoons and comic strips, of various genres of feature films, of advertisements that appear in magazines.[14] Most of these studies ask how certain views of life are structured and represented through audio-visual conventions appropriate to each genre or medium. In summary, these investigations have directly or indirectly clarified the structure of our symbolic environment, and demonstrated how public—mediated versions of life have affected the world of "real" human behavior.

The same sets of questions relevant to mass communication also apply to *private* communication. Mass media can be understood to represent statements about life constructed by "an unelected media elite." But modern camera technology allows ordinary people to participate in pictorial communication in personal and private ways. Participation is now open to anyone. Any ordinary person, untrained in the visual arts of unskilled in media production, can make personal audio-visual statements about private aspects of life.

But how do these personal systems of communication work? How do people organize and use symbolic forms to perform this task? The answers are found in the structure and functioning of "home mode" pictorial communication.

The Home Mode Of Pictorial Communication

Communication is defined as "a social process, within a specific context, in which signs are produced and transmitted, perceived, and treated as messages from which meaning can be inferred."[15] Snapshots, home movies, and home video are forms of home mode communication. The "home mode" is described as a pattern of interpersonal and small group communication centered around the home. In later chapters we will illustrate and elaborate on pieces of this definition: details of this social process, how it works within specific contexts, the structure of the transmission system, and the implicit and explicit messages that are implied and inferred in amateur forms of photography.

This concept of *mode* allows us to place pictures, as symbolic forms, into a process of social communication. My emphasis on "social" takes precedence over psychological explanations.[16] The social basis of this communication model will become clearer when we discuss the importance of shared knowledge and related patterns of appropriate behavior that will underlie our concept of "Kodak culture." For instance, examples will be given of how there are social pressures for people to make snapshots of their children when they are smiling rather than crying, when they are healthy rather than hurt or ill, or when they are dressed in clean clothes rather than in torn or dirty ones.

One primary characteristic of the home mode is its selection of an audience. For instance, one person stated, "I wouldn't think of showing these (home) movies to just anyone who comes into the house... If they were not relatives, and close relatives at that, I'd want to make sure that we were all good friends, or at least that we knew each other pretty well... " We will see that people using home mode channels know each other in personal ways. Photographers usually know or know of the people in their pictures; and viewers, usually know the photographer, and, most of the time, either know or can identify the subjects of the pictures. In Chapters six and seven, we will see that photographers and viewers both must share certain kinds of background information in order to make sense of their pictures.

These personal and private features serve to distinguish the home mode from mass modes of communication in other ways too. Mass modes include transient messages that have been produced through public symbol systems[17] for mass distribution to large, heterogeneous, anonymous audiences. For instance, feature films (whether shown in movie theaters, on network television, or on home video recorders) are examples of mass modes, whereas home movies and travel films represent the home mode; still photographs published in popular magazines,

newspapers, and books exemplify mass modes, whereas snapshots collected in family albums are part of home mode visual communication.[18]

We will also see that the selection and details of image content are often matters of private information. For instance, the content of a snapshot may be identified as simply "a boy and an adult standing in front of an automobile." On the other hand, members of a specific home mode "community" may say: "Oh, yes, that's Uncle Bill and Michael just before Bill was sent to Viet Nam. In fact that was the last time we saw him. He joked with us about giving that car to Michael if anything should happen. Bill bragged about how girls loved that car, and yeah, how girls got loved *in* that car."

Finally, this concept of "mode" is not equated with a specific medium of communication. The same mediums—writing, painting, drawing, photography, film, videotape—can be used for both mass communication and home mode communication. We are interested in *how* people use a medium, as both "producers" of messages and "audience" members, rather than in the medium per se. It is specifically this knowledge—knowing how to use visual media in home mode communication—that forms the core of Kodak culture.[19]

The Reality of Kodak Culture[20]

Occasionally we find a general and popularized notion of culture applied to photography and filmmaking. In one instance, social psychologist Stanley Milgram states: "The culture of photography is so widespread, and the normality of taking pictures so deeply rooted, that everyone understands what is meant to be photographed... "[21] But what is meant by "the normality of taking pictures"? Who has said what is normal and abnormal? Do all people from all societies and cultures recognize and adhere to the same schemes of normality? And how do ordinary people "know" what is and what is not "meant to be photographed"? How do we know what is acceptable and unacceptable subject matter for our snapshots? How do we learn when to begin and end the filming of a sequence of activity for our home movies? How do we decide what to photograph, when we are on vacation or being tourists? And finally how do these ideas get "so deeply rooted?" Can people change these ideas and norms by themselves as they wish?

Answers to these questions are usually explained and summarily dismissed as part of common sense knowledge. The idea that family photographers seem to know what to do without really thinking about it is expressed as follows: "It's not so much a question of planning it all out; it's not something that gets debated. We do and don't—I mean

someone has to remember to check the film and get out the camera. But generally we just know 'now's the time'."

We will use a concept of culture to take this inquiry several steps further. We will be examining *patterns of behavior* that define the normality of home mode pictures. Understanding the snapshot, the home movie, and the home video as culturally structured artifacts will help us recognize, explain, and understand these patterns of behavior. For instance, there are good reasons why having a baby and taking a trip are the two most common justifications for purchasing a new camera. There are good reasons why people take more pictures of their children when they are very young than when they are older, why parents take more pictures of their first born than later children, why family albums contain more pictures related to births than deaths, to achievements rather than defeats or disappointments, to vacation times rather than vocational activities. Many of these comparisons will be accompanied by detailed examples in the following chapters.

But, first, we must become more specific about our use of the term "culture." *Kodak Culture* will refer to whatever it is that one has to learn, know, *or* do in order to participate appropriately in what has been outlined as the home mode of pictorial communication.[22] As in most studies of culture, we are exploring ideas, values, and knowledge that are informally or unconsciously learned, shared, and consensually agreed upon in tacit ways by members of society—in this case, by ordinary people who use their cameras and pictures as part of everyday social life.

This cultural orientation to amateur photography provokes several general questions: How do people know what is expected of them when they are either taking personal pictures or appearing in front of a camera? How do people know when to show their pictures and to whom they should, or should not be shown? By studying Kodak culture, we want to learn how people have *organized themselves* socially to produce personalized versions of their own life experiences. In turn, we want to consider how ordinary people have *organized their thinking* about personal pictures in order to understand certain pictorial messages and make meaningful interpretations in appropriate ways. We also want to learn how Kodak culture provides a structured and patterned way of looking at the world in terms of reality construction and interpretation. Incorporating the ideas of Goodman and Worth, we are examining how a "real world" gets transformed into a symbolic world. We are exploring how picturetaking has the power to transform on-going patterns of activity into other behavioral routines—into patterns of behavior that

are socially appropriate and culturally expected when cameras are in use. We can then be more certain how worldview and "cameraview" articulate and compare with one another, and how ordinary people use their cameras and pictures to make biased statements about their life circumstances.

Alongside the *process* orientation of Kodak culture, the notion of *Polaroid People* suggests a content analysis of the life that appears in the pictorial *products* of camera use. We will be examining the composition of a symbolic world by asking "what's there?" The term "Polaroid people" is used to provoke an inventory (or environmental "topography") of specific people, places, and things that regularly appear in the photograph collection. We will be looking for the patterned qualities of one part of our symbolic environment—that is, the symbolic world and the look-at-life as they appear in shoeboxes of snapshots, in family albums, in home movies, or on home videotapes. A study of Polaroid people focuses on the pictorial representation of people in a symbolically formed community rather than a real life community of living, in-person people. As observers and scholars, we are visiting the life of people given to us in the form of personal pictures. This perspective prepares us for asking how these two types of communities are related to one another, and how on-going human life has been transformed into symbolically represented views of human life.

This concept of Polaroid people also raises questions about the appearance and performance of people. For instance, we might study the customs of preparation for making a personal "presentation of self" in a snapshot or home movie: do people insist on being seen by cameras in only certain poses or gestures, patterns of movement, states of dress, moments of activity, specific social circumstances? Or, is anything acceptable? Is it important that people are shown in these pictures with certain other people? If all these people are known to one another, *how* are they related, or *how* do they know each other?

Another set of questions involves the interpretation of the "world" of Polaroid people. How do snapshot appearances of particular people influence our memories of people we have actually met in the past, or structure an impression of people we will *never* meet? For instance, how do we come to "know" a grandmother or grandfather no longer alive, or a relative living in another country, from their pictures in the family album? In turn, what does "being in the album" mean, and, conversely, what does *not* being there mean? How do we integrate these photographic appearances with other information we have from other sources about specific people, events, activities, achievements?[23] In more general terms,

how does the symbolic world of Polaroid people affect our knowledge of the real world? And what kind of world do we see when we visit Polaroid people and study Kodak culture?

The relationship between Kodak culture and Polaroid people is found in a distinction made by Sol Worth when he discusses photographs as products *about* culture and as products *of* culture. In the former orientation, photographs can be used to collect evidence and data about "what's there."[24] But photographs are not totally objective; photographs and films also offer information on the culturally structured subjective *ways of seeing things* with cameras. They are products of a culture— products which reflect the subjective values of that culture. Thus, the latter orientation, *"of* culture," assumes significant attention alongside the more frequently considered *"about* culture." In this context, Worth urges the coordinated study of "what the members of society made pictures, of, how they made them, and in what contexts they made and looked at them.[25] Our study of Kodak culture is much indebted to this perspective.

And, finally, it should be made clear that the Polaroid people of Kodak culture are "in" pictures only; they should not be confused with real life people who actually take and look at pictures. Anyone can be a member of Kodak culture just as anyone can participate in home mode communication. The terms "ordinary people" and non-professional or amateur photographers will be used throughout the following chapters. My objective is to focus attention on people who "do" photography in periods of leisure as part of everyday life. They are "serious" about "getting good pictures" but not serious in the *art* of photographic representation. We are not concentrating on people with professional identities such as photographers, filmmakers, critics, scholars, or not people who have had extensive training in other forms of visual production.[26] These people are not the focus of this study. Nor are we studying "amateur" photographers who join camera clubs or enter photography contests or film festivals on a regular basis. These types of amateurs and even professional photographers, however, *can* participate in home mode communication when their intention is to make pictures for private uses and for personal reasons, and not for either financial reward or career objectives. In short, we are studying the photographic habits of people who feel they take pictures as records, for fun, and sometimes, to satisfy personal obligations. In this sense, we are exploring how ordinary people do ordinary photography.

Pictures Of Kodak Culture

So far, Kodak culture has been described as a theoretical construct that includes a type of knowledge and a profile of patterned behavior. To this we must add the material components of Kodak culture, namely the photographs themselves as well as the photographic equipment used to produce and show the pictures. Here I include equipment (cameras, projectors, screens, recorders, monitors), supplies (films, flashbulbs, albums, videotape) as well as specific types of photographic forms that we identify as snapshots (prints and slides), home movies, and home videotapes. Kodak culture was not possible until certain technological processes became simplified and made available to large numbers of people.[27]

Eastman Kodak has produced a remarkable history of marketing success. The year 1888 marked the availability of a camera with the famous motto "You Press the Button—We Do the Rest." This trend of catering to the needs of home mode communication continues to the present day as we see the emergence of 8mm videotape technology aimed at non-broadcast, home mode activities. Figures from marketing reports on the photographic industry give us a clear indication of how well amateur photography has become a part of American society. As Kodak is fond of saying, "What would the world be without pictures?"[28]

The quantity of annually produced home mode pictures is enormously large and continues to grow at an impressive rate. It is not surprising that Eastman Kodak and the Polaroid Corporation are considered blue chip stocks—industries of significant proportions. According to the *1983-84 Wolfman Report*, an annual marketing report for the photographic industry, amateur photographers took an estimated total of *11.75 billion* still pictures in the United States (figures are not available for worldwide production).[29] This figure and other relevant statistics appear in Table 1.

Table 1: Photograph Production

	1973	1983
Total still pictures taken by amateur photographers in the U.S.	6.23 billion	11.75 billion
Color photographs		96%
Black and white photographs		4%
Prints		90%
Slides		10%
Five year trend for prints		48%
Five year trend for slides		-16%

This overwhelming preference for color pictures and the increasing popularity of prints over slides helps us describe certain material features of home mode communication. In turn, we can refine our understanding of the symbolic world of snapshot photography. *The Wolfman Report* also indicates that an average of 126 still photographs were taken in each U.S. household in 1981. This figure represents a significant increase from an average of 77 pictures per household taken ten years earlier in 1971. These statistics supply us with strong evidence that participation in home mode communication is extremely popular, and that the quantity of picture taking is increasing.

Figures for camera ownership are equally impressive. *The Wolfman Report* indicates that approximately 93.2 percent of families living in the United States owned some type of camera equipment as of 1983. This number and related figures appear in Table 2.

Table 2: Camera Ownership

	1983
U.S. families owning some type of camera	93.2%
Ownership of a still camera	94.0%
Ownership of a self-developing camera	46.3%
Ownership of a motion picture camera	22.8%

Other marketing figures indicate that while ownership of cameras to make still photographs continues to increase, the sales of motion picture cameras used to make home movies continue to decrease. As of 1981, the Wolfman Report estimated that only 6 percent of American household were actually shooting home movies. But, by 1983, the report also noted that 11 percent of U.S. households contained some form of videotape equipment, and 28 percent of these households included a video camera for home recording. Speculation that people are simply changing mediums to continue their home "moviemaking" will be discussed in Chapter Nine.

It is clear that a large majority of American families is equipped with sufficient camera technology to produce pictures for home mode communication. However, possession of camera equipment does not necessarily imply active picture-taking. Equipment may be awaiting repair; people may not be taking pictures because of financial problems; or they may have temporarily lost interest. We will be looking for certain

life circumstances that seem to regenerate interest in photography on a regular basis.

But according to our earlier definitions, even camera ownership is not absolutely required to be included in Kodak culture. Cameraless people often become part of other's home mode photography and are given pictures of themselves. They can also have personal pictures made in photo booths or in inexpensive studio settings commonly located in department stores.

And finally, our concepts of Kodak culture and home mode are not restricted to particular types of cameras. Clearly most snapshots and home movies are taken with inexpensive cameras such as Instamatics, Polaroid cameras, Brownies or inexpensive 8mm or Super-8 motion picture cameras. As professional photographer Lisette Model points out: "Snapshots can be made with any camera—old cameras, new cameras, box cameras, Instamatics, and Nikons. But what makes them occur is a specific state of mind."[30] Camera models and related technology are less important than people's intended uses of their cameras and subsequent photographs.

Simply stated, virtually everyone draws upon Kodak culture in order to participate in home mode communication. Scholars are beginning to acknowledge what most ordinary people have accepted as common sense knowledge for some time: snapshots, home movies and home videotapes are extremely important to people in intensely personal ways. For instance, in a study completed in 1977, behavioral scientists Csikszentmihalyi and Rochberg-Halton asked 351 members of 82 families living in the Chicago metropolitan area "what are the things in your home which are special to you?" Overall, photographs ranked third behind furniture and visual art. When the authors studied responses across young children, their parents, and their grandparents, a dramatic age-related difference was found: "For the youngest generation photographs are the sixteenth category in order of frequency; for the grandparents they are the first."[31] That is, as people get older, personal photographic images, including snapshots and home movies, become more and more important.

Some people would claim that the annual human production of 11.75 billion of *anything* is worthy of cultural analysis. But more impressive is the realization that people are not *forced* to take and show all these pictures. There are no biological or physical pressures that require these kinds of photographic activities or accumulation of pictures. In contrast to physical survival, it appears that we are exploring a massive, but optional form of symbolic support for our existence and our lives.

We know that people make these pictures as part of leisure and pleasure, and sometimes as part of social and personal obligations.

The foregoing review has established certain quantitative dimensions of amateur photography. We are now suggesting a new and revitalized examination of the social, symbolic, and cultural reasons for the popularity indicated by the figures. It remains for us to relate these figures to social structure, behavioral patterns, and human communication.

Chapter Two

Social Organization, Kodak Culture, and Amateur Photography

Next we need to explore the relation of Kodak culture and the home mode to the social organization of amateur photography. We will outline a categorical scheme for knowing what to look for, what to treat as data, and how to classify, evaluate, and interpret the results.

An ethnographic approach can be used to study the relationship of Kodak culture to the home mode. Ethnographic methods of observation are used by social scientists to describe social and cultural settings or well defined parts of a culture. This research strategy emphasizes the first hand observation of behavior as it occurs in "natural contexts" of social life. In a sense we are trying to visit ordinary people to understand better how they use the home mode in patterned ways.

Anthropologist Bronislaw Malinowski is frequently cited for his claim that the goal of ethnography is "to grasp the native's point of view, his relation to life, to realize *his* vision of *his* world."[1] Thus we are drawn to an interpretation of how Kodak culture is responsible for a "vision of the world", a "vision" produced by ordinary "natives" as they use their cameras as part of everyday life.

Sociolinguistic Backgrounds

Ethnographies of speech communication offer detailed examinations of social contexts in which normal or "native" people engage in "states of talk" and (hopefully) "states of listening," speech "encounters," "events," and "acts." Anthropological studies done in cross-cultural, cross-regional, and cross-class contexts have demonstrated considerable variability in speech use and have clarified how speaking behavior is culturally ordered and socially maintained.

New areas of study were suggested when concepts central to an ethnography of speaking were generalized to the study of human communication.[2] In proposing an ethnographic approach to human communication, Dell Hymes summarized four basic questions:

1. What are the communicative events, and their components in a community?

2. What are the relationships among them?

17

3. What capabilities and states do they have, in general, and in particular events?

4. How do they work?[3]

The perspective that will be outlined and applied to the home mode addresses a similar set of questions, applying them to the structure of non-professional photographic communication.

In communications research, ethnographies of visual communication have been discussed,[4] and methods have been suggested for doing ethnographies of film communication in a framework of "ethnographic semiotics."[5] Following these theoretical leads, ethnographies of visual (pictorial) communication study how people go about producing images in different contexts, and how people go about interpreting messages from the vast array of pictures that appear in all contexts of daily life.

Our objective is to apply ethnographic methods to one model of pictorial communication. In most general terms, we are asking when, where, with whom, under what conditions, and for what reasons people are observed to be participating in any part of home mode communication. Purposefully being naive, we might initially ask if we are examining patterns of structured behavior or merely working on pictures made in an idiosyncratic or random manner. Is everyone doing the same thing with their cameras and pictures, or are different people producing distinctly different images and using them in unique and incomparable ways?

Another approach to the same line of inquiry is phrased as follows: While it is the case than anyone *can* take a picture of any person or anything, at any occasion, at any time, in any place, for any reason— and subsequently *show* that picture to any person, in any place, at any time, for any reason—*do* people, in fact, behave in this manner?[6]

The obvious answer to this rather awkwardly phrased question is that we *can* record almost anything we want in snapshot or home movie form, and we *can* subsequently show these images to almost anyone we wish. Clearly the advanced state of our camera technology allows this situation, and the advertising for, and by, the photographic industry promotes it. However, there is an important difference between what we *can* do and what we *do* do; a difference between potential for occurrence and actual occurrence; between hypothetical freedom of choice and culturally preferred, or even determined, patterns of choice.[7]

A Framework For Observation And Description

In Chapter One we stressed the ideas of social process and social organization. This is a convenient starting point for describing how

members of Kodak culture actually organize themselves to "do" amateur photography. Processes of pictorial communication consist of five kinds of what I have chosen to call "communication events", namely (1) planning events, (2,3) shooting events—which include two sub-categories of "on-camera" events and "behind-camera" events, (4) editing events, and (5) exhibition events. In addition, five kinds of "components" can be used to describe the operation of each event. Components include (1) participants, (2) settings, (3) topics, (4) message form, and (5) code.

When the sequential list of five events is arranged along a vertical axis and the list of five components is arranged along a horizontal axis, we produce a grid of 25 cells, as appears in Figure 3.

Figure 3
Descriptive Framework[8]

Events	Components				
	Partici-pants	Settings	Topics	Message Form	Code
Planning					
Shooting: on-camera					
Shooting: behind-camera					
Editing					
Exhibiting					

Each of these 25 cells represents an event-component relationship and, as such, generates particular kinds of questions that are useful for describing and comparing specific examples of image communication. When each component is referenced with each event, a pattern of activity and behavior emerges that is characteristic of a specific group's use of a specific genre of image communication. The framework should be understood and used as heuristic, helping to clarify which elements apply in all cases and which ones have only limited application.[9]

Image Communication Events

The first dimension of this framework consists of a series of five communication events. The term "communication event" is used because the activities that comprise such events are products of human choices, human decisions. By describing communication as social process, we seek to understand better the kinds of social requirements, restrictions, prescriptions, limitations imposed on it.

Questions include how people engage in each type of event. Their conscious and unconscious intentions as well as intentional and unintentional, perceived and unperceived functions should be examined. Other interests focus on the social norms by which people judge the success or failure of their participation in each event.

The production and exhibition of pictures are the central organizing concerns for each event. The action or activity constituting each communication event may be done by one or more people, and a variety of social acts may occur in each event. The sequence of these five events within the same production process is also variable. Some events must precede others; for instance, a filming event must come *before* either editing or exhibition events. However, filming events may also occur *after* editing or exhibition as well as planning events.

Planning Events

A Planning Event consists of any action(s) in which there is a formal or informal decision regarding the production of a photographic image(s). In all cases, some form of planning must occur before proceeding to the next category—shooting events.[10]

When looking at Planning Events, the following questions are relevant: What kinds of social preparation are seen to occur before the taking of snapshots or home movies? Who decides when pictures should be made, and who is asked to take the photographs? Who promotes or discourages the idea? What kinds of equipment or supplies must be borrowed or purchased? How important are technical preparations to the success of home mode communication? Is there any kind of specialized

learning or training necessary? Will the production require a shooting plan or some kind of script? What kinds of social organization and cooperation are needed?

Examples of planning events are found in advice columns that specialize in improving amateur photography and in creating more enjoyment from photographs. For instance, in an article about planning an album, entitled "Christmastime '72," Denise McCluggage suggests the following:

Plan ... production ahead of time. Decide which aspects of your life and times to cover, make a list of the pictures you'll need and set out to get them. ... When photographing your home life, don't overlook family vehicles and family pets. Line them up and get a shot of them: the cars, motorcycles, bikes or skate boards, the dogs, cats, guppies, parakeets or iguanas. If it's part of your household this Christmas, it belongs in your Christmas book. And why not get a shot of the postman coming up the walk loaded with Christmas mail? If you're using a Polaroid Land camera, take two pictures and give him one on the spot. ... Don't overlook your town and your neighborhood in the special holiday mood—the street corner Santa, the municipal decorations. ..."[11]

In addition to social and technical preparations, we might also ask about the mental "set" in planning a series of pictures. Ralph Hattersley reminds his readers to have the "right attitude" when he describes family photography as a "sacrament."[12] In contrast to these published commentaries, one informant simply said, "I really don't know how we decide that it's time to make a movie ... some occasion comes up and we just do it—that's about it." While column writers may be promoting a model of filmmaking that requires a lot of organization and planning—a model that approximates professional "production"— this kind of image production requires a pattern of work activities that conflicts with the home mode's preference for carefree and leisure activity. (In Chapter Four I will explore further the patterned differences between prescribed behaviors found in magazine advice columns and findings from fieldwork on "actual" home moviemaking activity.)

Shooting Events

A Shooting Event consists of any action(s) in which an image is put on film or videotape by using some type of camera. Shooting events occur in two forms, related to the action that occurs *in front of* a camera, and the action that occurs *behind* the camera.

On-Camera Shooting Events

An On-Camera Shooting Event consists of any action(s) that in some way structures the person(s) or thing(s) that "happens" *in front of* an

operating camera. In all cases, something has to appear or be placed in front of a loaded camera and be recorded on light sensitive material or magnetically sensitized tape.[13]

Distinguishing characteristics of Kodak culture have been derived by asking the following kinds of questions about on-camera shooting events: what kinds of behavior are observed to occur in front of a loaded, operating camera that is being used to make snapshots or home movies? Who or what is likely to be overlooked, neglected, or eliminated? What kinds of systematic rearrangements or transformations are made of people's appearances, of scenery or of events specifically for camera recording?[14] What kinds of settings, environments, activities or events are likely to be photographed, or never photographed? Do people insist on posing or "acting" different in any formal or informal way? Are conventions or standards for posing recognized, criticized, or otherwise commented on?

A few examples from a variety of sources will illustrate the notion of on-camera events. In one newspaper clipping entitled " 'I do' again for film" we read:

BRADWELL, England (AP)—Newlyweds Julie Hayward, 22, and Tony Mills, 23, walked down the aisle all over again in a replay of their wedding. After Julie married Tony last month a thief stole the film of the wedding. So Sunday, the couple and all 80 wedding guests turned up again for a rerun.[15]

Other examples are found in advice columns dedicated to "looking good" and being "more photogenic next time a shutterbug in your family aims and shoots."

Be natural, hang loose. A relaxed photo is the look of today; a contrived pose dates you.... Let the photographer get close to you. Someone raised on the Brownie camera stands fourteen feet away from the subject because he wants to include the Grand Canyon or the Spanish Steps when he should be concentrating on little old you.... There are special ways to relax for body shots. If you are standing, pull in your fanny and drop your shoulders so your neck emerges swan-like.... Don't pitch your body forward or your head will photograph too large.[16]

Behind-Camera Shooting Events

As a second kind of shooting event, *Behind*-Camera Shooting consists of any action(s) not in front of the camera but which in some way still structures the use and operation of it. Instead of attending to what appears "in" the picture, attention here is given to the behavior that is responsible for successfully recording the image. In all cases, someone must make a series of decisions regarding how, when, where, and why a camera is being used.

The relationship of Kodak culture and behind-camera shooting

events has been examined by asking the following kinds of questions: what kinds of behavior are characteristic of the person using the camera? Is there a noticeable behavioral routine or style of behind-camera performance? Who, more likely than not, will be asked to use the camera? Are there specific times and places that seem to require the making of snapshots or home movies? What are the relationships between the on-camera and behind-camera participants? Are verbal instructions part of the relationship between the person using the camera and the subject matter? What kinds of "directing" are involved? Is much attention given to "setting up" the shots, arranging the scenery, or use of "props"?[17]

Examples of behind-camera activities occasionally appear in the popular press. One unusual account from Canada is entitled "Lifer 'visits' her girl through movies—Mother-daughter bond kept alive:"

KINGSTON (CP)—A sympathetic prison warden, moved by a lifer's fear that her relationship with her child would evaporate, is making home movies to keep that bond alive. ... Miss Fehr, 26 ... [who] won't be eligible for parole until 1987 ... and one other female prisoner at the woman's prison in Kingston are pioneering a new prison program in which the women make videotapes of themselves, send them to their children and await a video replay.... But before any prisoner can make videotape, he or she must be screened by a psychiatrist to ensure that the prisoner can cope with the emotion charged experience. The child's guardian must also agree to the program.[18]

Occasionally we will learn more about social norms surrounding shooting events when things go wrong or someone becomes upset when a camera is being used.

Dear Abby: I am a clergyman and as such, I perform marriage ceremonies.

My pet peeve is the well-meaning shutterbug who insists on flashing his camera during the wedding service.

One such photographer actually kept crawling around on the altar, adjusting the bride's veil and the groom's coat. He even asked me to please "lean in" a little more toward the couple. And all this while I was performing the ceremony!

Please put something in your column to discourage this type of thing.

Distracted Pastor

Dear Distracted: Seems to me that a pastor performing a marriage is, or should be, in command. He should lay down conditions for photography....[19]

Editing Events

An Editing Event consists of any action(s) which transforms, accumulates, eliminates, arranges or rearranges images. Editing events occur after film or tape has been "exposed" but before a public showing.

Editing events include the viewing of contact sheets, rushes, or rough-cut edited footage on a viewer or projector by the imagemakers themselves. These activities are classified as "private" showings and are part of editing events. "Public" showings are characteristic of the next category of events, namely exhibition. Processing film, retouching still photographs, sequencing a series of prints or slides, or simply arranging a display of pictures are classified as editing activity.[20]

Our description of editing in the home mode is enhanced by asking the following kinds of questions: what kinds of editing are likely to be done on collections of snapshots or on individual rolls of home movies? Are any specific images regarded as "bad" pictures by either picturetakers and/or viewers? If so, what criterion are used for "badness" or "goodness"? Are "bad" images simply not used? Are they hidden? Are they just thrown away? Is the visual content of a snapshot or home movie manipulated or distorted in any way, such as scissoring, painting, or scratching-out parts of the pictures?

Examples of editing events may also be found in advice columns, or as part of picture-taking manuals. In one book entitled *Family Movie Fun for All*, we find the following:

Most movie makers hesitate to change the order of scenes, feeling that it is a little like changing the truth. Not at all. If changing the order of scenes from the way you shoot them helps to make your movie more interesting and informative you're actually making the truth stronger.[21]

This conversation emerged from an interview about organizing a family album:

RC: Chuck, you've been editing the album?

CW: Yes, I've been putting things in it.

VW (wife of CW): We don't edit—we put everything in (laughter).

CW: No, I do a little editing.

RC: What picture is likely not be put in?

CW: Oh, bad ones. (RC: What's a "bad" one?) Oh, blurry and where she's (two year old daughter) moving, and Velma loves to take repetition pictures; she'll just go 'click, click, click'—and I try to eliminate a couple of these periodically.

RC: Do they (the extras) get thrown away?

VW: No, those are the ones that get sent to the relatives if Leslie's not too blurry.

Finally we must consider the editing of individual images—acts

performed on an individual picture to create a meaningful change, deletion or rearrangement. In Robert Fanelli's 1976 study of six family albums, he found it necessary to code individual photographs for seven types of manipulation: (1) cropped frames; (2) cropping pictures along lines of a person's body; (3) writing or drawing on the front of photographs; (4) hand coloring or tinting the surface of the photograph; (5) captioning above or below the photograph; (6) altering captions; and (7) other various types of manipulations, such as scratching out a person's face or physical features, and the like.[22] Analysis of these examples develops further our central notion of a "constructed view of reality." These editing acts are done to create a preferred symbolic rendition of the past, of reality.[23]

Exhibition Events

An Exhibition Event consists of any action(s) which occurs after shooting, in which photographic, filmic, or video imagery is shown and viewed in a public context. For purposes of studying the home mode, we will call "public" any audience that consists of more than the picture-taker or the editor (if editing was done at all). We must be prepared to include one-or two-member audiences—as when an individual or two children want to look at an album or a tray of slides without the rest of the family.[24]

Information on how exhibition events work in the context of Kodak culture has been clarified by asking the following kinds of questions: what kinds of behavior characterize the exhibition and viewing of a collection of snapshots or home movies? How are exhibition events socially organized? Who initiates, promotes or restricts this activity? Where do these events take place? What other kinds of behavior of social activity are likely to accompany the showing of pictures? What are the social relationships between the people who plan the image, people who take them or appear in them, and the people who subsequently show or see the pictures?

The most commonly ridiculed example of home mode exhibition involves the showing of travel photographs (see Chapter Five) to relatives and friends who did not make the trip. A short satirical description of this phenomenon appeared in a popular magazine article entitled "How to Stop Them—after they've photographed Paris":

Let's be honest—is there anything worse than spending an evening at a friend's home looking at slides of his trip to Europe last summer? I say there's nothing worse.... Usually, there are four or five couples called together on a Saturday evening for this ritual. I always hope that nobody will ask to see the photos, but that has never happened. Somehow

the photos have some strange sense of inevitability about them. From the moment I walk in the door, I know it's only a matter of minutes until the familiar question is raised. "Mona, we're all dying to see your photographs of London. Will we get a chance to look at them tonight?"[25]

In a work on photo therapy (see Chapter Eight), the potential harmful effects of displaying the wrong photograph in the wrong place are described as follows:

In most middle-and upper-middle-class families, pictures are displayed in the foyer, family room, den or living room. But the pictures Dr. Kaslow finds most intriguing are in the bedroom. One couple in their early thirties came to her recently expressing concern about the wife's inability to have orgasms. "Who's in the bedroom with you?" Dr. Kaslow asked. The husband's answer: "My mother-in-law's picture is over the bed."[26]

Here we are given reason to study further, specific relationships between a particular communications event and the people involved (later referred to as "participants").

One last example serves to extend the significance of situation-specific relationships in exhibition events. In a newspaper article entitled "Cheesecake: Not with your wife, you don't" we read the following:

Marion Riddle, convicted of armed robbery in Michigan, decorated his cell in Marquette Branch Prison with photographs of his nude wife. Prison officials arrived to confiscate them, and Riddle ate them rather than give them up.

The officials came for the photographs because you are not allowed to put such pictures of your relatives on cell walls in the Grand Rapids prison. Pictures of other nude women, yes, but no photographs of someone "near and dear" to you. Prison officials say there are more fights and problems among inmates if someone steals the photos of a loved one than if photographs of nude women clipped from magazines are posted.

Saying his civil rights were violated, Riddle filed a lawsuit, but on Friday Chief U.S. District Judge Wendell Miles upheld the prison rule.

In addition, the judge upheld the prison's decision to suspend the couple's visitation rights after the incident in which Riddle consumed the evidence.[27]

This example provides us with a case of how an exhibition event is related to two specific components, namely *topic* and *participants*. In fact, two kinds of participants are important: on-camera subjects and audience members. Explicit attention is given to how pictures of nudes, appearing in popular magazines and on posters, are meant for large heterogeneous audiences: snapshots of nude relatives are not.

The second major dimension of our framework—namely Communicative Components—is meant to clarify further how each communication event varies according to (1) participant(s), (2) topic, (3) setting, (4) message form, and (5) code. Descriptions of the five components follows.

Participants

The Participants component involves anyone who participates in any activity for which the central organizing concern is producing pictorial communication. Here we are concerned with identifying people who take pictures, appear in pictures,[28] and look at pictures. In describing home mode patterns we would want to know if one person is in charge of each event; if the personnel changes from event to event; and how participants are known or related to one another in each event. Other pattern characteristics would include how specific roles are assigned or assumed in each event, whether complete freedom exists regarding who will do what, and who must participate in a specific way in order for an event to be considered "successful." We must consider situations when only one person is present—a child or an adult—and determine the relevance of non-human participants such as family pets.

Attention to participants is important to every communications event. Readers are reminded that our perspective is structured by the fact that neither cameras, lenses, nor film "make" pictures, but rather that people do. The success or failure of each communication event is dependent upon a process of selection, decision making, and choices made by human agents throughout each event.

We will see that certain problems encountered in different communication events illustrate the non-random quality of the selection of participants. In any social situation, there appears to be a fairly well-defined "role" for the photographer. This role, however, can sometimes be problematic. One couple in this study described a family argument and subsequent problems that developed after the husband forgot to buy the film for their daughter's birthday party: the wife claimed that it was her husband's responsibility to do this part—"he had always done it before, when we went on trips or for other parties." In another instance, a home moviemaker confessed that he only pretended to take pictures of non-family members at various social gatherings:

If an aunt brought a person to the party that we all didn't know, I'd pretend to take her picture but wouldn't—didn't want to waste the film; we're cheap, yeah, done that lots of times.....

It was strictly a family event; if there were other people in the movie, it was just because they were there at that time....

In other cases, the state of the on-camera participant may be in question. Consider the example of dead participants.

Dear Ann Landers: Would it be considered improper to take a photograph of a deceased

friend or relative in the slumber room during viewing hours?

I would like such pictures as final remembrances, but am reluctant to go ahead and take them. Of course, I would be discreet and wait until I was alone. Please give me your opinion..

— Want to Do What's Right

Dear W.T.D.W.R.: It is perfectly proper to photograph the deceased. In fact, according to the executives of two mortuaries with whom I checked, it is done frequently.[29]

In the case of wedding photography, the inclusion and positioning of specific relatives may cause unanticipated problems in on-camera participations.

Dear Ann Landers: I am John's third wife and I need to know what is proper under the circumstances. John's daughter (by his first wife) is getting married in the spring. Missy (not her real name) has asked her father to give her away.... Also what about the formal wedding pictures? Will you please tell me who should be included in the photos? (P.S. We all get along very well. No problems.)

— Win, Place and Show

Dear Show: ...As for the formal wedding photos, only the members of the wedding party should be included. These days, if all the ex's and their spouses were included, it would require a camera with an extra wide lens.[30]

We must also be willing to include non-human participants in our analysis, as in the case of surrogate children, or members of the non-human extended family. In one study of a childless couple's tourist photography, we read the following:

...I was interested in who became surrogates for the childless couple. I was rather surprised (to find) that the couple substituted each other. Johnny (the husband) became Barbara's (the wife) son, and Barbara became Johnny's daughter—as evidenced by the structure of how their photographs resembled the same type of format used to photograph children.... The couple's dog also served as a surrogate child. He had his own room, a small wardrobe which included sweaters, raincoat, boots, hats and toys. He went just about everywhere the family went as evidenced in their tourist photography. "Buffy" died two years ago ... an 11 x 14 picture encased in a ribboned frame hangs in the former room of the dog.[31]

In editing activity, "unwanted" or non-preferred participants may be symbolically eliminated from pictures. Family album makers have admitted to scissoring out bodies from snapshots or even scratching out faces of unliked participants.

In exhibition, decisions have to be made regarding who is allowed or invited to see photographs or movies. Placement of framed photographs on household walls may be based on unconscious decisions regarding

who should see whom in photographic form. For instance, there is often a marked difference between the selection of people who appear in photographs hung on livingroom or foyer walls vs. bedroom walls. The replacement or substitution of someone's image may be at issue. In a newspaper column entitled "Baby's Picture Gone to the Dogs," we read the following account:

Dear Abby: A neighbor of mine loves to sew, and she ... made a beautiful dress and bonnet for my daughter's fourth birthday, so I took the child to a photography studio and had a picture taken of her in that outfit. Then I bought a frame for it and presented it to my neighbor to show my appreciation.

She seemed pleased and placed the picture on her piano. A few months later I noticed that she had placed a picture of her dog in that frame, and my daughter's picture was nowhere to be seen.

Finally, I told her that as long as she wasn't displaying my daughter's picture I'd like to have it back.

She said "certainly." Then she got my daughter's picture out of a drawer and handed it to me.

I said: "How about the frame?"

She replied: "Oh, you can buy another one for 75 cents."

Abby, I was so hurt. That frame cost me $1.50. I didn't want to start an argument with her so I just kept my mouth shut.

What would you have done?

(Signed) Hurt

Dear Hurt: I'd have kept my mouth shut.[32]

Topic

The Topic component describes image content in terms of the subject matter, activities, events, and themes that are represented in pictures. Responses to the general question: "What is this picture of?" or "What is this movie about?" should elicit information on the topic. Responses to these questions should come from as many different participants as possible, because different people may have different interpretations of image content and significance. Viewers may disclose "behind-the-scenes" topics that would otherwise remain unseen by an investigator.

Home mode patterns will emerge from inventories of high and low frequency topics; lists of events and activities that are often—or never— included in snapshots, home movies or home videotapes help to clarify the pattern of choices. For instance, in a discussion of photo therapy,

authors Kaslow and Friedman make the following observations:

Few parents take photos during the time of a child's incapacitation. There appears to be a pervasive aversion to photographing children who are handicapped, temporarily disfigured, in oxygen tents, casts, following surgery, or during use of dialysis machines for kidney ailments. There are some exceptions to these generalizations. For instance, parents seem to delight in photographing children with a black eye, especially in color. So too do they take pleasure in pictorially capturing development changes, such as loss of baby front teeth, which will be replaced by second teeth. It may be that families have a tendency to take photos when the events or changes they are portraying represent progress.[33]

We will return several times to this notion of documenting and displaying a concept of "progress" because it is a central theme of the decision-making process we are studying.

An example of topic choice is found in the following letter sent from a woman to a soldier fighting in the Crimean war:

P.S. I send you, dear Alfred, a complete photographic apparatus, which will amuse you doubtlessly in your moments of leisure, and if you could send me home, dear, a good view of a nice battle. I should feel extremely obliged.

P.S. No. 2. If you could take the view, dear, just in the moment of of victory, I should like it all the better.[34]

Topics and themes that involve the "moment of victory" will appear in literal and metaphoric ways in many examples given in the next three chapters.

Statements on the topic and overall interpretations of a particular home mode image may vary through time, and differ depending on who is interpreting the picture. For instance, Chris Musello offers an example of a husband and wife mentioning different topics when looking at the same snapshot of a man standing in front of a car. The wife says: "Oh look at baldy! Here's a picture I posed of Sam with a haircut." The husband says of the same photograph: "This is a picture of our new car."[35]

Setting

In most cases, the Setting component refers to when and where a particular communication event takes place. The time and place of planning, editing, and exhibition events are easily described. In shooting events, however, setting may refer to *both* time and location of behind-camera activity as well as the setting in front of the camera. Sometimes these settings are different—as in the case of a set—a constructed time and place designed specifically for on-camera inclusion in a particular photographic image. Examples include studio backdrops, stage scenery,

disguised surroundings. In the home mode however, on-camera and behind-camera settings generally coincide. These is no "set"—the person with the camera, and the people in front of it, are all more-or-less "on location," in the same natural setting.

In discerning home mode patterns, we need to inventory the places and times that amateur photographers select as appropriate for either making or showing pictures. Notions of social prescription and proscription become important. Stanley Milgram notes: "Any place is considered appropriate for taking a picture, unless the photographs violate the sanctity or privacy, as a funeral parlor or brothel."[36] But this general observation of what people "can do" overlooks the possibility that notions of appropriateness may change according to individual social context and the identity of the photographer. More contextual sensitivity is needed.

In previous examples, reference has been made to such settings as hospitals, funeral homes, private homes. In the following chapters we will review the problematic status of certain sites classified as "public domain," preferred and ignored zones of private households, and such locations as museums, historical sites, and the variety of settings found at tourist locations. In the case of tourist photography or photography done "away from home," visual anthropologist John Collier, Jr. notes:

...There are in every culture certain locales and activities that the natives consider representative of their public image, areas and structures which they expect the stranger to recognize and enter and take pictures of—sites like public buildings, parks, or the town water-works, that are the pride images of a community.[37]

But tourists occasionally will attempt to photograph settings that might be considered embarrassments by community members—settings that tourists would never think of photographing in their own home towns. Certain problematic situations involving tourist photographers will be discussed in Chapter Five.

Message Form

Message Form, meaning the physical form, "shape" or kind of picture, is central to all other components. Home mode examples of message form include wallet photo, family album snapshot, framed graduation portrait, home movie. Our general objective is to examine how each message form is constructed and how other components relate to and structure the message form. However, description of this component need not be context specific. For instance, message form "snapshot" can be found in a variety of visual genres as part of art, photojournalism, advertising, and other commercial contexts.[38]

Explicit descriptions of message form are sometimes found, (in written) in definitions of snapshots, or in arguments regarding specific characteristics that distinguish the snapshot from other forms:

...the endeavor which is the least conscious, the least discriminating, the most self-effacing, and least sophisticated—the snapshot—is undoubtably the most consistently vital, straight-forward and moving of popularly produced images. The snapshot is a photograph made out of almost total visual innocence. It is the photograph used as a means of making private, family memorabilia, of recording the most ordinary, personal and communal affairs. While snapshots have been made solely for individual, personal recollection, they are remarkably homogeneous in subject matter, social viewpoint and visual style.[39]

With regard to the preference for color in the snapshot message form we read the following:

One has to accept a color photograph, first as a photograph. The hordes of home shutterbugs never question the vitality of color. They want a photograph of their family, house, swimming pool, or dog. When color film became available they used it. *Now we have millions of color images that document a way of life. This giant body of work constitutes a valid tradition in photography....* The home-picture-taker is the first to accept color photography as, simply, photography.[40]

Other questions and examples relevant to message form involve changes in their display or exhibition. For instance, snapshots will occasionally be published in newspaper articles or magazine stories. Facsimile (or "fake") snapshots may be found in advertisements and other commercial contexts in mass media (see Chapter Eight for additional discussion).

Code

The last component, Code, includes the characteristics that define a particular message form or "style" of image construction and composition. Description of code includes information on habits, conventions and/or routines that have structured shooting and/or editing events to give a certain "look" to images. Code *also* describes the patterns of social habits and conventions *within the photograph*.[41] For instance, we may describe a particular sequential ordering of shots in a movie or pictures in an album *as well as* a pattern of on-camera social behavior. Examples of the latter would include people always looking at the camera, or people always wearing new or clean clothes.[42] In both kinds of code description we are discussing image conventions of representation—the details of how some events, activities, or people are "translated" from on-going life situations to symbolic form, and the choices, decisions, rules, techniques used to make these transformations.[43]

Interesting and difficult questions are involved in code descriptions.

Film scholar James Potts addresses the question of how camera manufacturers might be determining or imposing on users certain 'Western' aesthetic or perceptual codes. He states: "It seems unlikely that the use of an Arriflex camera automatically imposes a Teutonic film style, that an Eclair gives Gallic flair, or that by toting a Japanese Super-8mm. camera with a power zoom one starts perceiving the world through the eyes of an oriental (however 'Westernized'). But it is becoming generally accepted that technology is not value-free: to some extent different technologies dictate the way in which we see the world, the way we record and interpret 'reality,' and they influence the types of codes we use to communicate a message."[44] With specific reference to our analysis of the home mode, Potts goes on to state: "Given a Box Brownie or Instamatic camera with a pretty basic standard lens, the tendency is to take medium-shots (or medium long shots). Then one is sure of focus and depth of field."[45] These comments speak directly to questions raised in Chapter One involving the relationship between pieces of imagemaking technology and imagemaking human beings. (Suggestions for how cross-cultural studies of home mode communication can address these questions will be given in Chapter Nine.)

Another example of code description combining human and technological elements is this description at the visual style of snapshots:

They are made at eye level, from the front and center, from the middle distance, and generally in bright, outdoor light. Yet because snapshooters are almost totally concerned with centering the subject, the forms at the edges are accidental, unexpected, unstructured, and—by any traditional standards of pictorial rightness—incorrect. Once centering the subject, the snapshooter allows the camera to organize the picture plane on its own optical, mechanical and chemical terms.[46]

Here, Jonathan Green offers an interesting mediation of human and technological participation. Again, our primary concerns are with imagemaking conventions that regularly reappear in home mode representation, suggesting viable alternative; in "traditional standards of pictorial rightness." The notion of "correctness" should be reconsidered not as an absolute term, but merely as an index of popular values or ideas about what is "right."[47]

"How-to-do-it" manuals will, in effect, discuss code when offering advice on how to tell a story with a sequence of pictures: instructions will be given for filming and editing a series of images to conform to a predetermined structure or code. It's worth noting, however, that there is some room for choice, for individual discression, in that the individual can chose and select among many codes, each of which may have its own standard of "correctness." A photographer may even claim not to

work within a recognizable, traditional code at all. According to one author, for instance forced attention to code is optional:

Sure it's nice to develop some form of thematic structure for your films, just as it might be nice to contrive a plotline for a photo album of snapshots. But your decision to do otherwise does not qualify you for the Guilt of the Ages...nor does it render your movies meaningless. If you choose to have your family films in a hodgepodge of random shots, your choice is legitimate and your pleasure in seeing the films will be diminished not one whit.[48]

Or attention to characterizing a particular individual viewpoint may be sufficient:

The home-movie style, as I see it, doesn't necessarily mean sloppy, overexposed, out-of-focus, constantly-panning-zooming garbage. It simply means a natural, unaffected viewpoint.[49]

Still, it is impossible to completely escape codes; the "natural viewpoint" is itself a way of seeing, a visual code. The apparent "hodgepodge," when examined, will reveal a patterned consistency.

Presented for purposes of a brief illustration of coding, I have selected just five pages of coding a family album consisting of 20 black and white photographs. These pages come from a 24 page album of 96 photographs that were shot between 1945 and 1970. The album was completed in 1971 by a woman, living in the midwest, for her son Peter, who is presently living in Philadelphia. (For study purposes, it is extremely useful to gain permission to photocopy or xerox each page of an album. Each picture may then be given an index number for various identification and analytic needs.)

An investigator should initially ask the custodian of a picture collection for a brief "introduction" to some of the general topographic features regularly seen in the images. Brief answers to "who's this," "what's this," and "where's this" will serve to orient a viewer. These responses, as limited as they are at this point, will allow an unfamiliar observer to fill in certain kinds of information without repeatedly asking for the same details about each picture. In addition, albums and picture collections will differ greatly with regard to the amount and/or kind of captioning that accompanies each image. Elaborate captioning and notations of "authorship" will make independent study easier and more efficient. For instance, in these 20 pictures, it becomes quite easy to "track" and identify the appearance of "Marne" (see photographs 2, 14, 15, 17) and "Grandpa" (2, 4, 15, 16, 17).

After a general familiarity has been gained, the event/component framework (p. 19) should be used as a guide for knowing what to ask.

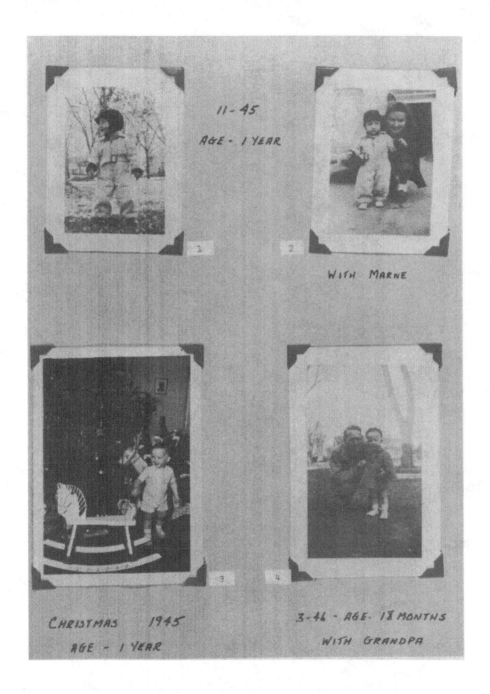

11 - 45
AGE - 1 YEAR

WITH MARNE

CHRISTMAS 1945
AGE - 1 YEAR

3-46 - AGE - 18 MONTHS
WITH GRANDPA

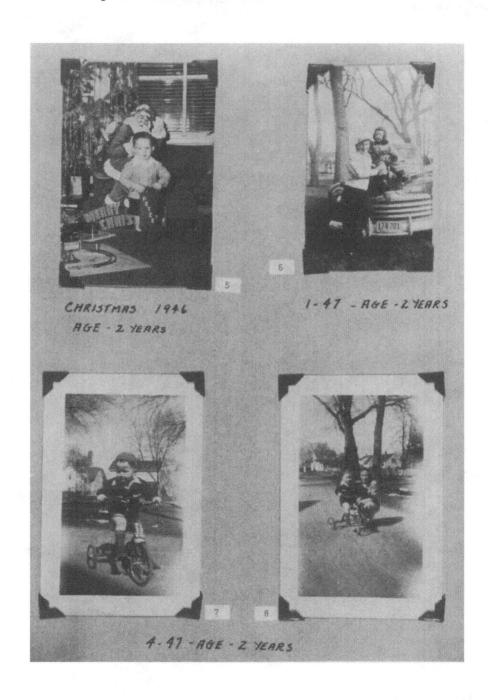

CHRISTMAS 1946
AGE - 2 YEARS

1-47 - AGE - 2 YEARS

4-47 - AGE - 2 YEARS

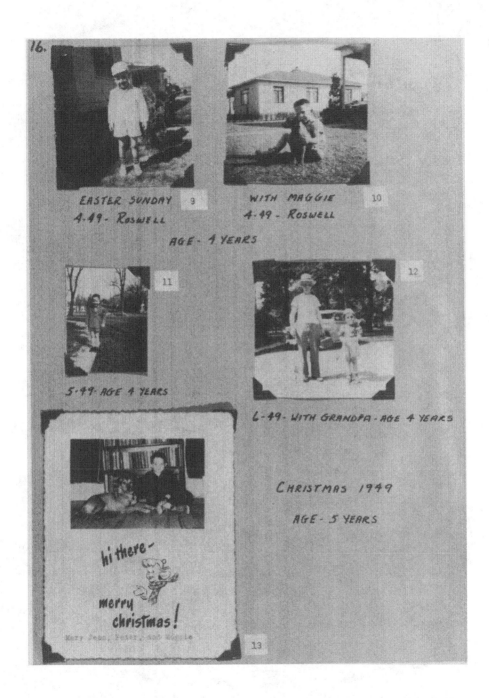

16.

EASTER SUNDAY ⑨
4-49- Roswell

WITH MAGGIE ⑩
4-49- Roswell

AGE- 4 YEARS

⑪

5-49- AGE 4 YEARS

⑫

6-49- WITH GRANDPA - AGE 4 YEARS

CHRISTMAS 1949

AGE- 5 YEARS

hi there-

merry
christmas!

⑬

GRANDMA - MARNE - GRANDPA
FAIRMONT - 1947

MARNE
NEW GUINEA - 1945

BILL WOLF - GRANDPA -
MRS. LANDERS - GRANDMA -
THAYLE - SKIP - PETER -
DARA

CHRISTMAS - 1950

GRANDMA - MARNE -
BLOOMINGTON

1969

Each picture may be subjected to a series of questions suggested by each cell of the framework. The next step is to reconstruct information about the structure of each communication event. We know that each of these 20 photographs is the result of *on-camera* and *behind-camera* activities that jointly comprised the *shooting event* responsible for the production of each picture. In turn, each album page is understood as the result of subsequent *editing* activity (selection, juxtaposition, mounting, and labelling of pictures—editing with specific kinds of *exhibition* activity in mind.

In this example, the following information has been generated from concentrating on cells in the framework that represent relationships between components and *shooting* events. Personal interviews with Peter and Peter's wife were necessary to provide most of the following information.

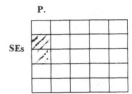

Shooting Event—Participants Component

Through independent observation and direct questioning we attempt to construct an inventory of human and non-human participants featured in the making of these pictures. First we find that every photograph includes one or more people. All but three pictures (85%) include Peter, and roughly half of these 17 pictures illustrate a relationship between Peter and one or more adults. We are then led to ask about specific kin or friendship relationships between Peter and these people who have been allowed to appear in these images. For instance, in photograph 16 we find Peter's maternal grandparents and five members of another family who were immediate neighbors and very close friends. The two children in this picture were Peter's most frequent playmates during that time. In picture 19 we find both maternal and paternal grandparents, Peter's mother, and one of her close friends. We must also be curious about the people who appear in the three snapshots that do not include Peter. For instance, in photograph 14 we see "Marne," Peter's maternal aunt; and in picture 17 we again see Aunt Marne seated with Peter's maternal grandmother. We should not overlook the two photographs that document a relationship with a non-human member of the family, namely their pet dog "Maggie" (see photographs 10, 13). And in yet

another non-human participant category, we find a life-sized cardboard representation of another important "person" namely Santa Claus (see photograph 5).

Exact identification of the photographer (as behind-camera participant) proves to be difficult in many cases. Owners of the album said that most of these pictures (85%) were taken by *either* Peter's mother *or* Aunt Marne. An unnamed professional photographer was hired to come to their house to shoot Christmas photographs 3 and 5, and an Army friend of Marne's took picture 14. Peter could not recall whether he or his mother took picture 17. The observed significance of knowing and remembering on-camera participants and the corresponding neglect and insignificance of identifying behind-camera participants will be discussed later, in the next three chapters.

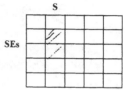

Shooting Event—Setting Component

When we cross-reference shooting events with setting, we are looking for regularities and consistencies for where these pictures were taken. We can independently conclude that 14 (70%) of these 20 photographs were made outside (although there could be some question about the boy scout picture, photograph 20). Personal questioning reveals that most (80%) of the pictures were made in or around the family house. These settings include backgrounds of grass, houses, trees, and sometimes the presence of the family car (2, 6, 12, 15). Most of the interior shots were done in a livingroom, and one (20) was taken in the basement. Most of the livingroom photographs were made in Peter's house; others were taken in a neighbor's house (16), and in Marne's home (17).

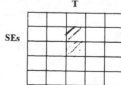

Shooting Event—Topic Component

When relating shooting event and topic we are asking about the specific occasion, or special event characteristics, of each photograph. For instance, in this collection we find such topics as Christmas time (3, 5, 16), Easter Sunday (9), "going fishing" (12), a family gathering

(15, 16, 19), Boy Scout meeting (20), the visit of a grandparent (4, 12, 17) and "looking like a football player" or showing off a new football helmet from a recent birthday (18). However, for several pictures, Peter was unable to recall specific activities that surrounded the picture taking. The lack of birthday party pictures confirmed Peter's remark that such parties were not popular events in their family. Again, the purpose of this questioning is to develop an inventory of the preferred and prescribed topics, activities, and themes that characterize this look at life.

MF

SEs

Shooting Event—Message Form

The album itself may be treated as the message form, as distinguished from other presentational formats (e.g. an enlarged and framed snapshot, a photo-cube, or merely a cardboard box of photographs), or other media formats (e.g. home movies, slides, or videotape). For some types of study, an album page or the category "snapshot image" may be more useful. In addition, even within these 20 photographs, we see how one form— the snapshot—may be transformed into another, as in the two Christmas photo-cards (see pictures 13, 18). Designation of message form is dependent on the kinds of questions being asked and the materials available for study.

(Space restrictions prevent including a copy of the entire 24 page album; thus we have alternated between three forms—the album, the album page, and individual snapshot images. Here, we have taken the liberty of letting these 20 photographs arranged on five album pages represent the entire album of 96 pictures, but *only* for purposes of this brief demonstration.)

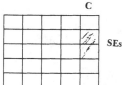

C

SEs

Shooting Event—Code Component

Code characteristics of each snapshot image have resulted from relationships between behind-camera and on-camera performances; code characteristics of the *album pages* have resulted from *editing* activity.

In the individual 20 pictures, we find that regularities in camera

use include full-body framing (90%), and centering people with an emphasis on keeping heads and eyes at the center of the image.[50] Other code characteristics include a tendency by the photographer to lower the camera angle, to get more of a ground level perspective as in a child's eye view (see photographs 1, 2, 4, 10, 13).

In terms of on-camera performance we also find regularities in how participants present themselves for camera recording. For instance, people face the camera in almost all of these examples. In 80 percent of these pictures, one or more participants is making direct eye contact with the camera. And in two exceptions (photographs 1, 3), we might claim that the one year old child has not yet learned this convention. We even find examples of guided interaction; we see how adults present and, in part, instruct children how to appear in front of an operating camera (see photographs 2, 4, 6, 8). In turn, we see how a child wants to present an animal, as in pictures 10 and possibly 13. Other code characteristics include "dressing up," smiling, and standing still.

In the case of an album the study of code also applies to understanding what has structured the order or *sequencing* of the images. While a variety of scenarios or programs is possible (featuring particular individuals, places, or events), a chronological progression is the easiest code to trace. In these 20 pictures we see Peter growing up between 1945 and 1952. Minor exceptions appear in one jump back in time (photograph 14) and one jump forward to 1969 (photograph 17).

This brief look at how one might operate on a collection of visual material illustrates the use of the event and component axis and associated sub-categories from our descriptive framework (p. 19). Readers are reminded that for purposes of illustration we have restricted ourselves to one row of cells in the framework. Relationships of components and events suggested by other cells will address other kinds of questions and illustrate other important characteristics of home mode communication. Results of each study depend on what specific questions are being asked, who is available for interviewing, and on which model of inference is acceptable. In each case we need to learn which members of a particular home mode community serve as repositories for certain kinds of information. (For instance, Peter's mother may have been able to fill in more contextual information related to descriptions of topic.)

In each study we are attempting a systematic and organized look at mediated life—but they are not just pictures of a mediated reality— they are evidence of a way of looking at, of constructing, a reality, a way of acting. Patterns of recurrence and regularity are sought to define a profile that describes home mode communication. Examples of

idiosyncratic behavior are expected; they help distinguish certain habits, routines, and formulas that appear with greater frequency and that are normative. Before going further, issues of appropriate behavior, patterns of prescription and proscription, and a notion of normative standard deserve additional clarification.

Photographic Norms As Social Conventions

A standard definition of social norm is "a rule or standard of behavior defined by the shared expectations of two or more people regarding what behavior is to be considered socially acceptable. Social norms provide guidelines to the range of behavior appropriate and applicable to particular social situations."[51] The question becomes what kinds of social norms serve as guidelines for enacting and recognizing "appropriate behavior," for taking "good photographs." Norms restrict the freedom which a picture-taker is allowed. The hypothetical freedom of camera and picture use is best debunked by examining the relationship of social norms to non-professional photography. Our definition of Kodak culture denies a system of free variation, and relies on our ability to discover patterns of prescribed behavior. A culturally structured set of norms helps us separate and differentiate what *can* be done—in a technical sense— from what can be done—in a social sense.

Legal restrictions and prohibitions relevant to home mode imagemaking are often either vague or non-existent. Two books on photography and the law[52] indicate that laws, as social norms, pertain more to genres of mass modes of pictorial communication—such as photojournalism, studio photography, fine art photography, professional filmmaking—than to genres of home mode activity. For instance, Chernoff and Sarbin do begin by asking a relevant legal question: "The first problem—and one which seems to puzzle many amateur photographers—is: Can I snap the shutter of my camera wherever and whenever I please? Can a policeman stop me from taking a picture of a street brawl? Can the guard at a museum prevent me from using flash? Can I take a picture of a military installation?"[53] However, the majority of their book is devoted to such problems as model release forms, copyright restrictions, "libel by photograph," licensing statues, and other topics generally irrelevant to home mode picturetaking.

Two situations when legal restrictions are relevant to Kodak culture deserve attention. Legal problems sometimes occur when vacationers become camera-carrying tourists. While visiting unfamiliar societies and areas, tourists may discover the existence of unannounced and unanticipated prohibitions on unrestricted picturetaking. For examples

an American high school teacher touring Kiev reported the following problem:

Officially, we were not to take pictures of bridges or of anything that might be of military or security importance. We were not to take pictures from an airplane, for example. . . .

We did get a bulletin from the American Embassy advising us not to take pictures of depressed areas. One member of our party, unaware of this injunction, snapped some people queued up to make some purchases. An irate woman hauled him off to the police station.[54]

(Many other examples of related occurrences will be given in Chapter Five).

Another area which attracts some attention involves the production, processing and occasional censorship of sexual photographs by commercial photo developers. A 1978 newspaper article reported "More nudes are showing up among family snapshots;"[55] some of the shots are not printed by film companies. Our attention here is directed toward the relationship of topic to editing events; "editing" has here been defined to include the selective processing and printing of photographic images whether done in a commercial laboratory or done in a home darkroom. Relevant questions include who decides what gets printed, which images are suitable for different contexts, and which pictures must not be distributed any further.

Processing companies have reacted in different ways to legalities surrounding their work. Some companies have conformed to Post Office regulations which unofficially apply "the criteria of (1) visible pubic hair or (2) a tendency to incite lustful or immoral thoughts or deeds. . .to pictures sent by mail. In either case the picture was considered obscene."[56] Sometimes this restriction is applied to advertisements for erotic or sexually provocative literature. But it also includes snapshots and home movies—"pictures of nudes, indecent postures and sexual activity"—sent to Kodak for processing and for return by mail.

Other situational factors may contribute to determining appropriate legalities. For instance, the U.S. Supreme Court ruled that obscenity must be judged in accordance with a "local community's standards." We may expect to find different judgments on processing images of nudes and sexual encounters. Michael Kaplan, Fotomat's California-based assistant general counsel, has stated that "what we'll print in Berkeley is completely different from what we'll print in Memphis."[57] In another example, Rick Wrightston, chairman of Alves Photo Services, Inc. of New England, repeated the fear of violating postal regulations. He tries to discourage customers who want their "obscene pictures" processed

and printed: "We'll occasionally tell them they can pick up their prints at the Braintree (Mass.) Police Department."[58]

Amateur photographers are generally exempt from legal restraints when shooting in settings classified as public domain. But selective prohibitions do exist and may be studied as problematic relationships between shooting events and either settings or topics.

When local ordinances do exist, photographers may become aware of them after a violation has occurred. One example comes from the "Letters to the Editor" column of a popular photography magazine.

> Subways are for snapshooting.

> I'd like to point out... that while it may be illegal to take pictures in the New York subways... you can probably beat the rap. That's what happened last summer when a young school teacher was given a summons for taking a picture of her friend on the subway platform from the Transit Authority. She pleaded not guilty in court and the judge dismissed the case. The D.A. explained later that the rule was in the interest of safety and that it gave them a chance to tell photographers that they couldn't use tripods (people could trip over them) or that flashbulbs could blind a motorman or passengers. The rules, of course, are designed primarily to control the shooting by professionals who might want to bring an entourage and much equipment underground for a shooting session.[59]

In many other instances explicit notice of local ordinances may be posted. The use of cameras may be restricted in such settings as live theatres, concert halls,[60] movie theatres, sports arenas, churches, museums, historic sites. However, even this classification requires additional refinement and situational definition. For instance, art museums may allow photographs to be taken of their permanent collections while prohibiting photography of borrowed or travelling exhibitions. Some sports arenas may prohibit the use of flash attachments while allowing available light photography. At the other extreme some events may actively promote and encourage the amateur use of cameras as in specially arranged "photo-days" at baseball stadiums, circuses, zoos.

It appears that legal restrictions are closely aligned with photographers' intentions to publish and distribute their images so it is primarily professional photographers and filmmakers who must be concerned with *legally* drawn licenses, releases and contracts; amateurs follow guidelines established as *social* licenses and social contracts. This distinction is not fully noted in the following question and answer exchange from *Photography and the Law*:

> Question:

> I plan to go to Europe this year and will want to photograph as much local color as possible. In snapping candids of people in their own surroundings the element of

spontaneity is often lost when the subject is approached to ask permission to photograph them before taking the picture. Is it advisable to take a candid photo without the subject's permission?

Answer

It can generally be said that it is not necessary to obtain someone's consent just to take his picture. You must remember that the reason for getting a release or written consent is to permit you to use or publish the picture for advertising or trade purposes. As long as the use which you make of a photograph taken gratuitously is not for advertising or trade purposes and is not libelous in nature, you will generally have no problem.[61]

Social considerations for appropriate photographer-subject interaction appear to be over-ruled or ignored in this response. But problems may develop when photographers rely only on legal guidelines. It may be more to the point to argue that professionals (photojournalists, special event (e.g. weddings) photographers) and amateurs follow different sets of social sanctions. Part of the photojournalist's job is to become familiar with legal restrictions and to know where and when they can be transgressed to win the approval of editors and other employers.[62] In comparison, the non-professional photographer is much less aware of legal restraints and "works" quite well without them. We shall see that many of the norms governing the appropriate use of cameras are not written down but are upheld by public sentiment. The tourist situation is an interesting example because different and often unfamiliar social and cultural contexts of "sentiment" are involved.

Kodak culture appears to be governed more by non-institutionalized norms and by folkways since, in most cases, non-conformity is *not* severely sanctioned. Social control works through weak and informal sanctions instead of laws. The rights and wrongs of this behavior are seldom enforced or maintained by political or legal authority. Kodak culture appears to be designed and maintained by cultural and social prescriptions that remain in peoples minds and are guided by public sentiment. Obviously no national, state, city, or county law exists to coerce parents to take pictures of new born children or children's birthday parties; it is "strange" and unusual, however, to find families who do not conform to this unwritten expectation. It will become clearer that picture taking habits and picture showing habits are guided by unspoken and unrealized social conventions.[63]

The origin, development, and change of conventions and norms over a time provide other problems for study. But while questions related to these issues represent legitimate and interesting lines of inquiry, the results reported in this book come from a synchronic (same time) perspective. And while readers of this book may discover an occasional

reference to observations of change and some speculations with regard to future change, for the most part, results have been limited to one period of time.

The event/component framework is useful for synchronic and diachronic comparisons. Synchronic comparisons can be made across picture collections belonging to individuals or individual families, to people from differing socio-economic statuses, social classes, geographic regions, subcultures, ethnic groups. The scheme also facilitates diachronic comparisons of imagery made by the same or similar groups of people. We might want to know, for instance, how specific topics or settings have been treated in home mode photography in different time periods, or how "acceptable" pictures and notions of appropriate picture taking behavior have changed through time.

Future studies might investigate how norms have changed, through time, with relation to such delicate subjects as corpse and/or funerary photography, to pregnancy, to images of breast feeding, to various kinds of "naughty" shots, or scenes of partial or complete nudity. The same questions can be asked about exhibition events. We will see how the taking of certain pictures is one matter, and how the showing of these pictures can involve another set of issues. We then may ask how norms have changed with regard to what gets shown in different social contexts of exhibition and display—as a framed enlargement hung in the livingroom, bedroom, den, or as a snapshot carried in a wallet, or sequestered in the back of a desk drawer.

However, some kinds of diachronic analyses of home mode communication are hindered by several factors. While many images from past time periods may be available for inspection, the lack of living informants will prevent the accumulation of valuable detailed information suggested by the framework. Because of this, we may not be able to reconstruct enough of the social context to make comparable statements to present conditions.

In summary, the organization of these unwritten conventions, habits, and patterns of photographic activity can be described and understood by using our event/component framework. This framework provides us with a tool to discuss our reactions to problematic situations as well as to clarify the unstated principles we apply to reach solutions. It helps us explain the logic of our unwritten agreements regarding when and where and with whom we should, or should not, use our cameras. Results of applying this framework to snapshots, home movies, and tourist photography will show how we have structured our behavior to produce structured views of our lives.

Chapter Three

Cinéma Naïveté: The Case of Home Movies

The event/component framework can be applied to pictorial materials in a number of ways in response to a variety of research questions. The next three chapters demonstrate both formal and informal applications of the framework to three genres of home mode communication. The first study of home movies uses the most literal interpretation of the framework, studying both communicative events and components as outlined in Chapter Two. I have introduced an additional dimension to this study of home movies which can also be applied to still photography and home videomaking: the application of the framework to *prescriptive behaviors*, found in advice columns and moviemaking manuals. This provides us with a comparison to observed patterns of home moviemaking. And so we can compare advice columns to actual behavior asking how do these two profiles of behavior compare with one another. And we can ask, in turn, how these two profiles relate to notions of "everyday life," "commonplace family activities," or "life around the house".

Early Material On Home Moviemaking

The study of home movies as a medium of visual communication has been virtually non-existent. The majority of published material on home movies appears in the form of How-To-Do-It manuals—hereafter referred to as "HTDI" manuals—advice books and short magazine articles on "How to Improve Your Home Movies."[1] All of these references present a stereotypic view of conventional home moviemaking behavior. Authors tend to downgrade and, at times, mock naive moviemaking habits. The books attempt to persuade home moviemakers to adopt attitudes, techniques, and conventions of professional filmmaking, by outlining a set of prescriptive guidelines on how to do it "right" and how to avoid "mistakes." This literature contains an interesting and quite complete paradigm of idealized behavior which we can compare to patterns of home moviemaking behavior that actually do occur.

49

We might expect that home movies—as filmic portraits of everyday life—would be extremely rich in ethnographic data and that, as such, these materials should be valued by social scientists as native views and constructions of intimate realities. However, the social science literature gives no evidence of any sustained interest in home moviemaking. Reference to either the making of these movies or the movies *per se* is parenthetical at best. Brief observations by David Sudnow,[2] Weston La Barre,[3] Edmund Carpenter,[4] and David MacDougall[5] are very brief and go in four different directions with no sense of sustained attention. For instance, when David MacDougall discusses the potential of studying films made by members of non-Western cultures, he states flatly: "Home movies tend to look similar in all societies." However, no supporting evidence is offered. Brief references of this nature remain merely anecdotal and speculative.

In most film literature—textbooks, journal articles, film criticism that deal with the study of film—amateur or conventional *home* moviemaking is seldom discussed. For most serious-minded filmmakers, home movies represent the thing *not* to do. It appears that genuine home movies have been too trivial a topic to merit serious attention from the film scholar.[5a] For the film critic, home movies have sometimes represented a standard for the evaluation and comparison with the more professional forms. For instance, Nicholas Pileggi's review of *The Godfather* is titled "The Making of 'the Godfather'—Sort of a Home Movie."[6]

The term "home movie" is becoming quite ambiguous. Recently we find it being used to reference a variety of filmic forms different from Kodak culture's home movies. It appears that some authors have carelessly attached the label to imply such qualities as "primitive," "naive," "non-professional," "inexperienced," "non-narrative," among others. Moreover, the identification of authentic home movies is being blurred by the emergence of other descriptive terms, visual concepts, and filmic forms: the literature now contains such terms as "film-diaries"[7] or "the diary-folk film,"[8] "first-person cinema,"[9] "personal family portraits,"[10] and "autobiographical film."[11] (The variety of meanings and emergent forms now associated with "home movie" will be reviewed and discussed in Chapter Eight.)

Home Movie Planning Events

The study of planning events for home movies reveals a major difference between prescribed behavior and actual behavior. Almost all

of the How-To-Do-It manuals surveyed here recommended some type of planning. One example of this emphasis came from an advice column:

How to Plan an Interesting film.

 All it takes is some extra thought. Take Christmas, for instance. It involves the entire family, and there is plenty of colorful activity. Start by making a list of the activities that your family normally engages in during the holiday. Break this into three parts: preparation, Christmas Eve, and Christmas Day. Now list the events in logical order.[12]

However, none of the informants in this study said that this type of planning was important. Seldom are there, in actual practice, extended discussions or debates regarding the question of whether to make a movie or not. Shooting scripts or acting scripts are seldom, if ever, written. Subjects said they "just knew" when to get out the camera and buy some film. Subjects implied that *planning* a home movie just did not make sense. When an informant was asked: "Who decides when your home movies should be made?" the response was: "We both do . . . There's no real system to that or consistency to that; it just strikes us to take some movies." Still, inspection of this family's collection of home movies revealed that a certain choice of settings and topics regularly reappeared. It is possible that this family did not want to feel tied to or regulated by a "system" and that conscious planning activity was more suited to other realms of their lives. But unconscious patterns do appear.

 Interviews with home moviemakers revealed an undesirable conflict between the ideal of spontaneity and the good intentions of planning a movie. In one example, a mother of two children explains how she and her husband tried a new approach to their moviemaking:

After the Christmas film, the next one, "the big snow," something really different happened because, Peter and I decided at that point—I think it was my idea—that we'd take a film of what it was like for Amelia to be 4 years old. I even sat down and wrote out the things I wanted to be in the film. The thing that is so different is that this is a very planned kind of preconceived attempt at a film. I had never done that before. It never really got off the ground and what it did was it cut off the spontaneity of the camera, because at one point I had started the film and it was sitting in the camera, and Peter wanted to use it in the backyard; he ran and got it and started taking a shot of Amelia and I got mad (laughter) because it was interrupting this planned film that I had done, and I think it was a different approach to the moviemaking, but it also cut the spontaneity of just having the camera there when you wanted it.

Other families have told of attempts to write a script for their movies, another form of planning activity. But equally as often, this strategy was criticized as being "contrived."

It appears that home moviemakers prefer to get to the filming and not treat the activity as "a production." Forms of planning such as script-writing, storyboard making, and listing shots seem to conflict with the emphasis on spontaneity. Home moviemakers "just know" when and how to make a movie and want to leave it at that. Planning, it seems, would take the fun out of the enterprise and call for a different kind of perspective. We may speculate that when people begin to plan their movies, they may have different notions of appropriate audiences in mind. In each case a different model of visual communication is operating, one that may or may not match what is prescribed in books on home *film* making.[13] This shift has more to do with how people think about picturemaking than with camera technology.

Thus, for this genre of film communication, unlike most others, planning and decision making do *not* consciously occur before filming begins. Decisions on specifically what to shoot and what to avoid take place tacitly, at the last moment, when the camera is loaded and the cameraman is looking through the viewfinder. Notions of what to shoot, and what not to shoot, however, are neither random nor, in most cases, problematic: they are determined not by law or prescriptive manuals, but by unwritten social values.

Home Movie Shooting Events—Behind-Camera

Another disparity emerges when we compare the behind-camera behavior prescribed by manuals and guides with examples of actual behavior exhibited by home moviemakers. The manuals tend to emphasize developing a sense of control by the moviemaker—control over what happens in front of the movie camera, and control over how the action can be shown later through editing. One guide book stresses an understanding of moviemaking as a director's event:

...remember that actual-event sequence needn't be movie sequence, so long as the latter makes sense... Look, always, for ways to enhance your story—not change it in substance, but add elements of excitement, comedy, drama, or suspense. And don't hesitate to create those elements *yourself*. (Don't forget that you're the whole show: producer, director, scriptwriter, cameraman, editor.) In any film you can ask your subjects to do something new or different if you feel it will make for good footage. We certainly don't advocate your pricking some innocent kid's balloon just so you can get some shots of a tear-streaked face. But why not make a funny face if what you're aiming for is childish laughter?[14]

But people who make and enjoy their home movies simply do not feel that the person with the camera "is the whole show." It's much more likely that the people who appear in the movies are given more attention,

and that this genre of movies is valued more for the content than the style of shooting or editing, the work behind the camera.

We find that HTDI manuals offer a lot of technical advice and strategies for the cameraman. For example, one advice column recommended the following:

Start your shooting with a long shot of your house and a member of the family putting a wreath on the front door. Move in for a medium shot of the person putting up the wreath and a ribbon on which you have printed your title—say "Christmas 1968."

Vary your shots. Film Mother entering with groceries, then stop the camera and move to another angle to shoot the bags being emptied. Move to another vantage point for a shot of the turkey being held aloft, then come in for a close-up of a child's face registering delight... you'll have a variety and a fast pace.[15]

Here we find prescriptions for behind-camera routines, for patterns of shots to produce a particular "look" at an event, place or activity. Other manuals prefer to go even further in advocating a controlled construction of an event. For instance:

Re-create it.... Say you've taken a room at a lakeside motel, and the kids emerge from the door and jump up and down and point excitedly to something they've discovered— a breath-taking view of nearby mountains, or an inviting beachfront complete with canoes. Marvelous shot. But you didn't get it, and now it's all over. Do not despair. Get out the camera, send the youngsters back inside, and have them come out and do it all over again![16]

However one Kodak manual cautioned its readers:

...if you intrude too much or try to direct too much, it's likely to loose all its genuine flavor, and the results won't have the really memorable quality that spells out B-O-Y.[17]

Some manuals offered a set of rules to overcome common behind-camera "mistakes." These corrective code-related rules included (1) start each sequence with an establishing shot; (2) photograph all scenes in logical order; (3) avoid excessive panning; pan only when following some action; (4) avoid excessive use of the zoom lens, etc. However, the majority of footage viewed for this study ignored all of these "rules." In fact, it appears that disobeying these rules describes the norm for behind-camera behavior. (Characteristics of this norm will be described further in a following section entitled "Code Characteristics.")

Subjects stated that they did not want to be bothered with thinking about camera techniques—as long as the pictures "came out," everything was fine. Again, as with planning, the HTDI manuals have emphasized an event and components that home moviemakers prefer to ignore.

However this situation is exactly reversed when we analyze "on-camera" events.

Home Movie Shooting Events—On-Camera

The HTDI manuals seldom give advice on how to behave while on-camera in home movies. Both the manuals and informants agreed that people frequently act "funny" when home movies are being made. The How-To-Do-It manuals describe this situation as follows:

There's something about a movie camera that makes people stop what they're doing and stare into the lens. Or, they may simply wave at the camera.[18]

[When most people] become aware that a camera's unblinking state is aimed in their direction, they react stiffly, self-consciously, and inhibited.[19]

More advice was offered on how *not* to behave. For example, one advice column cited "artificial posing" as a common reason for "disappointing" home movies:

People just standing in a group, a wife waving at the camera, a child making faces at the camera—all make dreadfully dull movie shots.[20]

Nothing looks quite so goofy as a group of people standing stiffly in the midst of a lively scene. You've got to get them to do something, but you can't leave it up to them, they haven't the slightest idea of what to do.[21]

The manuals resort to *behind*-camera instructions for adopting a filming strategy that causes minimal disturbance, instead of providing information for *on*-camera behavior:

...I believe that the best kind of home movies result when you avoid being self-conscious about shooting motion pictures. The camera just happens to be around when people are having fun and doing what they like.[22]

However, scenes of "natural" behavior were seldom seen in the home movies viewed for this study. Impromptu realities were greatly outnumbered by scenes of self-conscious hamming or "acting-up" for the camera. In general, patterns of on-camera behavior contradicted the behind-camera objectives recommended by the manuals. Capturing an impromptu reality was by far the *exception* rather than the rule.

Observations made by subjects about on-camera performance also contradicted the HTDI manuals' claim that posing was "dreadfully dull," and that reactions to the camera produced "disappointing results." Instead, viewers generally expressed delight and pleasure when seeing these facial and gestural reactions to being "caught" on-camera. It appears

that waving at the lens, making faces, posing stiffly, and the like are entirely appropriate examples of accepted behavior for this event. Informants openly recalled the fun they enjoyed when they were *in* the movies rather than shooting the movies.

Home Movie Editing Events

Editing in this mode of visual communication represents the fourth non-overlapping example of prescribed behavior vs. actual moviemaking. Almost all of the HTDI manuals promote some form of editing for the home moviemaker. Editing is given as much attention as planning and shooting the movie. For instance, one advice column stated that moviemakers just don't take advantage of editing's potential:

This is an all too frequently neglected aspect of home filmmaking, yet with just a few cuts and splices any film can be made to look better.... To edit is first to remove, then to rearrange, then to remove once more.[23]

In actuality, however, most home moviemakers were extremely reluctant to do any editing at all. They simply did not want to be bothered with cutting, "gluing" or taping pieces of film; it was hard enough to keep all of their reels of movies in order "never mind fooling around with individual shots." Few attempts were made either to cut out poorly exposed (or even unexposed) footage or to rearrange shots within one roll of film. When some form of editing was observed, it generally meant cutting off some excess leader at either end of the 50 foot roll and splicing two or more rolls together. The motivation for this accumulative "cutting" was simply to produce a movie that would take a longer time to show on the projector.

Thus editing is not emphasized in actual home moviemaking. Two reasons come to mind for this. First, it may represent an unwelcome intrusion of "work" into what is classified by most people as "play." Or second, editing is unpopular because it does not share the social qualities that underlie the other events. One guide book stresses the solitary nature of editing as follows:

Do try to get people to leave you alone while you're editing a film; that includes your family. It may take hours, or days, or weeks. However long, the process needs a lot of thought to be carried out successfully. *Uninterrupted* thought.[24]

It appears that home moviemaking comprises activities that people prefer to do together in each other's company, as a social activity in which the experiences are shared. One author explains how the isolation factor is not conducive to underlying social functions of the home mode process:

...relatively few home moviemakers do any editing. The reasons most amateurs decline the process are understandable enough. While filming is a social activity, editing is generally a solitary one. You sit there by yourself, cutting the film, deciding where to put the shots, and splicing everything back together again; it is not really an activity conducive to inviting people to come and play with you.[25]

Such an explanation gives added significance to the social base of these communication events and provides a beginning to a discussion of social functions (which will appear in Chapter Seven).

Home Movie Exhibition Events

The last category under examination here is "exhibition." A comparison of the emphasis put on exhibition events by both the HTDI manuals and moviemakers reveals another set of differences similar to those that were observed for on-camera events. The manuals have little to say; the home movie makers a lot.

Importance placed on showing movies, in the home mode, is mentioned by Don Sutherland, a regular contributor to *Popular Photography*. He makes a meaningful distinction between the interests of professional and amateur filmmakers: "As a pro, I enjoy the challenges of shooting movies; as an amateur, my pleasure is in showing them.... What makes it worthwhile is seeing the event replayed on the screen...."[26]

In general, the manuals ignore exhibition activity. When mentioned, emphasis is placed on what to do to prevent boredom. In a chapter entitled "The Anatomy of Boredom: Medium Without a Message," authors Schultz and Schultz describe the situation as follows:

Certainly a home movie can contain mistakes: out-of-focus blurs, or under-exposed scenes, or flashes of light between shots. These flubs may annoy an audience, foster dizziness and headaches, and render valuable service to the aspirin industry.... Friends and relatives who squirm through these technical goofs may get a bit surly, but they won't fall asleep... —and we, and most other people—can sit happily enthralled through a two-hour movie in a theater, but find an acute attack of sleeping sickness coming on halfway through a ten-minute home movie.[27]

However, home movie viewers do not necessarily see the "flubs" and "goofs" as worthy of critical attention. This example illustrates how we differentially attend or disattend visual presentations that appear in different social contexts of exhibition.

The manuals tend to emphasize shooting and editing techniques that must precede exhibition. Editing advice is offered after the following comments sub-titled "How to Stop Torturing Family and Friends":

Consider your audience. The lights are extinguished and everyone settles back to enjoy your movies. They aren't permitted to settle very far or very comfortably though, because four minutes later...on will come the lights again while you rewind and thread a new roll through the projector. This spasmodic sort of performance is upsetting to the digestion, not to mention what it will do to one's temper.[28]

Home moviemakers are advised to lengthen their reels of film by splicing rolls together to make a longer screening time.

For most home moviemakers, exhibition events are exciting times. Informants reported that home movies are usually shown in a party atmosphere, not too unlike the one that originally inspired the shooting of the films. The social qualities of viewing are nicely expressed in the following comments made by a husband and wife:

Mrs. M.: You see, we sometimes show our movies to a lot of people... in the last few times it's been at least eight or ten people.... And there's kind of an old time movie theater atmosphere... you know everybody sits down, gets themselves a comfortable seat, it's really quite a performance, you know, so that's part of the ritual.

Mr. M.: The idea is to share it at the same time...
Yeah, there's definitely a group dynamics thing—it's very important that people see it together.

In summary, a consistent non-overlapping pattern of emphases has emerged for the five categories of film communication events. In general, the process of visual communication that has been extracted from the literature, addressed to those intending to participate in this form of communication, bears little resemblance to actual behavior exhibited by moviemakers in the home mode. The HTDI manuals promote the creation of a symbolic environment that emphasizes *manipulation* of a reality. Home moviemakers, however, stress the use of filmmaking technology to record, document, and *reproduce* a reality. It is interesting to note that the "naive" home moviemaker embraces the view of filmmaking often promulgated by social scientists of certain schools, i.e. that editing is "bad," planning the subjects' activity is taboo, objectivity is equal to no editing, and so on.

From this analysis, we understand better how the notion of symbolic manipulation applies to this particular genre of film communication. It is obvious that any form of mediation involves the creation and manipulation of symbols. Technologically-mediated realities allow several different sources of manipulation. For instance, behind-camera events, on-camera events, and editing events offer different, but not mutually exclusive, chances for symbolic manipulation. Not all forms of film communication use or emphasize the same events, and different patterns of emphasis separate one film genre from another. Home movies,

in comparison to home movie literature, or Hollywood films, for example, stress a manipulation of symbols primarily in on-camera events and ignore opportunities in both behind-camera and editing events. This pattern is unlike most other genres of film communication.

It is now possible to characterize further the process and events of home movie communication by examining the second dimension of the framework, namely, the film communication *components*. Each component—participants, settings, topics, message form, code—should be examined in relationship to each event. Since on-camera and exhibition events are most important in home moviemaking, we will limit our discussion to these events and their relevant components.

Participants

The majority of home movies contain pictures of people. Both the HTDI manuals and actual home movies agree on this point. Almost all shots contain people rather than things—with the exception of the commonly seen household pets or animals in other contexts. One moviemaker told me:

Almost never is there not a face—99% of the time. That's just the way we operate: we think film is too expensive to expend it on non-people, or unless it has some historic value, it has nothing.

The HTDI manuals frequently indicated who should be included in the movies. An informal inventory of participants appropriately included in on-camera events appeared as follows:

Good movies... are entertaining. It's fun to see movies of picnics, vacations, ski outings, and badminton games when they involve friends, neighbors and relatives.... Add color, depth, and interest to your scenic movies by including friends or family members in the foreground.[29]

Thus according to the prescribed norm, the community of participants appeared to be limited to immediate family members, relatives, close friends and neighbors (the close friends do not have to be neighbors, but the neighbors have to be close friends). A similar inventory of participants was prescribed for home movie exhibitions. A consensus on this point was found in all HTDI manuals studied for this report.[30]

The frequent cartoon of "reluctant" and bored viewers of home movies depicts an "inappropriate choice" of participants for an exhibition event. In other words, the distressed viewer is outside the appropriate collection of participants.

This pattern of preferred participation was strictly adhered to in the home movies that were viewed for this study. By far, the most popular choice of subjects were young children in the family of the moviemaker. Asking informants if and when this closed community of participation could ever be broken, I was told:

If an aunt brought a person to the party that we all didn't know, I'd pretend to take her picture but wouldn't—didn't want to waste the film; we're cheap, yeah, done that lots of times.

It was strictly a family event; if there were other people in the movie it was just because they were there at that time.

This attitude was very obvious in the content of the movies. The camera seems to tolerate the "other" people in scenes of crowded places (especially beach and amusement parks). However the camera does not attend to unknown people as well as it does the central characters of the home movie community.

The pattern of appropriate participants is further clarified when we consider other people who are known and who regularly interact with different family members, but do *not* appear in movies. For instance, home movies might well include the family doctor, the mailman, the paper boy, delivery men, trash collectors, metermen, various repair personnel, and the like; but home movies do not show these people. Movies could also include people selling magazine subscriptions, Girl Scout cookies, Avon products, or tickets for various raffles, police dances, or people soliciting funds for political candidates, local charities, school events, or offering information on Jehovah's Witnesses, an anti-nuclear rally, and so on. Inclusion of these kinds of people is highly unlikely in spite of their regular appearances "at home." On the other hand, family relatives (especially favored relatives) are likely to be included because of their regular, if infrequent, appearance "at home."

Several other characteristics of appropriate on-camera participants further reveal the pattern. For instance, participants are almost always awake. Rare exceptions include shots of people who have dozed-off while sunbathing in the backyard or at the beach. Adults are never totally naked, though bathing suits are common. Young children may appear naked in scenes of bathing, in backyard pools or sprinklers, or at the beach. On-camera participants are almost always in good health. People who are ill and bedridden with a communicable disease or a broken limb are generally not included. One does not see a person vomiting in home movies. Aspects of the recovery process may appear, as in showing a child's cast on a broken arm or leg, covered with colorful signatures.

Finally, participants are always alive; dead people are not appropriate subjects. Home movies shot at funerals are very rare.

Determining which participant is designated as cameraman is also important. In nearly all cases investigated for this study, the male head of the household used the camera most of the time. In a few cases, a teenage son (but not daughter) who was learning about cameras and filmmaking, took over this responsibility. One HTDI manual noted other possibilities!

Good news for you Dad! Your... camera can be operated easily by Mom, a friend, even the children. Lets Dad get in the movies too![31]

In actuality, however, the rule was that Father participated more in behind-camera events than in on-camera events. Another piece of advice suggested the following:

By the way, if you should want your entire party in the same scenes...just set the camera and ask a friendly-looking by-stander if he'll do the shooting. You'll hardly ever get a turndown.[31]a

There is more flexibility in letting someone unknown, yet "friendly-looking," take the pictures than having a stranger share a major or minor role *in* the movies.

Thus another important characteristic of this film genre is the expressed importance for most participants to *appear* in the movies. Here, to "make a movie" does not mean attention to or responsibility for shooting the movie, setting the camera, deciding what to film, etc. it means being in a movie. This finding conforms previous remarks on attention given to on-camera activity and neglect of behind-camera events.

A common attitude in home photography is that cameras take the pictures and that the people behind the cameras have very little to do with the process. In this sense, the cameraman becomes a by-stander while the competent technology of the camera apparatus is totally responsible.[32] With reference to symbolic manipulation, the presentation of oneself and manipulation of oneself are *more* important than controlling and manipulating the symbolic content from behind the camera. This finding also corroborates results of the event analysis presented earlier.

Topics
Examination further develops a profile of patterned social behavior.

Present camera technology allows pictures to be taken of nearly anything, regardless of excessive movement, varying light conditions, size of subject matter, and so on. This is as true for professional filmmaking equipment as for the less expensive cameras usually used for home moviemaking. Advertisements for popular cameras encourage camera use "anywhere" or "any time." The HTDI manuals echo this attitude. In one of many examples, we read:

> Good movies are especially great in a few years when you want to relive a trip to the lake, the shore, or to the big city; the snowball battle the kids had after the blizzard of '68; Johnny's first birthday and his first steps; the day you got the new station wagon; the Easter-egg hunt—*it's an endless list.* [emphasis mine][33]

The HTDI guides and advice columns frequently suggest "a complete filmed record"[34] of family life, or an "endless list" of suitable subject matter, claiming "the movie potentialities are measureless."[35] An extreme example appeared in an advice column entitled "A Good Home Movie is Not Necessarily 'Well Made'":

> ...there are nevertheless dozens of dreary routines that you might someday be glad you filmed.... Your route to work, your friends' houses, the same old tennis court, a plain old bus....[36]

However, in these cases, we are again dealing with what "could be" done—and not necessarily what *is* done. The list of topics that home moviemakers actually do record is *not* endless. The selection of topics that the home moviemaker *can* make and the actual list that he *does* make do *not* coincide. The actual list of preferred topics and themes is quite restricted and limited. Surprisingly, while we might expect *"home movies"* or "family movies" to be mostly concerned with family-life-at-home, it appears that only a narrow spectrum of everyday life is selected for recording on film. A small fraction of every-day-life-at-home is combined with a lot of unusual-life-away-from-home.

This combination is best understood when outlined in several broad categories of topics found to be the most appropriate choices.

(1) *Vacation activity* is very well represented. For instance, home movies contain many scenes of children at the beach or the lakeside during summer vacation. Picnicking, camping, and boating activity are frequently seen along with swimming, water skiing, and bicycle riding. Winter vacations include scenes of skiing and ice skating. Children regularly appear in various play activities—floating a toy sailboat, chasing a ball, climbing a tree, playing on swings, or in other activities where a lot of action and movement is involved.

(2) *Holiday activity* frequently demands use of a movie camera. For instance, home moviemakers are likely to include images of the Christmas tree or of the family opening presents; Thanksgiving dinner; an Easter-egg hunt in the backyard; or colorful Halloween costumes.

(3) *Special events* in the lives of family members (especially children) frequently appear in home movies. Examples here include a christening, a birthday party, a bar mitzvah reception, a communion, graduation day, a trip to an amusement park, a parade or sports event with a family member involved, a wedding and reception, an anniversary party, a baby shower, and the like.

(4) *Local activity* will also be filmed when slightly unusual events are taking place. For instance, home movies are likely to include scenes of snow-ball throwing, lawn parties, a baby learning to walk in the backyard, playing with garden flowers or in a sprinkler. Children and adults are frequently seen showing off something new such as a new toy, bicycle, clothes, or car. Family pets are also regularly filmed when playing with family members, chasing sticks or balls, and so on.

The pattern is further clarified when considering the many activities around-the-house that are *not* included as appropriate topics. For instance, one seldom, if ever, finds family members preparing, eating, or cleaning up from breakfast, lunch, or dinner in home movies. On the other hand, we do find that a "special" meal will be filmed such as Thanksgiving, a birthday meal, a meal at a wedding reception or a summer barbecue when relatives, neighbors, or friends are present. We don't expect to see people getting dressed in the morning or getting undressed and going to bed at night; we don't see family members going to the bathroom to either wash or use the toilet, though young children infrequently appear in bathtubs. We don't see children going to school (except possibly "the first day of school") or father or mother going to work. Nor do we see scenes of washing dishes, cleaning house, or doing house repairs (other than a major renovation). We don't see family members reading a book or magazine, watching television, using the telephone, listening to records or the radio, or writing a letter. We do not see scenes of children being scolded, or family quarrels or scenes of intimate lovemaking.

In other topic categories, additional restrictions are easily recognized. For instance, not all religious or calendar holidays are represented in home movies. While birthday movies are very common, deaths of family members are not included. While vacation activities are common, vocational ones are not seen; seldom if ever do home moviemakers use their cameras at the workplace. While the purchase and ownership of

new possessions may be celebrated in home movies, old or used items about to be sold, traded, or discarded will not be acknowledged. Weddings, and wedding parties are very common but divorce procedures are not. However, with an increased social acceptance of divorce ceremonies, and even divorce parties, it is likely that divorce movies will become commonplace in the future. (Parallels to the content of snapshots will be discussed in Chapter Four.)

In summary, it seems to be the case that the list of excluded topics is much longer than that of included ones. Obviously, what is supposed to be a documentation of daily family life, isn't at all. Rather than finding that anything can be filmed, we find a very selective choice of topics.

Settings

Most home movies do not use stage sets, they are shot on location. The filmmaker, in other words, is in the setting more or less that he is filming. In terms of our framework it is highly likely that when describing the setting for a filming *event* the act of filming coincides with the setting description in the movies itself.[37] For instance, film shot at the beach (film event) shows scenes of action that actually did occur at the beach (film setting). Just as participants do not disguise themselves to "play" fictitious characters, settings are not radically changed for appearance in home movies. Though some forms of minor modifications may precede filming. Just as children may be "cleaned-up" or adults may check their appearance in a mirror before picturetaking, home moviemakers may insist on neatening up the livingroom or getting rid of backyard trash before movies are shot.

Readers should understand that for most of the previous analysis of topic, I held the setting variable constant—namely, "at-home." However, it appears that not every part of the home is included in home movies. When filming inside a home, moviemakers seldom used their cameras (and lights) in bedrooms, bathrooms, attics, cellars, or kitchens. Thus, while "anywhere" is theoretically and technically possible, it is *not* the case that any setting in or around the house will be used. Home movie settings are usually restricted to livingrooms, diningrooms, and backyards. Exceptions occur in the case of a baby's bedroom, children using a bathtub, or a special dinner or meal eaten in the kitchen.

While the home setting is frequently used, this setting usually requires another special element. Christmas day, Thanksgiving dinner, an Easter egg hunt, or relatives visiting to see a new baby for the first time provide this additional element. Something must intrude, be it a holiday or a disaster, a snow storm or a hurricane, to change the common

appearance of the home setting. In this sense, home movies do *not* record the reality of everyday life. Instead we find a carefully selected repertory of highlighted times and occurrences that a family is likely to celebrate and wish to remember.

Another category of home movie settings might be labelled "away-from-home." On an everyday basis, family members leave their homes for various reasons. However, very few types of away-from-home settings include a filming event. In general, only three types of social activity are important to this context, namely, trips to the home of a relative (or very close friends), special events, and vacation trips. The first group conforms to at-home characteristics previously described. The second category of special events frequently takes moviemakers away from home and includes a graduation in a school auditorium, a parade in a city street, a wedding reception, and so on.

A third category can be called "vacation movies" or "travel films." These movies usually document "special" places like a wildlife preserve, a zoo, an historic site, a national park or landmark, an Indian Reservation or a natural "wonder" like Niagara Falls or the Grand Canyon. Frequently, picturetaking travellers will be provided with camera instructions and specifications for capturing the best shot.

The qualification, "special," is meant in a very positive sense. We do not find pictures of city slums, abandoned housing or city dumps in home movies—at least not in home movies made of our society. However, these scenes may optionally be included in travel movies made of other societies.

The majority of away-from-home movies are made during vacation times. When vacation consists of staying at a seaside cottage, a mountain retreat, a wooded camping spot, etc., topics are filmed that would not deserve attention when movies were made at-home. For instance, in a vacation setting, home movies are likely to include common everyday activities such as riding a bicycle, playing catch or frisbee, or just roughhousing on the ground. We find that topic choice for filming events may co-vary with setting choice, and that ironically, topics and activities common to everyday life *at*-home are more often filmed *away*-from-home.

Description of setting also includes the place where exhibition events take place—where the movies are shown. This is perhaps the most distinctive characteristic of all home movies, and potentially, the most abused. In almost all cases investigated, home movies were shown in a livingroom, a den, or a recreation room of a private home—an area that can accommodate a relatively small number of people. Only in extremely unusual circumstances will home movies be shown in movie

theaters, drive-in theaters, school auditoriums, or other kinds of public exhibition settings. Only rarely will a home movie be screened in what might be called "alternative theaters" such as film festivals,[38] galleries, archives, collectives, or become part of a museum collection of films.

Still, deviations from the norm occasionally appear. An unusual use of home movies was suggested in 1975 by Donald Wells when he began to market a "color television tombstone." Wells proposed to install a stainless steel box, equipped with a television screen, in a grave marker to show a 10-minute videotaped obituary of the deceased. Wells stated that "if the deceased neglected to have his 10-minute videotape prepared by professionals while he was still alive, it could be put together posthumously from home movies."[39] Generally, however, the gravesite is not accepted as an appropriate setting for home movie exhibition. While notions of appropriated behavior can change, it is unlikely that Wells sold many of his $6,000 units.

Code Characteristics

A description of a code includes the elements or units that define the message form, in this case, a home movie. While it is easy to label a film "like home movies," a description of its code allows us to specify what kinds of behind-camera and on-camera behavior determine this recognizable style. The following patterns appeared with highest frequencies.

(1) In general, there was a great deal of camera movement and a strong tendency to pan. Frequently the camera tried to follow pieces of action and to stay with whatever was moving or doing something. In scenery shots, panning was equally extensive, and the cameraman tried to cram as much into the picture as possible.

(2) There was a frequent use of the zoom technique. The majority of the newer cameras have a zoom lens built into the camera body, and home moviemakers seem to feel they should use it.

(3) The majority of shots in home movies were "long" and "medium" shots. Close-up shots were rare, but are more common in more recent films. The tendency is to draw back from the subject matter leaving the central concern of the shot (person, place, thing, etc.) rather small in the overall picture. Standard compositions most often included a great deal of "empty" space around the objects of central concern.

(4) More footage was poorly exposed in older home movies than in the recently made films. Automatic exposure meters have been built into the newer camera models. Of the poorly exposed footage, more shots were under-exposed than over-exposed.

(5) Lengths of shots in a home movie varied greatly. The older cameras were spring wound: this regulated the maximum length of any shot. Most of the newer cameras are battery operated. Now one movie can consist of two 25 foot long shots, or with the cartridge loaded cameras, one 50 foot shot. However, this seldom, if ever, happens.

(6) The shots contained in any 50 foot reel of film *seemed* to begin and end anywhere, with little visual continuity, and no apparent conventional order or sequence. The shots were not necessarily related to one another beyond the fact that they were shot in the same place, about the same thing, at the same time, or were all shot by the same person. There was little if any attempt to structure a sequence of shots in terms of storyline or plot.

The possible structures other than conventional narrative or story have yet to be explored. But it seems clear that people making home movies did not make them randomly. They were following a pattern that doesn't seem to conform to that of other pictorial genres.

(7) The same 50 foot roll of film will sometimes contain shots from several shooting sessions. Different location or times of shooting were not separated by any visible marker such as a short piece of unexposed film or blank leader.

(8) Jump shots occurred regularly. Rather than finding a flow or conventional blending of shots into a smooth sequence, we found that the shots of a home movie tended to skip around, and appeared to be rough, and jumpy.

In comparison, the "How-To-Do-It" manuals tended to treat these moviemaking traits as "mistakes." For instance, the advice books attempted to persuade moviemakers to be more mindful of shot juxtaposition, either as in-camera editing or as editing done after film processing. In one guide book, we find the following comment:

In short, *a good cut is a cut the audience accepts*; that's about the only way we can put it.... But a shot of little Susie's birthday party followed by a fast cut to the Grand Canyon, *wouldn't* be accepted—unless you had made it clear that a trip to the Canyon was Susie's birthday present.[40]

The point here is that home movie audiences have learned to accept and understand this type of fast cut. Observation of people looking at home movies has shown that jump cuts are quite common and seldom pose problems of interpretation. What may be accepted and treated as meaningful or meaningless varies from one genre of film communication to another.

A description of code also includes a description of any repetitive pattern in the on-camera performance. Each of the following tendencies mentioned in interviews as one of the "common things that happen in home movies":

(1) Very frequently one sees people, especially children, walking directly toward the camera, sometimes directly into the lens.

(2) There is an extraordinarily large amount of just staring into the lens of the camera. People look as though the camera is going to make some form of acknowledgement. This staring is similar to the looks of people sitting for still portraits.

(3) People will strike a pose or present a "camera face" for an operating movie camera. Subjects will "project" themselves as the camera watches them.

(4) There is a lot of waving at the camera. This seems to be considered appropriate when the cameraman says, "okay, do something," or "move!" People will also wave when they first realize that the camera is taking pictures. HTDI manuals are critical of this behavior referring to waving as a "problem" that photographers will often experience with family members and friends. For instance, one advice book refers to on-camera participants as:

highly susceptible to an ailment we call the Waving Syndrome. Symptoms, appearing the moment they see the camera, typically consist of gaping, grinning, facemaking in younger subjects, and—especially—waving. Why do they do this? They do this because they know you're taking pictures, and they feel silly; they thereupon tend to make asses of themselves in an entirely futile attempt to appear unsilly.[41]

In part, it is this collection of behavioral traits for both behind-camera activity and on-camera appearances that people refer to when they say "it looks like a home movie." In almost all cases, however, a "rule" can be found in the HTDI manuals that contradicts these "natural" tendencies. The guides frequently profess a sense of misplaced elitism that bears little relevance to what home moviemakers and audiences actually appreciate or dislike. It must be concluded that the HTDI manuals are promoting the production of a different style of film and, in turn, a different pattern of film communication.

Conclusions

Reasons for the disparities between prescribed and "actual" paradigms of home moviemaking are varied. Of course there are economic interests held by camera and film companies who sponsor the publication of several guidebooks and moviemaking manuals. Their financial position is improved if they can persuade amateur moviemakers to film

a greater variety of subject matter (topics and settings), and to be more selective in what they save—that is, to shoot more footage and edit more for a final film. These companies help the public believe that purchasing a "better" camera will make "better" movies—movies that would include varied techniques such as fades, dissolves, double exposure, slow and fast motion, varied focal length images, and the like. However, other reasons are more significant to our concept of Kodak culture.

Other explanations are based on certain assumptions found in the guidebooks. For instance, that there are big differences between *film*making and *movie*making, and that the former, being vastly superior to the latter, should provide the proper model for all motion picturemaking. Further, that (1) ordinary people do not naturally know how to produce a proper film; (2) that some type of structured learning must occur; and (3) that there are definite right and wrong ways to go about it. It appears that for the guidebooks, the same norms of shot composition and juxtaposition apply to all kinds of movies. Finally, authors of manuals assume that there is only one way of looking at, interpreting, and appreciating a motion picture. Throughout these guidebooks, the communications context is not a significant question.

Disparity between guidelines and observed behavior is understand-able when we consider the following factors. Home moviemakers are generally "at play" when shooting their film; they want to do what seemingly comes naturally—anything else might represent "work" and threaten or negate a sense of leisure. Granted, that what is work for some people is play for others; the reverse is also true. However, the threshold for work during home moviemaking is generally quite low.

Home moviemakers' standards for success, correctness, personal value, and even aesthetics do *not* appear to be based on how they would evaluate other filmic forms. Their expectations are different for feature films and forms of documentary film. Where the context of production is different, the context of evaluation is different. Probably home moviemaking and appreciation imitates previous home moviemaking and *not* professional forms of film communication. Home moviemaking de-emphasizes the manipulative potential of the recording technology. Home movies stress a documentary function, in order to produce a copy of a familiar reality. Again, however, it is not the case that *everything* is shown or that *anything* can happen. It seems clear that different types of visual recording modes, media and codes emphasize different parts of the overall process of representation.

The structure of selection and manipulation in home movies rules out the possibility that home movies document a reality of everyday life. Instead, we find a *special* reality documented in the home movie. Commonplace behavior, mundane activities, and everyday happenings do *not* get recorded. Just as we can not easily see our own culture, we tend not to find it with our cameras.

Chapter Four

Snapshot Communication: Exploring The Decisive Half Minute

When studying snapshots and snapshot communication in the same way as home movies, two facts become evident. First, a great deal of similarity between home movies and snapshots appears in the patterned choice of participants, settings, topics, and certain aspects of code structure, in spite of differences between motion and still photography. The structure and sequence of communication events—planning, editing, etc.— is also the same. In general, behavioral components appear to coincide; the friendly commands "smile" or "say cheese" replace requests to "move" or "do something."

Secondly, photography guides and manuals offer the same kinds of advice and admonishments. Prescriptions for image content are generally the same. As expected, movement and action are emphasized primarily in the movie guides. However, story-telling and the production of sequenced images are emphasized in guides for both mediums. Advertisements for Kodak, as "America's Storyteller" come to mind.[1]

Snapshot collections, like home movies, reveal most photographer's reluctance to create visual stories or visual narratives. The narrative remains in the heads of the picturemakers and on-camera participants for *verbal* telling and re-telling during exhibition events. Significant details remain as part of the context; the story does not appear in the album or on the screen; it is not "told" by the images. In this sense, a picture may be "worth a 1000 words,"...words that are stimulated by and accompany the showing of a snapshot. Home mode imagery provides an example of how pictures don't literally "say" anything— people do the talking.

To help reduce the apparent sense of visual redundancy which underlies all home mode pictorial communication, another strategy of presentation will be used in this chapter. Kodak's slogan "America's Storyteller" provided an interesting stimulus to reformulate the notion of "story" into the context of an individual *lifetime*. Snapshot photographs document key moments in an individual's life, a life story. Readers are asked to consider the following question: When in the course of a lifetime is a white middle class member of American society asked

70

to appear as an on-camera participant in snapshot communication? Our strategy will be to outline the settings, topics, events, and activities from birth to death that prompt snapshot recording for future home mode exhibition.[2]

Approaches To The Snapshot

Nearly every member of American society makes, appears in, or uses snapshots on some way. Alan Coleman, in discussing the immense popularity of the snapshot, wrote:

Today there are billions of photographs commercially processed each year in the United States alone. Most of these are snapshots destined for scrapbooks and shoe boxes.... They are made, treasured, scrutinized, lived with, and passed on. As a demotic artifact, the photo album is so ubiquitous and so much taken for granted as part of life of our society that it seems somewhat shocking and revealing to encounter one of those rare families—the Nixons, for example—which has kept no family album. And it is a rare person indeed who has not appeared in dozens, even hundreds of photographs.[3]

The snapshot has been defined and described in different ways and has been valued for a variety of reasons. A paucity of literature exists on home movies, but the same can not be said for snapshots. The problem which remains is one of sorting out the public and private contexts, in which the snapshot image and its variations appear (see Chapter Eight). Some types of discussion are more useful than others when interpreting snapshots as they relate to our notion of Kodak culture. Two alternative approaches are very useful; the technical approach, and the folk art approach.

Chemical-Technical Concerns

According to many historical accounts, the photographic form "snapshot" did not emerge until the appropriate technologies had been developed. For instance, Halpern notes that as late as 1850, "casual family life was not yet recognized as legitimate subject matter, nor was there a willingness to let the first cumbersome cameras [meaning "photographs," of course—ed.] diverge from accepted pictorial standards. It was not until thirty years later that technical innovations in photography and the idealization of the nuclear family allowed the snapshot to begin its rise to dominance."[4] Photographs however have been used *as* snapshots, that is, for purposes of private visual communication—since the invention of the photographic process around 1839.

Camera equipment is still considered relevant in some snapshot definitions. Photographer Paul Strand cites the requirements of candid photography: "The snapshot...is also more or less synonymous with the hand camera.... When I asked "When is a photograph a snapshot and when is it not a snapshot," you might say it is a snapshot when it becomes necessary to stop movement."[5] However, Lisette Model contradicts this when she says, "Snapshots can be made with any camera, old cameras, new cameras, box cameras, Instamatics and Nikons."[6] It is important to stress that snapshots *can* be made by pin-hole cameras and Polaroids as well as the more complex and expensive Leicas and Hasselblads. In addition, large format cameras as well as coin-operated machine cameras *can* be used to make snapshots. However, it appears that less complex and less expensive cameras are *usually* used.

Aesthetic and stylistic considerations are related to Strand's concern with stopping movement, and to differences between capabilities of studio cameras and handheld ones.[7] Previous discussions of snapshots have emphasized one stylistic feature—namely, the notion of a hurried shot taken without deliberation. For instance, several authors have been quick to mention the derivation of the word "snapshot":

Since 1860, when Sir John Herschell first borrowed the hunting expression and applied it to photography, the word snapshot has been an uneasy, equivocal, enigmatic term.[8]

...the earliest recorded use of the word was in the diary of an English sportsman...who in 1808 noted that almost every bird he got was by snapshot meaning a hurried shot taken without deliberate aim.[9]

However, anyone who has ever glanced at a family album or watched people actually making snapshots understands that the majority of these images are made with considerable *deliberation*. Photographers will frequently pose their subject matter or arrange for the inclusion of an important background setting, as in many tourist snapshots (see Chapter Five).

Kouwenhoven's remark indicates some disagreement with our observation:

Snapshots are predominantly photographs taken quickly with a minimum of deliberate posing on the part of the people represented and with a minimum of deliberate selectivity on the part of the photographer so far as vantage point and framing or cropping of the image are concerned.[10]

And Kouwenhoven may be quite correct when comparing the "deliberation" of perhaps the fashion photographer, the studio portrait photographer or the commercial landscape photographer to the

snapshooter. However, it is to our advantage to distinguish "artistic" deliberations from social ones. In the former, we can include aesthetically preferred compositions, framings, croppings, proper lighting, shading, and the like; in the latter, we must include socially preferred compositions such as who gets into the photograph (or kept out of it), who stands next to whom, everyone looking at the camera, where the photograph is taken, and so on. In making a portrait, artistic deliberations might demand a person show "his best side"; social deliberations might insist that the photographer wait until a person smiled, waved, or simply "looked nice."

Folk Art Concerns

Concern with aesthetic properties of snapshot images coupled with the immense popularity of snapshot-making has led several writers to discuss this pictorial form as *folk art*. In 1944, Willard Morgan, director of the Museum of Modern Art's Photography Center, organized a show entitled "The American Snapshot." In a catalog accompanying that exhibition, Morgan stated that:

the snapshot has become in truth, a folk art, spontaneous, almost effortless, yet deeply expressive. It is an honest art, partly because the natural domain of the camera is in the world of things as they are, and partly because it is simply more trouble to make an untrue than a true picture. Above all, the folk art of the camera is unselfconscious. It may be a significant form of self-expression, but the snapshooter doesn't think of it that way. He takes pictures merely because he likes to.[11]

Elsewhere, Richard Christopherson has attempted to distinguish the *fine* art photographer from the *folk* art counterpart. With regard to the latter, he says: "Making photographs, looking at photographs, and the photographic process has touched virtually every area of our private lives.... In terms of numbers of participants, it is possibly the greatest folk art of all time."[12] Christopherson has subtly called our attention to participation in the process of "art" production and use, and leads us closer to an understanding of the communication context of "art" as an expressive form.

However, the classification of folk art remains vague for these authors. It is unclear why we should call this material a form of art at all. This definition could exclude many important aspects of photos. For instance, in the Authors' Forward to *America Snapshots* (1977), Graves and Payne note the following:

...while looking through our parents' and grandparents' albums we saw a number of pictures which deserved some sort of special consideration. A few transcended the boundaries of the ordinary and carried an integrity and life of their own. We thought that these images could exist outside the family albums.... We were on a search for those pictures which were complete visual statements, needing neither explanation nor rationalization. We picked images which were extraordinary for use, relying on our own photographic intuition and sensitivity.[13]

But study of Kodak culture is not primarily concerned with the few exceptions that transcend the boundaries of the ordinary. We are examining the nature of the boundaries. In contrast to exalting the exceptional snapshots that can stand alone, we seek to understand better how the majority of "ordinary" snapshots exist within the social contexts of a human communication system.

The point here is that most people would agree that a snapshot has a particular "look" to it—a look that is, in part, characterized by the aesthetics and technology of production, although these characteristics are of secondary importance. For purposes of understanding Kodak culture, we need to consider the social construction of that "look" and, secondarily, acknowledge the social context of how that look is looked at and interpreted. The technical, aesthetic or formal aspects are not unimportant, but they have been examined and emphasized in the past while socio-cultural aspects have been neglected.

The classification of snapshots, home movies and home video as material culture—a broader category that easily subsumes folk art—makes more sense. Specifically, the work of folklorist Henry Glassie is relevant when he defines material culture as embracing "those segments of human learning which provide a person with plans, methods, and reasons for producing things which can be seen and touched."[14] We will claim that the tangible material components of Kodak culture are the results of plans, methods, and reasons that are often unarticulated yet still a part of ongoing life. Once snapshots, as material culture, are produced, in a sense they reproduce themselves as integrated parts of human life cycles.

Snapshot Sequences Of The Life Cycle

When exploring life histories or stories through photographs, we quickly see that during one's lifetime, some on-camera appearances are purely voluntary while others are obligatory and coerced by legal and "official" regulations. Examples include the common passport photo and the increasingly popular identification-type photographs affixed to various cards and licenses. I.D. photos may be required on a driver's license, on bank cards used for check cashing or withdrawals, on I.D. cards used by university students, factory workers, military personnel,

hospital staff.[15] Ordinary people may be required to carry as many as four or five of these images with them on everyday business in everyday life.

Another set of on-camera appearances is characterized more by social coercion than by legal regulation. Most group-affiliation pictures fall within this group: school class pictures, summer camp portraits, sport team portraits, school yearbook composites, high school and college fraternity or sorority pictures, church tour parties. In these cases, on-camera appearance is socially coerced. It would be awkward to refuse to cooperate in these imagemaking events. A repeated reluctance to participate might well lead observers to speculate that the non-participant was anti-social or crazy.

The study of Kodak culture is concerned with the *voluntary* appearance of people in snapshots, realizing that the social and cultural contexts of home mode communication impose a sense of obligation on this seemingly voluntary activity.

Again, we start from simple orienting questions: What things are actually included in photographs? Is everything included? What social and cultural biases affect snapshots that ostensibly "document a person's life?" We will explore the sequence and structure of snapshot images that are frequently organized into various types of photograph albums and slide trays. Our descriptive strategy will focus on what it means to be photographed in snapshot form in American society. A (semi-) detached, (quasi-)objective perspective will document the human topography of snapshot collections—how a person "gets to appear in" snapshots from birth to death, and how this lifetime is transformed into photographic symbolic form.

Beginnings

We start with a real life beginning—the birth of a child. Various marketing reports indicate that two kinds of important activities and events are primarily responsible for camera buying: the birth of a baby, and taking a vacation trip. Consumer analyst Augustus Wolfman and others report that married couples with children are twice as likely to own and use a camera than couples without children.[16] But when, where, and under what circumstances is the newborn child first photographed?

The majority of first pictures of a person are taken through the viewing windows of a hospital's nursery. It appears that the image of the newborn child sleeping in a maternity ward crib is preferred to earlier moments. Several characteristics of this setting characterize the tone for later home mode imagery: maternity nurses have bathed and diapered

the baby and tucked it into one of the nursery's bassinets; newborn children are placed "on display" for regularly timed viewings by family members, relatives, friends, and other hospital visitors. Cameras are as common as cigars at this point.

Most hospitals allow and expect camera use for baby photography. However, in one report, I learned of a hospital in Texas where visitors were prohibited from photographing newborn children. The hospital administration had hired their own professional photographers to make baby pictures for a fee.[17] Here we have a variation on the theme of "image vendor" commonly found at popular tourist sites, historical monuments, and other celebrated locations—(see Chapter Five).

Social attitudes affect the kinds of shots that are taken. Some parents feel that pictures made in the hospital nursery are not adequate to celebrate the beginning of life. As potential fathers become more actively involved in the delivery process and natural childbirth methods become more popular, the potential for moment-of-birth pictures increases. One parent described his feelings as follows:

I've been too involved in helping her with her breathing exercises to make any pictures— and anyway, who wants to photograph one's wife as she tries to cope with pain?
...I'm tempted to ask the nurse to lock my camera away until it's all over, but I keep thinking of the birth and how much I want a photographic record of it....But the thought of photographing the birth of my own child is scary! Nature may not allow me the time to focus and fool with f-stops or lens speeds, and I'm fearful I'll miss something if I should dare peer through my lens... 5:58 P.M. My daughter is born! Click. My Nikon reacts.... My daughter is now cleaned and prepared for her first experience in her mother's arms. Click! The Nikon records the event.[18]

The author of this account is careful to add that most Lamaze-practicing hospitals outside New York City do not permit child deliveries to become photography events. Hospital administrators claim that the potential for legal problems is too high; doctors claim that photography may cause unnecessary disruptions and distractions, and that the presence of a camera may create a "circus atmosphere." (My speculation is that as videotape documentation of surgical procedures becomes more common, hospitals will initiate their own production of birth videotapes. Parents will be able to purchase copies of tapes that depict successful births for screening on video equipment kept at home.)

But while birth photography may become more accepted and popular, it appears that for the time being most parents have preferred the picture of the newborn child asleep in the hospital nursery as the starting point of photographed life. Clean children will consistently be favored over dirty ones, and the appearance of blood is generally not

snapshot material. Regardless, it is certain that the presentation-of-self before a camera lens starts very early in one's lifetime.

Pictures are also commonly made when the baby is brought to its mother in her hospital room for holding, feeding, or viewing. This is an interesting occurrence for several reasons. Hospitalized patients, hospital rooms, and general visual evidence of hospitalization are not usually thought to be appropriate to snapshot communication. However, this particular event overrules these tacitly held restrictions. Secondly, the occasion provides a rare instance in which an adult will be photographed in bed. The mother is neither "sick" nor sad. Although hospitalized, she is considered "well," healthy, very happy, and participating in a new personal and social relationship of extreme significance. Such characteristics are the making of snapshot photography. (If, on the other hand, the delivery was accompanied by serious medical complications, photography would be unlikely.)

The first days and weeks of a baby's life contain high priority moments and occurrences suitable for snapshot recording. Bringing-baby-home represents one example of such an event: snapshots are made of mother emerging from the car, baby in her arms, walking into the house. These moments comprise a very important transition period, since, during this time, a *series* of first-time events takes place. If the newborn has siblings, the "first time" that brothers or sisters see the baby will be photographed. Similar photographic attention will be given to first-looks by extended family members. A grandparent holding a grandchild carries enormous personal value—sentimental and social—for the participants.

The most common snapshot found in all albums and photograph collections (studied for this report) focuses on the theme of relationships. This photograph typically shows a parent (grandparent, great-grandparent, or other relative) holding a baby while standing outside, near the front steps of the house or by a side wall of the house. Some form of colorful shrubbery or flowering bush is frequently and preferentially included. The picture is usually a long shot, or full body shot, and both participants are seen facing the camera.[19] The contents of this image reflect several kinds of significant relationships: intergenerational ties and kinship bonds; connections to the land and accumulated goods; and aesthetic preferences and relationships. Kinship, material culture, and aesthetic preference are wrapped up in one snapshot.

Another related factor deserves attention. These kinds of pictures which include family members from different generations of the same family become more valued as time passes. Grandparents and parents die; children may not actually remember seeing their grandparents or

elderly aunts and uncles in face-to-face interactions. However, the photographs offer evidence of the fact that a meeting did occur, that interaction took place, and that these people touched and held each other at one time. Secondly, informants frequently mention that these photographs tend to structure and maintain the memory of forgotten events. We are reminded of William M. Ivins' frequently quoted truism that "at any given moment the accepted report of an event is of greater importance than the event, for what we think about and act upon is the symbolic report and not the concrete event itself."[20] Two points: the photograph of baby and grandmother is tacitly acknowledged and revered as the "accepted report" and, secondly, lacking additional verbal description of the event, the photograph is *all* that *is* left of the event.

During the first few months of life, infants remain as high priority choices for on-camera participation as accepted targets for Instamatics, Polaroids, or other still and motion picture cameras. Parents may face a personal challenge to have their camera loaded and ready to record the "first smile" or first bottle. Other choices of activity may include the child dressed in a pretty "sleeper," being fed in an infant seat, reaching for a mobile, holding someone's finger; bathing activity is also popular provided not too much crying or unexplainable anxiety is involved. It appears that non-crying facial expressions are much preferred to crying and distressed ones; and once a child begins to smile, smiling faces are preferred above all else.

Photographs of crying expressions are interesting because their low frequency is related to other renditions of "off-moments" that appear elsewhere in an album or collection. A typical snapshot collection will include several shots of baby demonstrating an "extreme-crying" facial expression. This image tends to violate the norm of general happiness and lack of distress that is expressed throughout the collection. The reason for the apparent exception may be that these infrequent "stress points" serve as token representations of the tough, unpleasant side of life, but only in contexts of either no-permanent-damage or "it's-not-really-so-bad-as-all-that." Snapshot photography is not done when infants or older children become ill and require a trip to a hospital's emergency room or a pediatrician's immediate attention. The infrequent shot of baby crying is interpreted within this "no-permanent damage" context. If the child was really ailing, we wouldn't be seeing it in the family album.

Choices of some mother-baby activities are controversial. While a picture of baby sucking on a bottle is usually accepted, showing a baby nursing from the real nipple on mother's breast is not. Several informants had difficulty articulating reasons for this beyond stating: "You wouldn't

find that in my album...that (breastfeeding) should have been kept private...."

Parents actively record *physical* changes and important moments that occur at home under private circumstances; the next semi-public photographic event for many families focuses on the *spiritual* development of the child. Lavish amounts of attention are given to two-to-six week old children during a Baptism or Christening ceremony. Photographic attention is seemingly required. A professional photographer might be hired to document the event. In most cases, relatives of the child and close family friends take the photographs. Cameras may occasionally be used in the church but more frequently during a social gathering outside the church or during a party following the church service. Some ministers and priests prohibit camera use during the actual ceremony. However, they are generally not reluctant to simulate the special moment at the altar after the "real" ceremony.

Some families proudly devote entire albums to a child's baptism. Neglecting the photographic component of this event can have social repercussions. The mother of a recently baptized baby said:

My cousin Lynn was upset when we did this for her (organized the baptism and served as God-parents)—we didn't have any pictures taken. We feel we lost a lot by not having something to show her baby later—that is 'proof of what happened to me.' Not that having pictures will make it (the baptism) more significant in the end, in religious terms but it's still important.[21]

The recording by strangers of a child's existence may begin as early as six weeks. Baby photography is so well institutionalized and accepted that diaper companies attempt to lure expectant mothers to use their services by promising free-of-charge two 5″ by 7″ color prints of the new baby. When observing a baby photographer at work, one quickly becomes aware that a routine is in progress. To borrow from Benjamin Whorf and Sol Worth, this might be called a "vidistic routine" that conforms to a set of "fashions of showing." A baby photographer, traveling from home to home, will shoot a sequence of 12 photographs according to a required set of limb arrangements, complete with appropriate props, in under 30 minutes, trying to schedule a minimum of 10 babies each working day.

In a personal example, the author's second-born daughter, Claire, was having her pictures taken by a baby photographer hired by a diaper company. Claire's mother politely, and then not so politely, requested that he eliminate the well known 'blanket over the head' shot. This photographer simply stated that he might be fired if he returned to the studio without such a pose.

This photographer's response provides us with a useful metaphor for describing the significance of such snapshots. Again differences between what must be done vs. what *should* or commonly *is* done come to mind. While parents and children could certainly survive without these pictures, there is something socially inappropriate and even circumspect about not producing these symbolic renditions of early life. This can be seen strikingly in a example in which one 20 year old informant developed extreme psychological distress after learning that her parents did not have snapshots of her childhood, to the extent that she doubted her biological relationship with people she knew as parents:

When I was small, they (her parents) were not that well off, so they didn't take many pictures of me—but my older brother, they have plenty of pictures of him. I think there's much more joy with the first child. Anyway, I couldn't find any pictures of me—my grandmother borrowed them and her house burned and up they went. I really thought I was adopted—my birth certificate was lost too. I asked my parents and they laughed; they didn't want another child (none of us were planned), so why would they go and adopt another? I didn't believe them until my birth certificate was found.... Missing pictures make you feel unwanted; you see thousands of pictures of brothers and none of you—you begin to wonder.[22]

We are provided with an example of how these snapshots have acquired the status of expected and even required artifacts. Apparently snapshots are regarded as a legitimate form of evidence ranking alongside the significance of birth certificates for documenting family membership.

From Infancy To Toddlerhood

A variety of visible changes occur as a child experiences infancy and progresses toward toddlerhood. Topics continue to include life's early successes and accomplishments. Album snapshots commonly document the baby turning over for the first time, learning to crawl, the emergence of the first tooth, and later highlighted by "baby's first steps." Again, photographic emphasis is given to significant and visible changes in the child's development.

The early years of a child's life offer many appropriate times for photographic recording; life-around-the-house is suitable in terms of settings and topics. But we must further ask if everything—all aspects of home life—may be included in the photographs. The actual location where a baby, child, or adult will be photographed deserves attention: the backyard, the driveway, or front door steps frequently appear in snapshots as appropriate outdoor settings; for indoor settings, the livingroom, kitchen, and nursery are commonly used. Babies and young children are likely to be photographed in a wider selection of home

settings than adults. It appears that choice of appropriate setting becomes more restricted as on-camera participants grow older.

The bathroom is an interesting territory in this context. It appears that use of the bathtub area of this room is appropriate for photographs of young children. However, photographic attention to the toilet facilities is unusual. A picture of a child, bare-bottomed, "doing number 1" in a toilet bowl offers us an example of a socially restricted topic. The poster entitled "Efforts," taken from a 1929 reprinted photograph of a naked baby sitting on a chamber pot, is popular because it surpasses some of these restrictions in a comfortable way. When parents do choose to make such a snapshot, it is done in a humorous context. The tacit assumption is that they will not be able to take such a photograph in coming years.

Completion of the first year of a child's life is highlighted by the taking of many snapshots during the "First Birthday Party." Although pictures may have been taken on days labelled "one week old," "one month old," "six months old," the first annual birthday is much more elaborate. Snapshots will include the cake, cards, candles, new toys, attending relatives, friends, and so on. The child will be allowed to make a mess while devouring the food; photographs will be taken before the baby is cleaned up. These images tend to celebrate behavior and presentation that will not be acceptable later in life. As such, these images also provide comic relief within the total snapshot collection.

Snapshots may be so plentiful during this period that parents may decide to devote an entire album to the first year of life. In addition, the child may be photographed during events and times devoted to other family members: birthdays, social gatherings during calendar or religious holidays, and other parties will provide ample excuses and appropriate conditions to photograph the young child. By the end of the first year, patterned dimensions of a child's on-camera participation in snapshot photography have been established. The frequency of the child's appearance will diminish after the first year.

There are, however, certain regular appearances that a growing child will continue to make. Christmas and Chanakah provide interesting examples. *The Wolfman Report* indicates that nationally the day before Christmas is the time of highest film sales, and two days before Christmas ranks second.[23] Parents may decide to include a snapshot of the new family member in the annual Christmas card as "good news" or evidence of a good year.[24] In rarer cases, Christmas photo-stamps may be ordered to decorate the Christmas card envelope. Eastman Kodak, and Fotomat advertise the popular Christmas Photo-Card, in which inscriptions such

as "Christmas Greetings from the Rogers Family" will accompany a snapshot image of family members. It is not uncommon to find the family pet (usually the dog(s)) juxtaposed with young children—while parents may be excluded from the image. As one informant confessed, he thought it somewhat ostentatious to include himself and his wife on the card but thought that everyone would enjoy seeing his children. This is an interesting strategy for "showing off" one's family without showing off one's self.

The Christmas card photograph is an interesting example of politely extending the audience for a snapshot. Originally photographed by a family member, the snapshot image will be professionally duplicated for distribution to members of the Christmas list. This list comprises a carefully selected network of consanguineal and affinal relatives, fictive kin, some neighbors, close friends, old acquaintances, and, sometimes, persons involved with the family in functional relationships (work or professional colleagues). In other words this list includes some people who would normally be within the home mode community of accepted participants, in either on-camera events or exhibition events, but the list *also* includes people who might never be included or who might be included at a later time. In this way the photo-card can be an uncoerced invitation and opportunity to become a temporary participant in someone else's home mode communication.

Institutions pervade the home; the home enters into institutions. An example of institutionalizing the home mode image involves the young child's personal appearance with a celebrated character—in this case, Santa Claus. When we take a child to visit Santa in a major department store, we see how professional photographers have organized the scene to produce standardized, inexpensive pictures of the child on Santa's knee. "First trip to Santa," and subsequent trips are frequently represented in a family's album.[25] The theme of a child meeting various celebrities, from distant relatives to media personalities and sports stars, from Santa Claus and circus clowns to native members of exotic tourist communities, is enacted here and will be repeated elsewhere in the snapshot collection.

Of course, Christmas day will be highlighted with several appropriate "good time" scenes which may include a child or other family members opening and showing off presents on Christmas morning.[26] Goals here include capturing a child's first look at a new toy, and photographing expressions of surprise, excitement and pleasure at possessing something new and desired. Christmas morning pictures are interesting because we see several "breaks" with norms that remain rigidly controlled

throughout the rest of the snapshot collection. Attention here is given to the presence of adults dressed in pajamas, nightgowns, bathrobes, and the like. People are photographed in dishevelled appearances associated with early morning. In addition, the livingroom is a mess, cluttered with torn papers, ribbons, and the like. Concepts of appropriate on-camera activity and appearance have been adjusted and slightly rearranged to suit the occasion.

Throughout the years of childhood, many of these photographic occasions will be repeated. Christmas times and the first seven to ten birthdays in a child's life often appear in snapshot collections. An important part of these images will be devoted to gift-giving activity and the special kinds of presents received by the child. The first tricycle, or later bicycle, a new dress-up uniform are frequently seen. Children may be photographed in a new G.I. Joe or sailor's outfit, a nurse's dress, cowboy or cowgirl outfits,[27] a new cheerleader's dress, a baseball or football uniform. These presents may be classified and photographically celebrated as the acquisition of new material wealth. They also express the themes of "trying on" a new identity by presenting the child in a positively valued non-childlike role, and, as such, represent a playful extension into future time. This pattern of uniform display will be repeated in later years when the same person enters a new recreational or occupational status such as a member of the Boy or Girl Scouts, a particular sports team (secondary school, college, professional), goes off to summer camp, joins the Armed Forces, or becomes a member of a nursing staff or medical team.

Annual picturetaking also occurs during such popular holidays as Thanksgiving and Easter. Thanksgiving day, like Christmas and Chanakah, provides the context for family reunions, and a major dinner is prepared to focus the event. This holiday provides another time when old snapshots will be looked at and talked about which, in part, serves as a stimulus for new imagemaking. This regularly occurring practice contributes a sense of continuity and a reassuring redundancy to the entire collection.

The celebration of Easter also offers several elements that naturally play into established and prerequisite dimensions of snapshot photography. Children will be specially dressed in Easter "finery," in clean and new clothes presenting an appearance of young adults. As such they will be photographed on the way to or coming from a Sunday church service, a relative's house for a special dinner, or, in rarer instances, participating in a local parade. Special moments in life are once again

celebrated in snapshot form, and people are again seen putting their best foot forward.

Childhood and Adolescence

Continuing to track the visual representation of a young person, we find other transitional periods "marked" in snapshot form. Between the ages of eight and thirteen the occurrence of certain religious events will determine camera activity. For instance children participating in their first holy communion or confirmation will be photographed. Transitions into adulthood celebrated in bar mitzvah and bas mitzvah ceremonies are also very common.[28] Key snapshot themes, including recognition of a new status, spiritual change, and new identity are, in conjunction with the special set of clothing, the production of a visibly new and unusual appearance—maintained and repeated as dimensions of appropriate imagery.

It is not uncommon to find that these events undergo multiple-camera recordings. As noted in Chapter Three, motion picture cameras may be used to produce a home movie of selected segments of the proceedings. The family may also contract a professional photographer to produce an album dedicated to the event. Relatives and friends of the child's parents may bring their own cameras to make other pictures of the same event. Some of these snapshot images will be given to the child's family at a later date, or pictures made with instant cameras will be given away *during* the social gathering. This photographic activity and the resultant pictures play an interesting and important role in socially ordered reciprocal relationships surrounding the entire event. They serve to restate and reify social structure and social organization. The invitation for instance, to attend a confirmation or bar mitzvah (and associated parties) will be "paid back" in several ways and forms of gift-giving—the gift of snapshots represents an extension of this patterned reciprocity.[29] They represent a special kind of personal gift that carries meta-messages of high approval, congratulations, acknowledgement of group membership, conveying the general statement that "these people are doing it right."

A renewed interest in birthday snapshots develops for the sixteenth birthday of female children and is reflected in the following example:

When I turned sixteen I had a "Sweet Sixteen" party at an Italian restaurant. After spending a great deal of time in the planning of this activity, all members of the family felt it important to take pictures. This birthday was a special one for me. On becoming "16" I could now drive, smoke cigarettes and stay out later on the weekends.

My Aunt Bobbie, who is the camera buff of the family consented to do all the picture taking. She took candid shots of me and my peers and me with members of my family, as well as prearranged group pictures of relatives and friends who attended the party.

I was photographed opening presents, reading cards, cutting the cake and kissing friends. I appeared in at least two thirds of the 30 pictures that were taken at this party.[30]

Again, we have an example of how photography is used to celebrate a juncture and turning point—a time when the young person is allowed to do more things that conform to adult life. The fact that a party is held to celebrate the event further increases the likelihood of snapshot recording.

Young people once more become the center of photographic interest when school graduations occur. Before graduation, pictures will be taken by a professional photographer hired by the school to produce portraits for the yearbook; student photographers on the yearbook staff may shoot candids for this publication; parents will take snapshots of their children during commencement exercises. Parents may begin shooting graduations when the child is as young as five or six, if the school organizes an event to commemorate the commencement from nursery school or kindergarten into the first grade. This documentary tradition continues through the awarding of graduate and/or honorary degrees. Photograph vendors—photographers who shoot and sell Polaroid images at specific photogenic activities and locations—will wait outside commencement exercises to photograph the robed graduate and parents for people who forgot to bring a camera. Again, we see how themes of transition and moments of accomplishment, dramatized by the wearing of special uniforms, are a major element in snapshot renditions.

Social events associated with school graduations are also considered appropriate subjects for snapshot photographs. Common examples include pictures of son or daughter formally dressed to attend the junior or senior prom. One example combines the significance of the prom with an unanticipated "last occurrence":

Of course, the camera was brought out when one of us was going to a prom. Individual pictures were taken of each member of the family with the prom-goer. By the time the person was ready to leave for the prom, all they could see was lights flashing. My mom usually made our prom gowns. My junior prom dress was the last one she made. She died that night. I carry that photograph in my wallet.[31]

Uniforms again play an important role: the son's rented tuxedo and the daughter's special and expensive gown decorated with a corsage, conform to the requirements of "looking good." Usually these pictures include the son's or daughter's date for the dance and later parties. Both people look very grown up for snapshot recording by parents. And in fact, these serious and affectionate interpersonal relationships, voluntarily

entered into by son or daughter, foreshadow the beginning of a new stage of life, and a new album or collection of snapshots.

Early Adulthood

By the time of high school or college graduation it is no longer correct to refer to our central character as a child. The next time we see this person depicted in snapshot form may be his or her entrance into the Armed Forces or his first weekend home on-leave. Snapshotmaking may be supplemented by a studio portrait of the new recruit. Earlier snapshots featuring a G.I. Joe or sailor's outfit are repeated in somewhat of a self-fulfilling prophesy. We now see the same person grown up and wearing the official version of the same uniform. Some families have a complete album of snapshots devoted to this period of life spent away from home, which are sometimes referred to as the "war album" or service album. In one account, an Army private described the snapshots he made while stationed in Germany between 1968 and 1970.

Reflecting back, I now see that they (179 snapshots) were taken mostly for my family back home, to see me in my new home. There is a great picture of me grinning while sewing my P.F.C. stripes on my clothes when I received my first rank promotion. This ties in with the American cultural concept of achievement and to reaffirm the fact that I was doing okay.[32]

This last comment is, of course, quite right. Not only was he doing "okay," but he was being *promoted*, a key element that seemingly directs the snapshot story of life.

As we progress here along our generalized chronology of a lifetime, we discover that events surrounding a wedding provide the next set of on-camera appearances. Here, aside from the wedding ceremony *per se*, it is helpful to consider snapshotmaking that occurs during such related events as wedding showers,[33] bachelor parties, the reception following the wedding, and certain honeymoon experiences.[34]

The vast majority of weddings are subjected to photographic rendition in several forms.[35] The presence of a photographer is as accepted as the presence of a minister, priest, or rabbi. A professional wedding photographer may be contracted to produce the official pictorial version of the event in the form of a personalized album. In other cases, a free lance "advanced amateur" or aspiring art photographer, as friend of the family, may be asked to perform this task. It is also likely that cameras will be used by relatives, friends and guests—all with varying degrees of photographic expertise—to produce several versions of the wedding events. These pictures will be presented to the newlywed couple at a

later date, thus renewing a cycle of reciprocal gift-giving according to a pattern of exchange described earlier.

A wedding provides a unique combination of previously described photogenic qualities that seemingly determine snapshotmaking. Social characteristics of the event offer obvious significance. The event produces obligations on the part of immediate and extended family members, as well as close friends, to gather and witness personally the origin of a new family unit. Generational kin ties and affinal relationships are re-established and reified. Fictive kin and friendship relationships are acknowledged. Photographs taken at this time tend to solidify this network in symbolic form. Weddings are also times of intense social activity and gift-giving. Special forms of dress are prescribed and generally adhered to. Children are present and expected to be "on good behavior" all of which further contributes to the preferred pattern of snapshot imagery. Religious ritual and a multi-layered scheme of social ritual provide high priority opportunities for amateur camera use.

The bride and groom may openly seek to eliminate some of the conventionalized and commercialized aspects of a formal wedding. For instance, they may choose to be married in a non-church setting, wear non-traditional wedding attire, or select an unusual choice of music (if any). However, it is highly unlikely that photography will be eliminated entirely and that guests will be prevented from taking pictures of the event.[36]

It is interesting to ask when *in* the course of joining two people in a marriage bond the photographic recording ends. It appears that private honeymoon photography is quite common, but it is seldom discussed or shown during later exhibition events. Polaroid and other instant picture cameras have been popular wedding gifts, being used to produce the occasional "naughty" shot. Honeymoon bungalows in the Catskill Mountains not only provide the heartshaped bathtub but also include a remote-controlled camera for recording the intimate moments. Comparable honeymoon spots in Japan are now offering videotape units for similar purposes.

In addition, professional photographers are employed by these honeymoon hotels. Customary shots will be made during dinner, while the newlyweds are dancing, or in various other leisure activities. However, they will also offer to take certain shots of staged intimacy. Examples include the couple in bed, pulling the sheets up to their necks; or the couple taking a bubble bath together in their heartshaped tub. The photographer will attempt to sell them a complete album of these photographs.

Thus the social context of "honeymoon" allows for and even promotes another set of norms for on-camera appearance. Whether made with the camera's self-timing device or an extension cable release, or shot by a professional photographer, these pictures are being made largely for private and not for public consumption. Semi-nude adults in bathtubs, adults in bed intimating sexual activity are not common settings and topics of the family collection.[37] However, boundaries still do exist. Shots of a completely nude couple in scenes of sexual intercourse are not done.

Married Life

There is less variety to on-camera appearances during the years following a marriage than before it, and "our person" will not be featured as the central character as he or she was during childhood. By this time, certain patterns of appearance and habits of picturetaking have been established and considerable repetition of settings and topics will occur. Adults will take part in other people's events—especially children's birthdays, parties given by adult friends, holiday gatherings, and the like. Annual round photography will continue; on-camera appearances will occur during family reunions, special dinners and vacations as usual. But there is much less to say about the last two-thirds of life (roughly between the ages of 25 and 75) than the first 25 years.

In the later two-thirds, increased attention is given to on-camera appearances that are part of vacation time or travel experiences. According to one account, approximately 70 percent of all photographs taken in the world each year are made by vacationers.[38] Snapshots that include people at the beach, a resort, a lake, a mountain cabin, during a trip across country, or traveling abroad are very common. Adults may be featured in such recreation activity as skiing, swimming, sailing, hunting,[39] horseback riding, etc. Frequent attention is also given to adults standing next to a historical monument, a celebrated countryside, mountain terrain, or shoreline (see Chapter Five).

While vacation snapshots are very common, settings and topics related to vocation activity are relatively rare. People seldom make snapshots in the workplace, though snapshots may be taken to work and shown to friendly fellow workers. When pictures are made at work it is usually because the husband owns or runs a business than can be identified with a particular building. He, as owner, will be juxtaposed with this building or sign that indicates his ownership. People who clearly work for someone else, as part of some formal organization, alongside other workers, tend not to appear in snapshot form. As Richard Oestreicher has noticed, "people in snapshot albums did not seem to

go to work. The world that they wanted to remember was the world first of their families and second of their possessions. Their houses were there; their cars were there; their leisure and its symbols were there. Their work was best forgotten."[40] Still, exceptions may occur during an annual Christmas office party or a party that celebrates "25 Years in the Business."

The next major episode of snapshot significance brings us full circle back to childbirth. As expected, social events related to the birth will receive considerable snapshot attention. During a baby shower, for instance, the mother-to-be will be featured as an on-camera participant. An entire "Shower Album" may be produced during this time.

Expectant mothers are featured more than husbands. The woman is manifesting a positively valued change in physical appearance, accompanied by a change of clothing, whereas the expectant father looks much the same, as he always has. The dimension of visible change plays an important role once again. The first few weeks and months of pregnancy may be accompanied by "morning sickness" and receive less photographic attention than later months. Snapshots will be made when the wife clearly "shows," when her posture changes, when she generally looks different. A humorous, quasi-naughty shot may show the pregnant wife in an ill-fitting bathing suit. Snapshots made the day before delivery will be especially valued.

After the birth, snapshot attention shifts dramatically to the newborn child as featured on-camera participant. The mother or father will remain as part of many baby pictures, but central attention is now given to their child.

Parenthood

During the middle third of "our person's" hypothetical lifetime, he or she will be photographed with other kinds of acquisitions. There is a tendency to attend photographically to certain new items of material culture. Snapshots will be made of adults standing next to, or sitting in, the new car, motorcycle or van, a new motorboat, sailboat or yacht;[41] snapshots may be made of the proud occupants of a new apartment or owners of a new town house, summer home, mountain retreat, or even a new tent and camping gear. In other cases, new clothing may be featured, such as a woman in her new fur coat, or a new ski outfit may be the center of interest.[42] While celebrating new material acquisitions, these snapshots are calling attention to the fact that life is progressing along a successful path. Certain non-photographable successes have resulted in the ability to purchase and own these items

and to live in a comfortable manner. The consumer ethic is not neglected in this pictorial version of life.

Other familiar themes and tendencies continue to appear. For instance, the infrequent and potentially embarrassing shot may be attempted several times. People by this age are "camera wise," and it may be much more difficult to catch the candid moment when an alert on-camera participant is genuinely off-guard. A special snapshot strategy may be necessitated. In one example, Bob Fanelli reports the following circumstances for creating the "naughty" snapshot.

My friend Jack had worn a hole in the seat of his pants. Pictures were being taken continuously during the course of the day (a family gathering) and his sister, Patsy, wanted to get one of the hole in Jack's pants. Whenever Jack entered or left the room, he walked sideways, facing her, so that she could not get the picture. When he did this, he turned his back to me. While he was out of the room it was suggested that I take the picture while Patsy decoyed him with another camera. I agreed to this. The flash of the camera caused a roar of laughter from the family and an embarrassed exclamation from Jack, who had been 'caught with his pants down' in a manner of speaking.[43]

The snapshot collection also begins to reflect a tendency to celebrate the past, as people participate in certain "re-doings." Aside from the continuous appearance of family reunions, wedding anniversary parties, and the like, we find images of reunion of high school, college, military, and even summer camp friends included in the collection. These photographs also call attention to familiar themes of change, and later, to survival.

The Later Years

During the last third of one's expected lifetime, on-camera participation becomes even less frequent. Infrequent special events predominate such as summer family reunions, parties that celebrate a 10th, 25th, 40th, or 50th anniversary, birthday parties—especially when children, grandchildren, and other relatives have come to visit. Travels during summer vacation and later during retirement provide other familiar examples.

A new sensitivity to inappropriate on-camera appearance may be activated during old age. Infrequent on-camera appearances may result from a tacit collusion between a photographer and an older person suffering some form of infirmity. As an example:

It was also during this time that my grandmother became ill, and Dad even began to slack off taking pictures at family get togethers. He didn't seem to want to document her as bound to a wheelchair and ill—a reality he didn't want to structure or record for a while. Thus, even some of the happy occasions weren't structured into sequences because

excluding grandmother from the pictures didn't seem appropriate, yet neither did photographing her as an invalid. Gradually, as we all grew more accustomed to her invalid-state the camera was again seen at more occasions than it had for a time.[44]

Snapshot photographers experience a time of adjustment, and, eventually accept images of family members in a state of "maybe-not-getting-better."

During the last years of life, there is a tendency for children or grandchildren to be on the lookout for the last birthday, anniversary, Christmas, or Thanksgiving party of their aging parents or grandparents. Older people have reported a reluctance to be photographed at this stage. They may not want to be seen in snapshots that show either the natural effects of aging, such as wrinkles, awkward postures, a different smile because of false teeth, or even thick lensed eye-glasses, or unnatural effects of illness, a recent hospitalization, or physical handicaps.[45]

Images Of Life's End

The actual end of life is seldom documented in snapshot form. The physical process of dying, the precise moment of death, funeral procedures and ceremonies, and graveside interment were not accepted as appropriate subject matter by most people. Common reactions to the very possibility ranged from "unheard of" to "ghastly" and "disgusting" to "religiously forbidden."

While the majority of cases did not possess snapshots of dying or dead parents or relatives, several people related interesting accounts of this practice. One report indicated that a sense of ambivalence may exist regarding the taking of snapshots during a parent's funeral. A 20 year old son reported his feelings:

Overweight diabetics shouldn't drink is the moral of the story. I quietly packed my camera for the funeral. Who was I trying to kid? Quite apart from the expected family response, did I really need any help remembering the hideous make-up job, an ill fitting jacket, the 'weeping rail,' flowers everywhere, cloying air, an empty eulogy delivered with authority by some unctuous rent-a-twit? Hell no. I wasn't going to play photojournalist at my own father's funeral...the images are quite indelible without Kodak Tri-X. I've been back to the gravesite, with my camera. I feel like I'm daring myself to take pictures— for reasons I don't entirely understand...

Well, what of it? I look at pictures of Christmas '76—they take on a new significance because they are the last pictures of my father. It occurs to me that the pictures are all you get to keep to augment your memories. At times, I wish I'd taken pictures of the funeral—he's my father, and the hell with what everyone thinks...[46]

At the other extreme, one informant recalled knowing a young boy who had died of leukemia. During his illness, his mother extensively photographed his various hospital experiences. These photos were hung

on the walls all around the diningroom. At the time of his death, his mother photographed him. She also photographed his entire funeral event: the coffin coming down the church aisle, the coffin before the altar during service, and the burial. These were photographed with a Polaroid camera. Upon returning home after the burial, his mother spread the photographs on top of his bed to be viewed by the guests who came to pay their respects to the family.[47]

In contrast to isolated and idiosyncratic opinions, clear examples of cultural variability were discovered.[48] It appears that many Polish and some Italian families feel that funerary and corpse photography are appropriate and serve important purposes:

A widow of Polish nationality (probably a second or third generation American) had such a photograph (of a deceased family member taken during the funeral) that she carried around in her pocketbook. It was a color Poloroid "snapshot" of her dead husband lying in his casket and probably taken five years ago. Another case was that of some Italian immigrants who live in Montgomery County (Pennsylvania). They have a photograph of their dead son in his casket, framed and mounted on their mantle in the living room, an area of the house sometimes used for the entertainment of visitors... But one person recalled a time in which he was asked to photograph a dead relative during the viewing because he was very familiar with the use of cameras. He did so and with reluctance. His reasons for his attitude was that he personally felt the act was "hideous and disgusting."[49]

The death of a family member is obviously a difficult and painful time, a time that will be remembered. A funeral provides the context for a gathering of extended family members and friends; frequently a meal will be served as part of a wake ceremony. In spite of these conditions, conducive to a lot of snapshotmaking, cameras will generally not be used. A death is an important example of a significant family event that is *not* recorded in snapshot form. In this case the photograph collection does *not* reflect all the parts of a life history that must be remembered by family members.[50]

And so, before we accept a facile and common conclusion that a snapshot collection chronicles a lifetime or serves as a visual version or visual narrative of a personal autobiography, several precautionary and sobering comments are in order. We should ask what personal, psychological, or social disasters that have happened to members of a family during this lifetime, or which "off moments" in life, are *not* represented in snapshot form. What forces of suppression, deletion, alteration, or elimination are working to balance or counteract certain familiar characteristics of home photography like intensification, elaboration, exaggeration, and repetition?[51] Like any other communicative form, how does the family album serve to conceal information by systematically ignoring and thus eliminating certain times, events,

places, and people?[52] Our final generalizations will be more convincing
if we can argue from both sides, that is, from examples of exclusions
as well as inclusions. If we now take one step backward, we can briefly
examine what has been systematically and unconsciously left out of a
"complete" on-camera record of life.

Patterned Eliminations

As we found in our study of home movies, some of the missing
images turn out to be the polar opposites of commonly chosen topics.
For instance, we have reviewed the emphasis on times of birth, and the
absence of death-related topics and events. A similar pattern exists for
family pets; snapshots of puppies and kittens are more popular than
animals on their last legs. The same emphasis-neglect pattern applies
to the difference between attention given to vacation and the neglect
of vocation or work-related activity.

We also noticed how weddings received multiple-camera attention,
while divorce proceedings were not included. An interesting exception
to this neglect pattern was published in a newspaper, underscoring its
newsworthyness. In the clipping, entitled "Americana: Photos in
Splitsville," we read:

Now, in beautiful living color, you can get a photographic record of every step of
your divorce proceedings.

Louis Grenier, a Chicago photographer, has gone into the divorce album business.
For $200 a day, Grenier, 39 and a bachelor, will stay with a couple throughout their
divorce action, making candid shots every step of the way.

He says: 'Wedding albums have been big items of photographers for years, but now
I think the country is ready for divorce albums. The divorce album will be a record of
how things were, and I think it will serve as a warning to both parties not to let things
get that bad the next time around.[53]

It is possible to become more specific about times and places not
shown. Regarding the subject, for instance, of a newborn baby, we seldom
if ever find snapshots of changing dirty diapers, or times of the problematic
diaper rash, the midnight, two, or four A.M. feedings, reactions to
immunization injections, the health problems that require a pediatrician's
attention, and so on. In the case of weddings, we seldom if ever see
scenes of crying and related moments of anxiety, and minor arguments
over details of protocol or reception plans. We don't even find snapshots
of the wedding rehearsal and other important preparations. Many other
examples could be given. Let it suffice to say that in these cases, more
is left out than included.

We have mentioned a tendency to photograph a series of "first-times." This list includes a child's first steps, first haircut, first day at school or summer camp, first trip to a vacation site, first bicycle, car, sailboat, apartment, house, and the like. Two points must be added. The first is that there is a lengthy list of "important" first-times that are *never* recorded in snapshot form which includes a child's first medical check-up or trip to the dentist or hospital, a daughter's first menstrual period, a child's first masturbation, a wife's first days of pregnancy or first moments of labor pains, and the like. While snapshots of new places of residence are common, the admittance to a nursing home in later life is not. The second point is that *last*-time events, as opposed to first-time events, are seldom found in the collection.

Many things are left out of photographs. After reviewing the 197 snapshots he had made while stationed in Germany, a former Army recruit discovered he had made no pictures of the

Army daily routine such as reveille, parades, inspections, cleaning weapons, muddy field problems, forced marches, simulated combat missions, canned rations, officer harassment, tanks policing the areas (picking up butts, leaves, and garbage), racial problems, boredom, homesickness, German populace indifference and sometime hostility, American cultural deprivation, zilch sex life, freaking out on drugs, paranoia, drunkenness, etc., etc., etc.... None of these negative images are to be found in my collection.[54]

There is also a general neglect of daily life around the house. We seldom if ever find snapshot images of people taking showers, brushing teeth, combing hair, shaving, using the toilet, people preparing breakfast or dinner, washing the dishes, using the clothes washer or dryer (or hanging clothes out to dry), vacuuming, dusting, polishing furniture or silverware, or otherwise cleaning the house. Nor do we see people reading newspapers or books, writing a letter, using the telephone, listening to a radio or stereo, watching television, playing cards or board games. When ordinary, normal, and usual incidents of everyday life are photographed, it is probably because a slight variation has been introduced to alter, or humorously comment upon, the activity. For example

Several pictures in Emma's album seemed to be ordinary around the house activity, but this did not prove true upon closer examination. For example, one picture in the album showed Emma's husband sitting in his chair reading the evening paper. However, a close look revealed that the paper was upside down.[55]

As in our findings for home movies, patterns of content can be clarified by considering why specific people are included or excluded

on a regular basis.(Simple frequency counts indicate that between 91 and 95 percent of a family's snapshot collection will feature people.[56])

Snapshot collections and family albums frequently provide visual "maps" of kinship networks. One family album may include three generations of people. An album maker's parents and children will frequently be found together next to aunts, uncles, cousins and fictive relatives. This is *not* to say that *all* members of a nuclear or extended family will be present in photographic symbolic form. Disliked relatives are likely to be selectively eliminated from this symbolic gathering. In one report, an example of this type of exclusion was described as follows: "July, 1945—her husband is never seen in any photo (everyone hates him including her, because of his obnoxious stupid manner)."

A second set of social relationships found in snapshot collections includes non-kin groups—groups that are organized along lines of close friendships or other significant social affiliations. Family album makers are likely to include pictures of good friends living in the neighborhood, of school teams, class groups and summer camp groups, of fellow workers, or special party gatherings, of holiday celebrations with special people, and the like.

It appears then, that in home snapshot collections, all on-camera participants will know each other in some socially significant way. This is not likely to be true for other forms of photographic recording. However, not all groups of people in one's network of non-kin social organization will be represented. We seldom find pictures of "the crowd at the office," the boys at the bar or the gym, members of the carpool, the PTA, the bingo group, or part of the church congregation.[57]

Groups of unknown people, collections of strangers or disliked people have very little place in most snapshot collections, though "friendly looking" strangers may occasionally be asked "to take a picture of all of us together" to avoid leaving an important person out of a snapshot.

Similar to home movies, people can also be eliminated after the snapshot has been taken. The most obvious way is to throw out images of disfavored people. However, these "bad people" may be in the same picture with favored participants; unlike home movies, the problem then becomes how to eliminate the bad while saving the good. In Fanelli's 1976 study of six family albums, he discovered several types of manipulations or alterations to solve this problem. He mentions examples of cropping pictures along lines of a person's body to take someone "out," and scratching out a person's face or physical features. An

interesting example of this symbolic severing of an unpopular kin relationship is provided by Fanelli:

> The Fowler siblings all professed to hate their mother, who was (and remains) cruel and hostile towards them. When Kathy Fowler (daughter) moved out of her mother's house, she argued with her over the ownership of the family album. The upshot was that the mother got the book, which she had once purchased, while the daughter (Kathy) got the pictures, which had been left to her on her father's death. After removing all of the photographs, Ms. Fowler (Kathy) proceeded to cut her mother and her unpopular Russian relatives out of the pictures, placing them into a separate envelope. This symbolic severing of the family was generally supported by her brother and two sisters, one of whom said that she wished that her mother had never existed."[58]

The notion of *change* is very important. Moments of positively valued change, marked by parties, official recognition, or public celebration, "punctuate" the collection's view of life. When I asked one informant if certain ages occur in snapshots more than others, she replied: "The growth of a child—there are certain times when there is no change at all, so you don't take the picture. But children go through more changes so you want to record them. My parents didn't have much interest in photographs and they couldn't afford pictures of me as a child." Distinguishing a pattern becomes clearer when we recognize times of change that are selectively ignored by the camera. Some instances have already been mentioned; Kaslow and Friedman suggest a strong negative relationship between picturetaking and "critical times":

> ...during periods of stress and family crisis, we note that there is a sharp drop in the number of pictures taken. This includes periods surrounding illness, death, family separations and fragmentations, and heightened conflict between different members and fractions of the family.... Periods of depression, crisis, disorganization, and rapid family change are often characterized by the absence of pictures. Gaps in the picture chronology can point to questions to be asked about loss, separation, disappointments, and grief.[59]

(Further characterization of the home mode worldview based on themes of personal and social change will be discussed in the concluding chapter.)

By reviewing these inclusion-exclusion examples, we understand better how snapshot collections afford us a very limited view—an incomplete rather than a "complete" look at life. We find that the vast majority of a person's life is lived away from the view of a camera lens. If we estimate a life expectancy of 75 years, perhaps specific moments amounting to *one percent* of these 27,375 days will be selected for snapshot making.

Kodak's phrase "for the times of your life" takes on a strange significance in this perspective. Time seems oddly warped, or concentrated, by photography. One percent represents an incomplete

record to say the least. Furthermore, if we estimate that an average snapshot collection consists of 3000 pictures (an estimate based on the total accumulation in albums, drawers, boxes, wallets, etc.), and the average shutter speed of cameras used to make these images was 1/100th of a second, we find that the total collection represents thirty seconds of accumulated life. Our task becomes one of knowing the dimensions of this view of life, the tacit selection of this one percent of days alive, and the significance of this decisive half-minute.

This chapter does not provide a complete description of any one snapshot collection or any one family album, nor is the description of any one collection ever a complete description of all albums; family albums will differ in terms of specific content characteristics.[60] Such differences, considered here as surface characteristics, must be expected to vary systematically in relation to social characteristics of each home mode community. For instance content and form variation might appear in relation to (1) historical time frame—regarding technological developments (more outdoor than indoor settings, more black and white than color pictures) or political context (presence or absence of military involvement); (2) family composition (frequent appearance or absence of children or living extended family members; the use of pets in roles of surrogate children); (3) religion (the appearance of bar mitzvah versus holy communion pictures; attention given to members of the clergy); (4) ethnicity (celebration of various ethnic holidays, or the presence or absence of funeral and/or corpse photographs); (5) geographic location (the relative presence or absence of certain snow-related recreation or beach photography).

An additional note of clarification is needed regarding the historical time frame limitation. Historical variability may also be expected in social conventions of picturetaking and picture use, in institutionalized and non-institutionalized sanctions surrounding both professional and non-professional photography, and in notions of appropriate and expected behavior. As noted in Chapter Two, the present study has developed from a relatively static synchronic look at pictorial forms that actually record changes in people's lives. Much work remains to be done on how conventions, sanctions, and related behaviors change *diachronically*—through time—and how technical, social, and cultural factors contribute to such changes.

The examples included in this chapter should serve to expose the "controlling" dimensions of the snapshot's contrived and biased rendition of life. Several other authors have attempted to summarize these dimensions by generalizing a view presented in snapshot collections.

For instance, "The sunny side of the street eclipses the seamy side"[61] in amateur snapshots; a family album shows "all that is life-affirming and pleasurable, while it systematically suppresses life's pains;"[62] and in another case, "Hard times of any sort...(or) the inclusion of images with unpleasant associations would mar the genial atmosphere that characterizes these albums."[63] And finally, Julia Hirsch in her book *Family Photographs* (1981) notes:

> Family photographs, so generous with views of darling babies and loving couples, do not show grades failed, jobs lost, opportunities missed; and the divorced spouse can easily be torn up or cut out of a family group. The renegade, wastrel, the outlaw are not pictured in their extremities. They are simply not pictured at all. The family pictures we like best are poignant—and optimistic.[64]

Going even further, Kouwenhoven speculates on the general development and consequences of this special "snapshot view" of reality:

> Unwittingly, amateur snapshooters were revolutionizing mankind's way of seeing. We do not yet realize I think how fundamentally snapshots altered the way people saw one another and the world around them by reshaping our conceptions of what is real and therefore of what is important.... From them we learn what is worth looking for and looking at.... [65]

Kouwenhoven reminds us an important characteristic of all symbolic forms—namely that a process of human *selection* is always involved. In turn, the results of this selection inform us what is worth looking at and therefore what is important. In contrast to popularized and accepted views that photographic images serve us as objective, authentic, "true-to-life" visual accounts of what "is there," we must understand that pictures can never show everything. At best, we say that photographs offer us meditated reconstructions of portions of the visible environment. Snapshots do *not* offer us a documentary account of exactly what the world looked like; collections of snapshots do *not* provide viewers with a magical mirror of the past and present "true" situations. It is more the case that snapshooters and family album makers selectively expose parts of their world to their cameras; or, said differently, snapshooters selectively use their cameras at specific times, in specific places, during specific events and for specific reasons. In subtle and unconscious ways, these glimpses of life are then carefully interwoven and used to construct at patterned view or perspective that visualizes what is valued or preferred, what is correct or right, and what is significantly and positively related to what else. The redundancy within snapshot imagery, created by the patterned use of participants, topics and settings, may thus be understood as a reaffirmation of culturally structured values.

By looking at cultural valves, we begin to see a pattern of generalizeable dimensions. The snapshot rendition is best characterized as an expression of conspicuous success, personal progress, and general happiness. Snapshot collections manifest a pride-filled movement toward adult life. Children and young adults are frequently seen to "play" older, as evidenced in the appearance of many first-time events, achievements, and accomplishments. Images acknowledge that the next step in life has been taken in a proper and successful manner. The snapshot version of life appears to be characterized by outwardly visible evidence of socially accepted and positively valued change. Snapshots celebrate change by visually representing events in life that make a difference—difference in the direction of success and happiness. In this sense, the central theme of the family album echoes a statement frequently repeated by Ronald Reagan when he made television commercials for the General Electric Corporation: "Progress is our most important product."

These images acknowledge a conformity to certain cultural ideals such as living a comfortable life, maintaining a happy growing family, and living in social contexts where people get along with one another. Illness, depression, painful experiences, interpersonal conflicts, personal disappointments, social failures and dreary settings have no place in this construction of life. In this way, snapshots propose answers to such questions as: What is good about life and human existence? How should life be lived, and what should it look like? Which people and what events, places, times merit special attention and repeated articulation? Snapshot makers are devoted to producing a special kind of truth about life, a particular biased view of human existence. Their use of cameras results in one of our photographic versions of life—one of many symbolic renditions that comprise our everyday symbolic environment.

Chapter Five

Tourist Photography: Camera Recreation

By traveling and visiting unfamiliar places in the world, tourist photographers are offered new opportunities to reorganize certain components in shooting events. For instance, tourists often try to photograph people, places, activities, events that are not normally part of their at-home experience. But there are new hazards: any examination of tourist photography provides many instances when camera-using tourists and members of host communities may *not* share the same sets of understandings, expectations, and social conventions regarding pictorial representation. Difficulties can result from the mismatch.

Members of the same culture tacitly come to agree on norms of inclusion and exclusion of picture content, on choices of appropriate and inappropriate camera use. However, in cross-cultural situations— common to many (but not all) tourist shooting events—the same assumptions may *not* be made. Hosts, as on-camera participants, and tourist-guests, as behind-camera participants, may not share the same agreements or norms regarding choices of appropriate settings, topics, activities, and people for photographic representation. Their "natural" inclinations or decision making processes may differ substantially, to the point where social problems occur.

When problems do occur, we are provided with a variety of behavioral examples that amply illustrate how norms for home mode photography may differ across societies and cultures. Our examination and understanding of these problems will be facilitated by a third application of the event/component framework, but one that is much less direct than appeared in the previous two chapters.

Tourism-Photography Relationships

Touristry, vacationing, and amateur photography have paralleled one another since the introduction of mass-produced portable cameras. This correlation is reflected in a variety of contemporary sources and in the earliest camera advertisements. As Susan Sontag noted: "...photography develops in tandem with one of the most characteristic of modern activities: tourism... It seems positively unnatural to travel

for pleasure without taking a camera along... Travel becomes a strategy for accumulating photographs... Most tourists feel compelled to put a camera between themselves and whatever is remarkable they encounter."[1] Another reference comes from Edwin Land: "... I began to sense the role of SX-70 as an explorer of new countries, not geographic countries, but human countries—millions of which exist throughout the world. I began to discern that a tourist in each of these "countries" could find the excitement and wonder and beauty which Goethe found in his trip to Italy."[2] In another context, folklorist Alan Dundes analyzes American folk speech for evidence of the primacy of vision in American culture and the "visual metaphorical mode":

> Consider the nature of American tourist philosophy—sightseeing. To "see the sights" is a common goal of tourists, a goal also reflected in the mania for snapping pictures as permanent records of what was seen. Typical travel boasting consists of inflicting an evening of slide viewing on unwary friends so that they may see what their hosts saw.

> This is surely a strange way of defining tourism... The seeing of many sights is, of course, consistent with a tendency to quantify living, and, specifically, with the desire to get one's money's worth.[3]

It has even been suggested that some tourists pay so much attention to photographing places, sites, etc. that they have to wait until they get their pictures back to see where they've visited.[4]

The camera has been one of the tourist's primary "identity badges" since the turn of the century. Early evidence of this phenomenon was published in *Country Life in America*. Examples include, "Vacation without a Kodak is a vacation without memories... (and) is a vacation wasted. A Kodak doubles the value of every journey and adds to the pleasure, present and future, of every outing. Take a Kodak with you" (June, 1909); "There's more to the vacation when you Kodak. More pleasure at the moment and afterward the added charm of pictures that tell the vacation story" (June, 1908); and "Vacation Days Are Kodak Days. The Kodaker has all the vacation delights that others have—and has pictures besides" (May, 1904).[5] Another early advertisement states: "Picture Ahead, Kodak as you go."[6] One of the first commercially produced 35mm cameras was specifically called "the Tourist Multiple." Invented by Henry Herbert, and patented in 1912, it was available to the public by 1914.[7] And in the first promotional booklets for its No. 3, 4, and 5 Kodak cameras, Eastman gave priority to the following statement when he outlined possible uses of his camera: "*Travellers and Tourists* use it to obtain a picturesque diary of their travels."[8] Thus Eastman was anxious to encourage the tie between being a traveller/

tourist and being a "Kodaker" as he promoted the equation: to travel means to Kodak.

Tourist Photography As A Subject Of Study

While photography and tourism may have developed in tandem as Sontag suggests, systematically organized attention to relationships between travellers, their camera use, and reactions of host populations has remained virtually non-existent. These relationships have seldom been understood as problematic. Recent scholarly books on tourism and tourist behavior by MacCannell (1976), Turner and Ash (1976), and Smith (1977) neglect this topic almost entirely.[9] Even Jafari's comprehensive bibliography[10] of 751 tourism-related studies and publications does not contain a single reference devoted specifically to tourist photography. Guide books on travel photography by Lessere (1966), Birnbaum (1970), and Dennis (1979), give detailed attention to camera technology but tend to ignore the social context of tourist photography.[11] Travel advice columns in amateur photography magazines, such as "Traveler's Camera" (*Popular Photography*), "The Well-Travelled Camera" (*Modern Photography*), and "Shutter Tripper" (*Travel and Camera*), also stress technical problems of camera use, but seldom mention social problems that occasionally result from an inappropriate choice of subject matter.

The implication is that there are certain taken-for-granted assumptions about tourist photography that are rarely questioned.

But what appears initially to be unproblematic develops upon further examination into unanticipated complexity. To expose and clarify salient dimensions of the problem, attention must be given to the following: (1) different kinds of tourists; (2) alternative ways of travelling; (3) different combinations of tourist motivations and expectations with respect to *both* being-a-tourist *and* using a camera; (4) how host populations have reacted to being visited and photographed on a regular basis; and (5) how host communities have imposed specific kinds of restrictions on camera use by tourists.[12]

A second set of considerations involves how photographic imagery has become a part of touristic phenomena. For instance, we know that (1) pictures are produced *for* tourists in both professional and non-professional contexts; (2) pictures are made professionally *about* tourists and places to visit; and (3) pictures are made *by* tourists themselves.[13] The third category is directly relevant to the home mode, because here is where we study the photographic behavior and habits of ordinary

people as they travel in a variety of ways, visit different types of settings, and interact with members of host communities.

Tourists Behind-Cameras

It becomes quickly apparent that many variables are operating when we try to isolate the notion of tourist-photographer as behind-camera participant. The complexity of tourist types and tourist-host relationships is easily overlooked. Though John Forster (1964), Eric Cohen (1972), and Valene Smith (1972) have all noted that significant differences exist between types of tourists.[14] At one extreme of Smith's seven-part scheme, the "explorer" is said to accept readily local norms whereas at the other extreme, the "mass tourist expects Western amenities, and the "charter tourist" demands them.[15]

We also find that several models exist for alternative social contexts of tourist activity. Host-guest relationships vary in conjunction with different sets of needs and expectations. We might logically expect that different kinds of tourists make different kinds of photographs that, in turn, "illustrate" a variety of host-tourist interactions.[16]

Three things are critical to an understanding of photography and tourism: (1) the relationship between certain tourist types and types of photographic behavior and/or contents of photographs; (2) the variable definition of normative behavior surrounding taking photographs in tourist sites, and (3) the variety of reactions exhibited by host community residents to being photographed.

Relating Tourist Type to Photography

Further study may establish patterned relationships between tourist/ type, host/tourist interaction, and particular choices of participants, topics, and settings found in a tourist's collection of photographs. One example of a potential correlation between tourist type and photographs is hinted at when Nelson Graburn discusses "the tourism of the timid"— tourists who travel surrounded by the comforts of their own culture and lifestyle:

Though undoubtedly enchanted by the view of God's handiwork through the pane of the air-conditioned bus or the porthole, they worship "plumbing that works" and "safe" water and food. The connection with the unfamiliar is likely to be purely visual, and filtered through sunglasses and a camera viewfinder.[17]

Much depends on what each type of tourist expects from his/her experience. The notion of expectation is suggested when Smith describes

the nature of tourism in Kotzebue, Alaska, and the average tourist's interest
in seeing the Midnight Sun:

After the dance performance finished at 9:00 P.M., the increased number of tourists strolled
the beachline, at the very hour when hunters returned and butchering commenced. Tourist
expectations were suddenly met—these were the things they came to see, and the pictures
they wanted, of Eskimo doing "Eskimo things."[18]

Regarding the motivations of tourist photographers, it is uncertain
how much they rely on their cameras to document or prove that they
have experienced some degree of authentic native life. Sociologist Dean
MacCannell concludes that "Touristic consciousness is motivated by its
desire for authentic experiences"[19] and that "Sightseers are motivated
by a desire to see life as it is really lived, even to get in with the natives...
"[20] However, many of these sights are staged.

It is uncertain how "staged native realities" satisfy tourists' needs.
Daniel Boorstin feels that the unending production of "pseudo-events"
is well appreciated:

And the tourist demands more and more pseudo-events. The most popular of these must
be easily photographed (plenty of daylight) and inoffensive—suitable for family viewing.
By the mirror-effect law of pseudo-events, they tend to become bland and unsurprising
reproductions of what the image-flooded tourist knew was there all the time. The tourist's
appetite for strangeness thus seems best satisfied when the pictures in his own mind are
verified in some far country.[21]

Edmund Carpenter appears to agree with Boorstin's description of the
tourist's search for pre-determined images:

When they travel, they want to see the Eiffel Tower or Grand Canyon exactly as they
saw them first on posters. An American tourist... does more than see the Eiffel Tower.
He photographs it exactly as he knows it from posters. Better still, he has someone
photograph him in front of it. Back home, that photograph reaffirms his identity within
that scene.[22]

Paul Byers might also adopt the Carpenter-Boorstin position. He notes:
"Our culture provides considerable training in seeing what we already
know in photographs. We tend to use our pictures as experiential
redundancy... [23]

On the other hand, though not referring to photography, MacCannell
is critical of the Boorstin-Carpenter position. He states that "None of
the accounts in my collection support Boorstin's contention that tourists
want superficial contrived experiences. Rather, tourists demand
authenticity, just as Boorstin does."[24]

Given a current lack of systematic research, generalizations regarding motivations of *all* kinds of tourists, travelers, and sightseers are for the most part unfounded. It may be that different kinds of tourists, as suggested by Forster, Cohen, and Smith, have different sets of motivations, expectations and thresholds of satisfaction and fulfillment. Furthermore, it is likely that they tend to photograph and document their "authentic" experiences in different ways. Thus MacCannell's and Boorstin's observations may both be correct, though they each refer to a different type of tourist. We must expect to find different patterns of photographic norms characteristic of different tourist-host interaction.

The Tourist Photographer's Freedom To "Shoot"

Acknowledging that tourists are fond of taking photographs, and that cameras serve as identity badges, raises many related questions. Sociologist Howard Becker has noted that in many situations (such as tourism) "carrying a camera validates your right to be there."[25] Sontag has observed: "The camera is a kind of passport that annihilates moral boundaries and social inhibitions, freeing the photographer from any responsibility toward the people photographed. The whole point of photographing people is that you are not intervening in their lives, only visiting them. The photographer is supertourist... "[26] However, the assumption that tourists are...allowed—possibly expected—to photograph *anything* and *everything* in sight requires closer attention to the social license accorded tourist photographers.

A remarkable generalization like Sontag's begs a critical examination of underlying issues. We are led back to our earlier commentary regarding the kinds of freedoms and restrictions that regulate what *can* and *can not* be photographed versus what *is* or *is not* photographed. Admittedly, regarding the hypothetical freedom of camera use, enthusiasm for taking pictures does approximate, at times, a policy of "shoot-now-and-answer-questions-later." This strategy seems to be adopted from photojournalists who are paid to get certain images at all costs. Leon Gersten notes:

Like many other writer-photographers, I used to live by three rules when I was traveling with my camera: (1) Always carry a fully loaded camera. (2) Take pictures of everything possible. (3) Never let anyone or anything stand in the way of getting a "good" shot because it is every photographer's God-given right to photograph everything when and where he or she wishes.[27]

The question for our purposes involves the social implications of this strategy when used by ordinary tourists visiting and photographing communities of unknown people.

Advice columns and photography guides generally perpetuate the travel photographer's right to use a camera without much restriction. Photographing unknown people, as on-camera participants, is spoken of as a challenge to be conquered. In an article entitled "Putting Poetry into Travel Snapshots," we read:

> For subjects that do not want to be photographed, or for the sheer pleasure of taking candid pictures, wear the camera around your neck with a long cable release (36 to 48 inches). You can fire away with impunity and most of your subjects will never be aware that they have been photographed. Framing is done by pointing your body in the direction of the person you are photographing and pressing the shutter release. Street noises will cover the sound.[28]

Other advice helps tourist photographers break their "psychological" blocks and inhibitions when shooting members of host communities:

> Even those who accept the necessity of moving in close are often reluctant to do so because they are afraid that the subject will be offended due to a transgression of some cultural or religious taboo. Or because they are concerned that they will be intruding on the person's privacy. Or, they may be worried that their attempts will be misunderstood and will make the subject angry or even violent.

> These are all common feelings, yet our experience has been that most people are pleased and flattered when approached to have their picture taken. Some even ask to be photographed. Even if you encounter resistance, don't always take no for an answer.[29]

In one article on moviemaking entitled "Shooting on the Run: How To Make A Vacation Film," author Janet Kealy states: "To raise your film above the snapshot level... study the people, and shoot everything that interests you... and don't be bullied by or intimidated by passersby. It's your vacation and your film... what you shoot is what you get."[30]

These accounts suggest a strategy for studying the patterned qualities of tourist photographic behavior. For instance, one might begin by examining kinds of restrictions, if any, put on tourists using their cameras. What kinds of activities, topics, settings, are "out of bounds"? Who imposed these restrictions? Why do they exist? How is such information about specific restricted subject matter or "views" made available to tourists? What formal and/or informal punishments exist for violating restriction. How seriously are they enforced and by whom?

Preliminary findings indicate that when formal restrictions exist, written information regarding them is hard to find. Literature from travel agents or embassies, or information from tour guide books is rare. Kodak publishes a series of pamphlets on picturetaking in 17 popular tourist sites, but they are primarily prescriptive—citing only appropriate views.

Social problems related to restricted subject matter in tourist sites are seldom mentioned.

One noticeable exception appears in the *Travel Photography* edition of the Time-Life Series on photography (1972). Entitled "Rules and Regulations in Foreign Lands," this article lists either "forbidden," or "permit required," or "no limit" on certain categories of subject matter such as (1) military and border areas, (2) airports, seaports, railroad stations, (3) views from commercial planes, (4) views from private planes, and (5) other restricted subjects:

The most common restrictions involve subject matter. As might be expected, almost every country (including the United States) prohibits indiscriminate photographing of its military sites, and many limit taking pictures from private planes. But some countries have taboos that are not so predictable. The Dominican Republic, which is sensitive about poverty, prohibits photographing slums and beggars; Haiti, at the other end of the same island, says nothing about the poor but frowns on taking pictures of the National Palace. Switzerland bans all photographs of the interiors of its celebrated banks. Iceland forbids taking pictures of four endangered species of birds (so they will not be frightened away from their mating and nesting areas). In Argentina and France the taboo involves cemeteries (evidently a matter of respecting the privacy of the dead); China, entrances to the Peking subway (because the subways also serve as bomb shelters).[32]

A tourist photographer may shoot scenes in foreign lands that he or she would never photograph at home. In one example, an American tourist in Heraklion, Crete, attempted to photograph his wife while she exchanged a traveler's check in the Bank of Greece.[33] In comparison, a bank transaction in one's home town would never be considered an appropriate topic for a snapshot. Apparently, the away-from-home context rearranges the framework for what people feel is appropriate behind-camera behavior. A different selection of settings and topics is introduced as a result of adopting the revised social license that tourists use when leaving home. Photographers make different decisions about what they "should" be allowed to do. It is undoubtably the case that many other instances of similar "violations" of local and/or national norms have occurred with varying degrees of negative sanctions and explicit punishments. To get a perspective on this, it is interesting to observe foreign tourists coming to parts of the United States and taking their liberties when photographing examples of *our* "native" life.[34]

Hosts As On-Camera Participants: Unanticipated Reactions

In most home mode photography, requesting that someone pose for a picture is generally unproblematic. Only certain people are asked, and the motives for the invitation are tacitly understood, accepted, and nearly always welcomed. However in much of tourist photography,

members of host communities are not known personally; photographers cannot always be sure of approval, enthusiasm or even consent. A growing number of reports indicate a variety of negative reactions to tourists' unrestricted camera use.

It becomes possible to develop a notion of "image sensitivity." Consider the following four examples from Alaska, Peru, Pennsylvania, and New Mexico, respectively.

...the many Eskimo passengers aboard airplanes that included tour parties overheard the departing visitors brag about the "pictures I got," and interpreted the remarks as ridicule, which cuts deep into native ethos. In response, Eskimo women began to refuse would-be-tourist photographers, then erected barricades to shield their work from tourist eyes....[35]

Latin American Indians and the rest of the mixed urban proletarian population are wary of tourists taking photographs of them; they feel cheated and used because they never see the end result of the action of the prowler with the camera.[36]

One of the major objections of the Amish people to tourism is the snapping of photographs. In the word of one young Amishman, "I just don't enjoy living in a museum or a zoo, whatever you would call it." According to another, "They invade your privacy. They are a nuisance when I got to town, for I can't go to any public place without being confronted by tourists who ask dumb questions and take pictures."[37]

Just because a funeral is being held in a foreign country does not make it a tourist's holiday. I used to wonder why the Indians in the American Southwest had closed so many photographic treasure areas to visitors until I saw a funeral disrupted by picture-snapping tourists at Taos Pueblo. The tourists were so insensitive they thought it was a ceremony being staged for their entertainment.[38]

Clearly, not all people in the world feel the same way about either being photographed or seeing themselves in photographs. It appears, however, that no one has attempted to examine systematically the behavioral variability and cultural constraints involved.

People who avoid outsiders' cameras may do so for different reasons. In one report from Guatemala:

In remote areas, people will often flee if a tourist's camera is aimed at them. Mothers will hide their children behind billowing skirts or cover their heads with shawls and chivy them out of sight like hens herding chickens from a hawk. Often men will made the sign of the cross and shout imprecations as they scurry out of sight.[39]

Another instance of a camera related disturbance in Turkey:

...I found that a camera can be a blasphemous assault against the sensibilities of a culture. In Turkey, for example, signs clearly spell out the ban on photographing women (a Moslem proscription against graven images). But how can one pass these exotic phantoms, bodies fully clothed and heads covered, without sneaking at least one shot?...

I waited at what I thought was a respectable distance to snap a brilliantly clad woman in a purdah, but it turned out the distance was still not great enough. The lady-in-focus heard the click and began to shriek. Soon people from all directions converged on the scene, clamoring in Turkish. The indignant woman pointed at me. As I rapidly retreated through a narrow passageway I felt like a rustler being pursued by a posse. Luckily I finally lost the thumping feet behind me. It was a truly great shot, but I paid for it in panic and in a near heart attack. In the future, I decided I'd be more deferential.[40]

From Peru:

Every culture varies in the degree to which it is camera shy. In Peru, the Indian women turn away when you aim the camera at them... No one knows what the tourist with the camera will do with one's image. Maybe when he gets back home, he will laugh at it, use if for darts, or as a stimulus for bizarre sexual experiments.[41]

From Indochina:

Once while I was taking pictures of a Chinese shopkeeper and his wife in Djakarta, their daughter suddenly stepped in to be photographed between them. Instantly, the mother flew out of the picture. "No! No!" she protested. "If you photograph three people together, one of them will die!"[42]

And, finally another example from Yugoslavia:

In Yugoslavia I once passed some peasant women doing their laundry in a stream by rubbing their wash against a stone. The sight was remarkable and the distance perfect so I reversed the car to come alongside the toiling women. I had just enough time to prop the camera firmly against the car window when they saw me aiming at them with my telephoto lens. They waved their arms at me frantically, but I stepped audaciously out of the car, and waited for them to lift their heads and continue with their washing. Tensely I snapped the shutter when they looked up. What a picture!

But what a reaction! With no warning, the three irate women tore at me with hate in their eyes, eager to snatch the camera that had invaded their privacy. As I dashed into the car to escape, sodden garments smacked hard against the rear window. Through my side-view mirror, I could see them clenching their fists. I could also hear them shouting their Serbo-Croatian curses.[43]

Other examples of image sensitivity may have more to do with protection and personal safety of particular members of the host community. As suggested in a *Life* article, policemen and military personnel are poor choices of on-camera participants in particular "delicate" situations:

To the Editor:

While vacationing in Altea, a small beach resort on the east coast of Spain, I thought to include a policeman in my snapshot of the colorful market scene. It was his shiny black hat that caught my eye.

Well, no sooner had I clicked my Instamatic than I was in a very angry confrontation with the policeman.

His insistence that I remove the film from my camera and smash the roll seemed a totally ridiculous request. "But I am an American tourist," I kept insisting, thinking that was the magic phrase.

Eventually, I watched quietly as he destroyed my film; it seemed better than facing the Spanish judicial system.

Later I heard that these particular policemen, once Franco's elite guards, are the prime targets of the Basque revolutionaries. Many have been the victims of assassins and, of course, do not want their photos taken by anyone.... [44]

Angry reactions may also result from situations in which a tourist adopts an inappropriate shooting strategy:

Perceiving people's fear of the camera also suggested using the more distant telephoto lens. While the telephoto made snooping easier, when the lens was noticed it elicited response number two; anger. Shooting into a poor district from the Duarte bridge in Santo Domingo, I caught a leisurely conversation between an attractive woman and a uniformed military policeman. She noticed me, and shortly afterwards the policeman was pointing his rifle at me and demanding the film. I still wonder if he was protecting the bridge, protecting her honor, or preserving his job. I earned my marks in Spanish that day by retaining both my life and the film. [45]

In a newspaper article that offers advice to travelers who might be caught in the middle of a military coup, Ralph Blumenthal notes: "Many Third World and Communist nations are also extremely sensitive about photography near any installation deemed of military importance. A hapless visitor to Ghana—where signs banned picture-taking at the airport—snapped a photo of his wife disembarking their plane—and was beaten by the police. "Tourists should not think they're at Buckingham Palace," Alan Riding, a Times correspondent in Latin America says. "Do not take pictures of soldiers." [46] The cultural context is very significant; photographing the soldier-guards at Buckingham Palace or the Royal Canadian Mounted Police is enthusiastically encouraged, whereas photographing soldiers during a coup could be fatal.

Insight into some of these examples is gained by employing an analysis of social interaction. Central to any kind of interaction is a notion of *exchange*. Considering the relationship of tourist photographers and native subjects, social psychologist Stanley Milgram suggests the following:

The photographing act is best seen as an exchange when we photograph other people... A photographer *takes* a picture... A tourist travels to a foreign country, sees a peasant in the field, and takes his picture. I find it hard to understand wherein the photographer derives the right to keep for his own purposes the image of the peasant's face. "Give it back," the peasant might cry, "it's my face not yours."[47]

An account of attempting to create a more just exchange is furnished by a tourist who created an experiment to "make friends and bring about personal encounters."

On previous trips abroad, armed with our movie and slide cameras, we often found that people turned away—or worse, ran away—from us. That didn't happen during our recent journey to Peru, when we added a Polaroid camera to our equipment and gave prints to our subjects on the spot... So willing were some would-be subjects that they offered to pay us to take a picture of them...no longer simply "tourista" customers, we had become the producers of a very marketable product.[48]

In some cases, money-for-photographs becomes important. For instance in a report from Marrakesh, Morocco:

We move along, A man sits with pale doves wandering among little vases of pale plastic flowers. "They are holy birds," he says. I give him a coin and shoot. A little boy comes along with a trained monkey not much smaller than he is. He makes it do a back flip. I shoot and give him a coin. Ten men in white are beating drums and jumping up and down while twirling the tassels of their skull caps. I shoot and hand out coins.

I photograph a man kissing his cobra and letting it crawl over his eyes. Then I find a medicine man sitting among little boxes of herbs and take more pictures just as the urchins descend on me again. One holds his hand over the lens and says I can't shoot until I pay him.[49]

However, the assumption that all people want to either see or have pictures of themselves should always be questioned. The relationship of people appearing in pictures and people looking at pictures must be treated as problematic.

We cannot assume that all people want to see themselves in pictures. We have to learn what they like to see. In some cultures pictures of people who have died turn the audience away. In a north India village wives are in purdah to protect themselves from outsiders. A husband would become very angry if you showed pictures of his wife to men outside the family. Even though village girls are permitted to dance outside the home on festival occasions, village elders would not like pictures of their daughters dancing shown in the public. Nice girls do not dance in public.[50]

Image Accommodations

It would seem fruitful to examine arrangements developed by host communities to accommodate increased demands for photographic images. Patterns of "image accommodation" or "image adaptation" have developed that attempt to satisfy both host and camera-using guest. A

host community can say, in either a formal or informal manner, "Absolutely No Photography Allowed" or "Photograph Anything"— but it appears that neither extreme occurs with any significant frequency. (However, a rare instance of extreme restriction comes from Staphurst, the Netherlands. Jules Farber reported that "a tourist clicking in this village is asking for trouble. In Staphurst, picture-taking is against the law, and a sign in front of the City Hall makes this clear in four languages—Dutch, German, English and French."[51]) In other instances, a country or community may require purchase of camera permits, licenses, or other forms of permission, but complete prohibition is rare. In a 1979 study done in Chiapas, Mexico, Bruno and Tiefenbacher reported that community members have placed a sign at the entrance to Zinacantan center, stating. "IT IS STRICTLY FORBIDDEN TO TAKE PHOTOS WITHOUT PERMISSION."[52]

One type of reaction to curbing or controlling the tourist's camera has been the government-sanctioned appearance of a new, iconographic "no photography" sign in various parts of the community, on specific buildings, and "protected" areas. Similar to a "No Passing" traffic sign, the "no photography" sign has a large black X drawn over the outline of a camera. Photographer Lawrence Salzmann remarked on the significance of these signs in Rumania:

Rumania offers the visiting photographer a variety of landscapes and people to photograph . . . The Rumanian people are among the world's friendliest and photographers are made quite welcome. Care should be taken, though, not to photograph any factories, men in uniform, railroads, airports, and wherever you see the [no photographs] sign.[53]

It appears that most tourist communities or sites at least implicitly encourage *some* form of photography. In most instances, for the tourist without a camera, or with a broken camera, local entrepreneurs will provide and sell a variety of professionally-produced pictures. Common examples are postcards and travel brochures in which outsiders are provided with preferred views of the host setting:

Egypt, for instance, has produced a crop of stories about tourists arrested for photographing Cairo bridges which are on all the tourist postcards. Again, they are sensitive about possible attacks on the Aswan Dam . . .
Tourists would be asked to leave their cameras behind them in their hotels when visiting this attraction, despite the fact that the lobbies were filled with brochures bursting with pictures of the dam.[54]

Other types of image accommodation may include the production and sale of slides, prints, and films. One example is offered by a tourist visiting the archaeological sites in Xian, China:

To the Editor:

...When visiting Xian last year, I, too, was disappointed in not being able to photograph the splendid excavation site. Indeed, the Chinese were so persistent about banning photographs that cameras were collected at the entrance and guides quietly patrolled the elevated walkway to enforce the "No Photo" signs.

Upon leaving the pit and retrieving my cameras, I was told that appropriate slides were available in the shop adjacent to the excavations. But, oh the price! In order to purchase one set of slides the 50 members of my tour group had to take up a collection. A clever fellow then took "his" slides home to America for duplication. All contributors thus received a selection of the photographs at a fraction of the price asked by the Chinese.[55]

Moreover host communities may help the tourist take "preferred views."...For instance, in parts of France, road signs indicate locations of "la belle vue" or "un vue unique" which specify a place to stop your car; instructions are given in three languages to ensure proper exposure. Similar examples are also found at picturesque canyons in the southwestern United States.[56] Carl Mydans mentions another way of assisting tourist photographers. Writing an advice article for the Time-Life series on photography, he relates an example of literal image substitution in which preferred views replaced inappropriate ones:

...one foreigner who was recently allowed to travel to North Korea tells the following story: accompanied by a guide, he took some pictures of a slum in Pyong-yang and left the exposed film cartridge in his room. After he returned home and had the film developed, he found that his exposed roll had been replaced with another. This one showed nothing but monuments.[57]

Other strategies of accommodation involve capitalizing on tourists' desire for photographs of native life or environment. Indigenous cameramen for instance may be available to photograph tourists as they visit particular sites. These "image vendors" have determined preferred views and proceed to make a living by satisfying tourists' requests for photographic souvenirs. There is, for example, a photographer at Lands End in Cornwall, England, who will take your pictures standing next to a sign that points west to your home town, and reads, "Chicago— 4723 miles." An example of the sometimes amazing efficiency of these operations was found in the Aegean Sea:

Tourists ferried from their cruise ship to a sea level quay are carried on muleback to the city of Santorini, high atop the towering cliffs. A never-ending mule train climbs a zig-zag road of 655 numbered steps, each set some five feet apart, to gain a plateau several feet above. A native photographer, armed with an antique bellows camera on a wooden tripod, clicks his shutter at each rider arriving near the top steps in a flurry of quick-plate-change magic. Processing techniques are also perfected to match machine

speeds, witnessed by the presentation of a fully developed black-and-white, 5 x 7-inch size print to each traveler reaching the end of the ride, priced $1.00 at 1975 exchange rates. One is led to suspect some outdoor dumbwaiter transport arrangement between the camera man and his cliff-top lab.[58]

Members of the host community may sometimes seek financial rewards for appearing in the pictures. For instance, Ximena Bunster B. writes in *Children Who Work*:

Life in the Sierra is hard and the economic options for women very few. The tourist trade offers poor women and children the possibility of cashing in on a native image. Attired in Indian dress they pose for tourists against the background of ancient temples, ruins and beautiful landscapes.

In one interview, a girl named Rosila says:

I earn about 10 "soles" each day helping tourists. I show them the ruins of Puca Pucara and I sit or stand still with my Llama who's called Martina so they can take photos of the two of us. Sometimes they pay me, sometimes they don't[59]

The ideal pattern of response appears to be to encourage use of tourists' cameras but on terms explicitly dictated by the host community. The host community attempts to regain a sense of private life out of camera range while it simultaneously provides visitors with appropriate, expected, and "authentic scenes" of local environment, of local indigenous architecture or of local native behavior. An example of such fabrication comes from Africa:

The thoughtless curiosity of some tourists in Africa, where travelers often insist on photographing the most primitive appearing people—not necessarily the most representative subjects—has forced at least one government there to consider desperate measures. An advisor to the tourist industry has proposed artificial villages complete with colorful but acceptable sophisticated "villagers" to pose for pictures. "It may be fake" he says, "but it's a lot less aggravation on both sides."[60]

Anthropologist Valene Smith discusses "model cultures" as one strategy of adaption to the disruptive effects of increased tourism: "Models appear to meet the ethnic expectations of tourists, as a reconstruction of the lifestyle they hoped to see, that also accords to them the freedom to wander and to photograph at will."[61] For instance, when Max Stanton describes the Polynesian Cultural Center, he remarks: "The visitor can briefly participate in a simple dance in the Samoan village, look over the shoulder of a person making *Tapa* in the Tonga area, and is encouraged to take pictures of Polynesians in Polynesian settings."[62] Examples in the United States include a mocked-up display chocolate factory built for tourists in Hershey, Pennsylvania; and "authentic"

restorations of Amish Villages and old covered bridges in Lancaster County, Pennsylvania.[63] In these cases, photographers are kept away from the "real thing" and offered artifacts of "fabricated authenticity" for photographic consumption.

Examples derive from tourists' need to find, witness, and photograph "local color." Davydd Greenwood describes local color as "the promotion of a commoditized version of local culture... "[64] Fabricated behavior organized for the camera includes staged voodoo ceremonies, re-enactments of great battles; "typical dances" performed by Native Americans and gypsies are also cited. Daniel Boorstin notes that the "sight-seeing items" cannot be "the real ritual or the real festival; that was never originally planned for the tourists. Like the hula dances now staged for photographer-tourists in Hawaii (courtesy of the Eastman Kodak Company), the widely appearing tourist attractions are apt to be those especially made for tourist consumption."[65]

In general, host communities seem to be taking a more active role in determining the content of the tourist's photographs. In these examples of fabricated scenery and image substitution, the natives seek stronger regulation of the host-tourist relationship not by eliminating the tourist's interest and revenues (by totally restricting camera use) but by allowing restricted use, simultaneously establishing a sense of relative privacy for themselves.

Conclusions

The foregoing remarks are not presented as a critical warning or moralistic statement regarding inconsiderate behavior by camera-carrying tourists. While it is tempting to recite a polemic regarding the evils of "the ugly tourist-photographer" or "vulgar tourism" in general we should not let ourselves become too subjective about these matters. Instead, our attempt has been to amplify, extend, and illustrate new objective uses of the event/component framework by including inter-cultural examples of host-tourist interaction. Needless to say, most of the questions suggested in these pages require much additional investigation, and many alternative conclusions should be considered.

Observations cited in this chapter have been selected to illustrate three relationships of photography and touristic phenomena. However, readers might be lead to three unfounded conclusions. First, we do not imply here that all tourists use cameras without any sense of social or personal regard for their subject matter. It is true that much tourist photography is done with little or no explicit information of local restrictions or knowledge of locally defined norms regarding appropriate

camera use. But these norms do exist. When this information is held in the oral tradition and maintained by local sentiment, social conflict may develop if the naive tourist photographer attempts to capture a set of "authentic" views of native life. The point is not that tourists and/or hosts have no social or personal regard for their subject, but that tourists and hosts may be exercising conflicting ethnocentric judgments when attempting to define appropriate camera use.

Secondly, we do not conclude that all tourists are unaware that what they photograph has a problematic relationship to "the real thing." The quest for authenticity may be relative: that is, tourist photographers are willing to suspend temporarily their knowledge that pictures they take are images that have been arranged, selected, sanctioned, and maintained by members of the host community and tourism professionals. Behavior may be directed more by a sense of "doing what tourists do," and that whatever is there, is real (or real enough) which, in turn, may mean that it is convenient enough for camera recording.

And third, it would be incorrect to claim that increased numbers of camera using tourists will function as the *primary* change agent in an accelerated process of culture modification, adaptation, or acculturation. The observation that many societies are undergoing increased touristic visitation *is* significant; the fact that most visitors carry and use cameras is important with respect to how natives/hosts feel about "being looked at" with or without still and motion picture cameras; in this sense, the use of cameras must be considered as a *contributing* agent to behavioral modification and social change.

The general questions of what tourists are "doing" when they take photographs—and what their pictures "do" for them after the trip—deserves additional attention for several reasons. If, as Dean MacCannell suggests, "sightseeing is a ritual performed to the differentiations of society,"[66] then how do tourist snapshots and travel movies serve to develop and maintain a celebration of differentiation?

On the other hand, MacCannell also suggests that tourism and sightseeing represent "a way of attempting to overcome the discontinuity of modernity, of incorporating its fragments into unified experience."[67] Again, we must ask if and how cameras and photographs function to develop a unified and integrated perspective on the world and its varied human conditions. While MacCannell's book ignores tourist photography, his answer to this question is suggested in the following comment: "The act of sightseeing is a kind of involvement with social appearances that helps the person to construct totalities from his disparate experiences. Thus, his life and his society can appear to him as an orderly

series of formal representations, like snapshots in a family album."[68]
The reference to Kodak culture is certainly appreciated and totally
appropriate. Millions of travel photograph albums and slide trays full
of Kodachrome transparencies fulfill this dual function of social
differentiation and incorporation.

Several trends appear to indicate stronger indigenous participation
in imagemaking and more control over what gets looked at and/or
photographed, and over what is subsequently shown to "people-at-
home." It is undoubtedly the case that peoples from all regions of the
world will begin to produce and continue to produce their own kind
of photographic imagery—pictures for themselves and for consumption
by visiting tourists. We are just beginning to learn about these activities
from such observers as Salzmann in Rumania (1976),[69] Cranz in China
(1978),[70] Sprague in West Africa (1978),[71] Neal in Guatemala (1975),[72]
and Tisa in Bengal or Bangladesh (1980).[73] The tourist photographer's
rendition will be balanced by indigenous visual reports of the society.
As the title of Tisa's article states: Bengali "Photographers have begun
to interpret their culture for themselves."

In parallel developments, tourists may find an increased freedom
to photograph—but on the native's terms. MacCannell has drawn
attention to the creation of "a series of special spaces designed to
accommodate tourists and to support their belief in the authenticity of
their experiences."[74] This can be interpreted in two ways: (1) as the creation
of staged back regions that keep tourists away from "real" back regions
that must remain private and inaccessible to the cameras of all outsiders;
or (2) as the production of "phoney folk culture" as suggested by John
Forster.[75] In either or both instances, fabricated presentations of native
culture are developed for tourist consumption.

Staging can convert or transform aspects of native life and culture
into photographic symbolic form—a "front" that meets the requirements
of easy camera recording. These re-presentations of native life may
conform to a homogeneous, stereotypic view of "others" that conveniently
and ethnocentrically matches the predetermined criterion of "otherness."
In other words, the concept "tourist" implies that there are also non-
tourists, or "others" who, in turn, are often stereotyped as "natives."

We may be witnessing a series of uncritically managed collusions
between native populations, "culture brokers," and tourist photographers
in the production of satisfactory images—"satisfactory," of course, to
the eyes and minds of the tourist. It will be interesting to see if and
how native populations seek more control over this phenomenon, in
an effort to present themselves in critically managed ways that satisfy

their own tastes and preferred images. Just as some art historians have discovered the deliberate transformation of indigenous art into hybrid forms that satisfy values, motives, perceptions, and aesthetics of Western art markets, we may now be seeing manipulation and re-creation of native life for the sake of tourists' photographic recreation.

Chapter Six

Interpreting Home Mode Imagery:
Conventions For Reconstructing A Reality

Introduction

What do ordinary people "do with" their personal pictures, and, in turn, what does this imagery "do for" ordinary people? "Doing with" implies a study of what ordinary people physically "do with" their pictures—how people organize their images for various exhibitions[1] and, secondly, how they organize themselves for showing off their pictures and, indeed, themselves. But we are also interested in what people *mentally* "do with" photographs. We want to examine the native logic that people apply to pictures in order to make appropriate, agreed upon, and satisfactory interpretations[2] of what is being looked at. We are investigating the roles played by photographers and viewers in an on-going constructive scheme of interpretation.

The "do with" dimension is inextricably woven to the "do for" dimension. What people get out of their images is closely tied to what the entire home mode enterprise psychologically does for participants. This, in turn, calls for an investigation of social and psychological functions of home mode communication (the subject of Chapter Seven).

Questions developed in these chapters are seen as surprisingly complicated because our culture does not treat the interpretation and use of most pictures as problematic. Home mode imagery is not expected to do much more than "document" or make copies of life experiences. But here we must unfortunately complicate the picture before we can accurately understand the full complexity of what we conceptually and socially do with home mode imagery.[3]

Any study of communication must attend to human involvement in both sides of the message form—production of the message and reception of the message, however it may be described—as encoding and decoding, as creation and re-creation, as production and reception, as construction and reconstruction, as articulation and interpretation. The general question posed in this chapter is how ordinary people interpret or reconstruct the rendition of life that is repeatedly presented in home imagery.

Interpreting Home Mode Imagery

The general question of how pictures are interpreted is complicated by factors that are unacknowledged by most people. Here we may profitably reintroduce Sol Worth's concern with an ethnographic semiotics which explores "how actual people make meaning of their symbolic universe. How they learn to make meaning... [in spite of the fact that] we do not think clearly of ourselves as humans who have to interpret symbolic articulation—signs and codes of our culture."[4] The important point is that for much of what we have described as Kodak culture, we just go ahead and do it as unproblematic "natural" behavior.

One way of approaching the relation of meaning and interpretive strategy is to draw upon a notion of communicative discourse. Again, we want to stress a perspective offered by sociolinguistics (rather than uncritically adopt terms from descriptive and structural linguistics). As described by Allan Sekula, photographic discourse is

an arena of information exchange, that is a system of relations between parties engaged in communicative activity.... The discourse is, in the most general sense, the context of the utterance, the conditions that constrain and support its meaning, that determine its semantic target.... A photographic discourse is a system within which the culture harnesses photographs to various representational tasks.[5]

Attention to communication context, culture, and the implication of multiple-image discourse is particularly useful for our purposes. The question becomes, "what kind of photographic and filmic discourse is central to home mode communication?"

Sekula goes on to develop a scheme of folklore, which includes a distinction between "symbolist" folk-myths versus "realist" folk-myths. In the latter, the photographer is conceived of as witness, and photography is primarily reportage; photography is grounded in theories of empirical truth, informative value, and finally metonymic significance.[6] In this realist perspective, photographic images come very close to copying reality and "standing for" the things, people, place that appear in pictures. The realist folk-myth is central to forms of "documentary" photography.

Sol Worth also attempts to contextualize the popular adherence to a "realist" semiotic paradigm as follows:

I believe that it was from the use to which archaeologists put photographs that cultural anthropology, sociology and now mass television and film developed the first—and still extremely important—semiotic paradigm about the use of pictures: that the purpose of taking pictures was to show *the truth* about whatever it was the picture purported to be of; an arrowhead, a potsherd, a house, a person, a dance, a ceremony, a war or any other behavior that people could perform, and cameras record.[7]

Worth is quite correct when he claims that the evidentiary quality of the photographic or filmic image is still extremely important and commonly used.[8] The on-going production, use, interpretation, and "authority" of home mode imagery is firmly based in this realist semiotic paradigm and in the realist folk-myth.

In the home mode, the "representational task" is literally just that— one of re-presenting, re-creating unmediated copies of the real world. Home mode imagery represents the bastion of the classical film theory which exalts the reproduction of "ontological reality."[9] Credence is given to the camera's ability to reproduce reality exactly "as things were" without undue attention to artifice. Viewers may believe that the "medium itself is considered transparent. The propositions carried through the medium are unbiased and therefore true."[10] While viewers do not confuse the actual photograph, slide, movie, or videotape for the real life objects and people they represent, viewers are willing to consider the images as completely accurate and true representations of what is shown. To think of these images in any other way would cause too much concern, confusion, and unwanted doubt for ordinary people regarding what they were actually looking at.[11]

To illustrate some of the potential confusions implied by Worth and Sekula, let us briefly examine several semantic problems with the commonly used question "What does this picture (home mode image) say?" Three problems with this choice of words should come to mind: 1) the question of pictures "saying" things; 2) to whom is the picture saying something?; and 3) under what circumstances is a particular picture being shown and viewed?

Our response to the first question could produce the paradox that a) pictures don't "say" anything at all, and b) pictures "say" many things. In the first case it is clear that a literal interpretation of "say" is wrong on two counts; pictures can't speak, as in say-out-loud, or even whisper. Not only can pictures not say ain't, as Worth suggests,[12] but pictures can't say anything.

Do we use the term "say" simply to avoid knowing more about the process of pictorial communication?[13] The form of the picture as such is just that—an inarticulate form. Pictures don't "say" anything; actual people use their eyes first, brains second, minds third, and vocal apparatus fourth to say something *about* pictures. In this sense, and only this sense, do pictures metaphorically make statements. To counteract these unfortunate semantics we must continually remind ourselves that individual *people* make interpretations of and statements

about, pictures they see. Viewers do the saying, *not* the pictures. We are studying human capacities and competencies to make meaning and not merely with arrangements of silver salt particles on paper or acetate base. The common statement that pictures "say" something is shorthand for a social process.

The second and related point is that the same picture may "say" different things (read, may be interpreted in different ways) to the same person or to different people. A particularly relevant example: when a husband and wife looked at the same snapshot of a man standing cross-armed in front of a parked car, the wife said, "Here's a picture I posed of Sam with a hair cut." The husband, on the other hand, said, "This is a picture of our new car."[14] When children and parents look at the same album snapshots, interpretations are also often quite different.

Nor should we assume that individual viewers will hold a fixed set of meanings through time. While dimensions of a particular interpretive strategy remain stable, details of meaning construction may change. In a letter written in 1832 from a father to his son, we read:

I think again of the treasured miniature of my mother...for no doubt I contemplate this picture with very different eyes from those with which I beheld it as a young soldier. Its meanings shifted radically on the day of my mother's death... and no doubt there will be other changes, though perhaps not so radical in effect, in the remaining years of my life. When this miniature becomes your own, it must have yet another meaning than it has for me, or than it has for you now. Hence, though we succeed in permanently fixing views from nature, we cannot hope to fix the mind that observes them.[15]

Such examples conform nicely to the theory that pictures—as all symbolic forms—are "multi-vocalic" (Turner, Sebeok) or "polysemic" (Barthes): they "say" many things. The polysemic quality of images makes sense on two counts. First, the same picture viewed by the same person can be construed or interpreted in a variety of ways, (suggesting a potential hierarchy of meaning constructs). Second, the same picture viewed by different people may provoke different meanings. Individual viewers bring a lifetime of individual viewing experience and interaction with visual forms to a specific exhibition/viewing event. Previous experience has produced a repertoire of viewing and interpretive conventions—a point that is frequently overlooked in theoretical discussions of how pictorial communication works.

With this potential heterogeneity and subsequent confusions in mind, we must ask about the forces that operated to collapse and thus limit the potential diversity of possible interpretations to a shared set of meanings as different viewers interpret the same picture. In an attempt to clarify this perspective further, attention must also be given to knowing

who is making a particular interpretation and, in turn, his/her relationship to a particular image.

The viewer may be within a group, or outside it. The two perspectives are frequently interchanged. In one case, we discuss the meanings accorded to a snapshot or home movie by members of a specific home mode community of participants; in other cases, statements of meaning may be generated by people outside a particular home mode community or by some unnamed, impersonal, or make-believe viewer. Different kinds of membership and different points of reference produce different interpretive statements (see Chapter Nine for additional comment).

The communications context must be kept in mind. Snapshots, home movies, and home videotapes are personal documents, and, as such, are meaningful to small groups of people who generally "know what's going on." Overlooking this point produces the following kind of statement: "One essential feature of the snapshot, I think, is the anonymity of the persons photographed."[16] But everyone studied for this report could identify the majority of people appearing in their snapshot collection.[17] Anonymity is the exception and not the rule: why *should* ordinary people keep, treasure, and revere personal pictures of people they can't identify?[18] (In fairness to the author of the last quotation, she goes on to make an important remark: "If we know who they are, they become a part of our experience—of our family, so to speak—and we can never disentangle them from our built in reactions to them."[19] Cognitive and social processes are thus integrated in interpretation and construction of meaning).

The important point is that when strangers look at home mode imagery, or when snapshots or home movies are shown in non-home mode contexts, the images are subjected to a variety of interpretive schemes, to various standards of value (see Chapter Eight). For instance, consider the anonymity issue once again:

The very anonymity of the collection of American types which parade through these amateur snapshots is, to me at least, an asset. Mother, Father, The Kids, The Clown; they are all here, caught in the act by that great social force that George Eastman of Rochester created in the 1880s.[20]

Identification and relationship of the viewer to the imagery are important at every turn. Outsiders do not have the types of knowledge or information needed and expected to make appropriate home mode interpretations of "what's going on." The "anonymity" is apparent only to the outsider.

But what can be said of "insiders?" That is, what happens when a person looks at his/her own collection of personal imagery?[21] What is the structure of the interpretive strategy that is unconsciously operationalized by ordinary people as they construct meaning from home mode imagery? What set of tacit agreements and understandings are operating that allow viewers to "make sense" out of these images and to render them as meaningful and unproblematic? In turn, how is the home mode interpretive strategy different from others we use as part of "common sense" and the everyday viewing of other kinds of photographic representation? A way of formulating these questions is to ask what transformations or adjustments must be made in thinking from the in-person, firsthand look at life to the mediated, camera—recorded look at life. Here we may profitably return to the significance of applying Erving Goffman's notions of primary framework, keys of reality, and frame analysis to the interpretation of home mode imagery.

The Home Mode Key Of Reality[22]

In discussing the home mode interpretation of life, Goffman's notion of "reality keying" is very useful. For Goffman, a *key* refers "to the set of conventions by which a given activity, one already meaningful in terms of some primary framework, is transformed into something patterned on this activity but seen by the participants to be something quit else. The process of transformation can be called keying."[23] Previous chapters have described sets of patterned conventions by which non-professional photographers go about transforming "real life" activity into mediated forms, into photographs. We are now concerned with how viewers treat these transformations, the "lively shadows"[24] of former activity, former realities. We attempt to see the structure of assumptions and patterned conventions that ordinary people have in mind when they "re-key" the mediated home mode version of life.

Initially these kinds of questions may sound unnecessary and even silly; we are exploring the structure, after all, of an aspect of common sense. It seems that people just look at snapshots and know what they're looking at. In most cases, anticipated and correct interpretations are no problem at all. Clearly, we learn to do this with written and spoken genres of verbal communication. However, little has been said of a parallel set of competencies developed for visual-pictorial modes. For instance, we have learned to differentiate the meaning of someone's death shown to us in the evening news, and in a Hollywood feature film; a picture of a nude body is not understood in identical ways when seen in an issue of *Penthouse*, a medical journal, or an art gallery; a passport

photograph is not "treated" in the same framework as other closely related forms as police mug shots or yearbook portraits. The tacit recognition and basic knowledge of different production contexts and imputed motivations stimulate and determine alternative types of meaning and significance. Home mode imagery represents one of many pictorial forms that are accompanied by a learned set of assumptions that ordinary people use when they look at, understand and interpret pictures.

Unacknowledged Assumptions

During a 1979 conference on the interpretation of family photographs, William Stapp from the Smithsonian Institution made the following comment:

Snapshot photographs pose very complicated questions because snapshot photography is in reality a very sophisticated mode of seeing. It is sophisticated, but it is naive at the same time.[25]

The same may be said of all home mode imagery. But how does this sophisticated way of seeing work?

Several orders of assumptions are operating and are responsible for the successful interpretation of photographs. At one general level, a set of assumptions is responsible for allowing, promoting, and facilitating a series of transformations or "adjustments" which allow us to recognize and interpret the content of photographs. These assumptions appear to be simple. However, they form a starting point for acknowledging all we "do" when understanding a picture. For instance, we understand or assume, when we look at a picture, that people, places, and things are generally not as small as they appear in photographic rendition, nor quite so flat and two-dimensional, nor only black, white, and shades of gray in colorless photographs. The appearance of frame-severed people, places, buildings, trees, etc., does not mean that the rest of the object does not exist. (We will not discuss these notions further.[26])

A second set of assumptions made by viewers of home mode imagery is somewhat more specific and involves the tricky issue of *intention*. Again, we must deal with layers of assumptions. Initially, we understand or assume that whatever is shown in a snapshot image (or on a screen, projected from a slide or film) is there for a reason; someone with an operating camera meant to make that image. These pictures are *not* accidents; they were not taken with time delay mechanisms that produce pictures at regular intervals regardless of what occurs in front of the camera. Nor are these pictures the results of remote controlled machinery or robots, triggered or wired to catch people unaware of an operating

camera. Minimally, these pictures are results of some person purposefully deciding to look at something while using a camera. In short, these images have been created with the purpose and intention of implying significance to what is shown, and of satisfying certain expectations of people who will view the pictures at a later time.

Another layer involves the *specific* presumptions that people make regarding the question, "why do we make photographs?" The answer to complicated questions of "why" people bother to make, keep, and view this imagery lies in examination of personal, social, and cultural contexts, and will be discussed in the next chapter.

With these broad assumptions in mind, we can now look specifically at the structure of assumptions in home mode interpretation. The following list describes the assumptions used when viewers go about "understanding" examples of home mode communication. This list has been derived from listening to many ordinary people discuss their picture collections. Some observations and comments came from participating in a variety of spontaneously occurring (or "natural") exhibition events; others came from social gatherings and screenings that were coerced because of my interests; and still others resulted from interviews that were understood as "official" research.[27] The list describes the key assumptions, the key of reality construction in the home mode:

1) Events depicted in images actually did happen at one time. We do not assume that time, effort, and money have been expended to produce a "fictionalized" account of what we see. Outside coercive forces were not operating to make things happen.

2) The people and places we see appeared just like they did when the camera originally took the pictures. Viewers are getting an objective and true view of reality—copies of what once happened. Cameras and pictures do not lie; they "tell" it the way it was or; what you see is what was there.

3) Activities depicted in these images happened "naturally." A camera was added to an on-going activity or brought to an event that would have occurred without a camera operating. The event was not organized or produced specifically for camera recording.

4) Depicted activities were not scripted, directed, or rehearsed in any theatrical or dramatic sense. On-camera behaviors may have been anticipated in that people expected picture-taking to occur. However, behavioral routines planned specifically for the camera are generally not expected or seen.

5) Examples of human behavior occurred "naturally." People seen in pictures are "playing" themselves, and do not appear as fabricated characters in fictitious roles. These people were not hired or financially rewarded for their on-camera appearances.

6) People shown in this imagery had full knowledge that an operating camera was present and being used by a known person. These images were not made by hidden cameras or by cameras operated by strangers for clandestine purposes.

7) The length of time it takes to show something happen in each shot of a home movie (screen time) is the same amount of time it occurred in "real" life. Shooting and editing techniques used to collapse units of time and space have not been introduced by the moviemaker.

8) Events and sequences of behavior actually did occur in the order in which they appear on the screen showing a home movie. Other things happened between shots but the overall chronology is true to original happenings. This assumption applies to viewing one roll of unedited film. In multi-roll screenings, the sequence may be "unnatural" when different rolls of movies are shown and seen "out of order."

9) In sequences of images, radical shifts in place and time are accepted and unproblematic. Jump cuts in home movies, radically changing time and place are not disturbing; these changes do not cause a sense of hopeless disorientation.

10) Errors, unanticipated accidents, and things that went "wrong" in behind-camera shooting or processing are dis-attended and tacitly ignored. Images that are underexposed, overexposed, fogged, double exposed or that show a finger partially obscuring the image are not discarded but rather appreciated for what can be recognized. Viewers are expected to get what they can out of each image.[28]

11) Still photographs that show cropped heads, faces, limbs, and other body parts are not insulting the on-camera participants. The frame-interrupted compositions happen by accident, and neither ill-will nor projection of physical disfiguration is intended.

12) It is assumed that viewers have the ability and willingness to "fill-in" contextual information that is either visually missing or partially obscured. Viewers, as appropriate audience members, are expected to have general familiarity with and some specific detailed information about the subject matter.

13) Viewers are being asked to relive and re-experience the times, places, people, and activities that have been accurately copied and preserved in pictures. This enterprise is praiseworthy and deserves repeated attention.

This combination of assumptions makes the contents of home mode imagery meaningful to viewers. Home mode imagery shown in appropriate social contexts carries with it this implicit set of instructions for viewing and interpretation. These instructions, based on or identical to the above set of assumptions and expectations, are packaged together as an interpretive strategy. In other words, these assumptions underlie the specific way we appreciate home photos and movies. This particular strategy serves to verify a conventionalized and habitual way of seeing things as real, to help make (similarly conventionalized) symbolic representations understood as copies of reality.

We have learned to do this with many other technically—mediated views of life—each of which has its own set of transformation conventions—conventions which tell us how to "translate" images. Viewers join photographers in collusions of belief systems and proceed

to cooperate in the communication of conventional, biased views of life. In most cases, we get what we have learned to expect. We see what we have been trained to see.

Obviously, our trained, standardized assumptions and expectations work quite well. Viewers aren't bewildered, "lost," or consistently confused by what they see. Viewers are not disoriented or upset by a particular pattern of shooting techniques and style that are characterized as unorthodox and "wrong" by professional standards of imagemaking. The code and logic of home mode representation has been tacitly agreed to; viewing participants know what to expect, what to "do" with the images they see, and how to respond appropriately. The internalization of this keying behavior facilitates the construction of meaning and is responsible for having these images "make sense."

The previous list of assumptions and expectations may appear obvious and self-evident. Can it be that complicated since interpretation is so seldom a problem? The claim "I already *know* all of that" will be made and in some senses, will be justified. After all, viewers must "know" the dimensions of this interpretive framework in order to participate in an appropriate fashion.

But by looking at the things we "know" from a new perspective, we can add to our knowledge. We can raise to consciousness things which we have done half-consciously in the past. And from this alternative vantage point, we can add to our understanding. It has not been our intention to handicap or paralyze by self-consciousness all future viewing of home mode imagery. Our purpose is to illustrate a particular kind of communicative talent and competence that often goes unacknowledged. All people who grow up surrounded by a multitude of pictures must develop abilities to distinguish between different kinds of photographic imagery, and, in turn, operationalize different interpretive frameworks when deriving meaning as part of everyday life.

Verbal Connections

From the past few pages, the impression is easily gotten that interpretation of visual materials is singularly a *visual* experience. It is indeed tempting to ignore *verbal* connections to imagery. This tendency is surprising when, in fact, the majority of our viewing and interpretive behavior is somehow accompanied by either spoken or written words or both. For instance, most films have titles and credits, as well as dialogue, narration, and sometimes subtitles. In addition, some kind of "audience talk" usually occurs before, during, or after the screening of a film. Photographs found in magazines and newspapers are captioned;

photographs in various advertisement contexts and other utilitarian modes are surrounded by words; photographs framed and hung in galleries are titled and may be accompanied by a catalogue or information sheet; and so on.

In the home mode certain relationships between visual and verbal channels of communication must be acknowledged. The most obvious and visible connections are seen in types of captioning and signing. For instance, individual snapshots may include written forms of identification (such as a date, the names of people, places, or specific events) or endearment ("To Chris, with all my love, Monique"). These inscriptions can appear on the front or back of the image or even in the white surrounding border. In albums, written forms of cryptic information can appear in the front; as the title of an album, or below or around individual mounted images. Home moviemakers, like snapshooters, may occasionally include written identifications of place ("Welcome to Yellowstone Park") and time in the form of road signs, town markers, or historic signs. Less frequently, moviemakers will film titles and possibly even credits for later editing. Recently, the popularity of sound home movie equipment has allowed for many other verbal-visual integrations and juxtapositions. The verbal domain will require much additional attention as home videotaping becomes available and accepted on a mass scale.

More important still is the written and spoken accompaniment delivered by people who are showing the slides or albums—people that we might call "image custodians." During exhibition events, people show their pictures to others as part of face-to-face interaction—delivering verbal, ongoing commentary. One study of a family's 5600 slides took over 26 hours of viewing and four hours of follow-up interviewing; the author stated it took so long because "often the project became bogged down in the stories behind each slide. But the stories seemed a part of their photography. It needed to come out."[29] Visual renditions of life experiences that appear in family albums, slide shows, or home movies are inevitably accompanied by parallel verbal accounts. Comments, in the form of storytelling and various recountings, serve to expand and complement minimal identifications common to other kinds of written captions.[30] Complete silence during a home mode exhibition event is socially inappropriate behavior—viewers and exhibitors are expected and conditioned to say something. These accompanying remarks appear to be as conventionalized as the imagery itself.

Storytelling and related comments may, in turn, stimulate additional activities: more dialogue, or more picturetaking, or searches for old photographs. People will remember other pictures they haven't seen for some time—"Whatever happened to the snapshots we took when cousin Bill and his horrible wife visited us in 1958?"—and a house-wide search for the missing photographs will ensue. On the other hand, image exhibition and related dialogues may serve to initiate more picturetaking during the same event, day, or visit. Thus, a continuity, a continuous involvement, in home mode imagery is maintained.

Family members will openly admit that not only are the same pictures repeatedly shown, but the same stories are heard time and time again. In these ways several additional layers of redundancy are built into home mode communication—a redundancy which serves to revive memories, maintain a continuity through time, and reify a sense of belonging, of social affiliation, and of personal existence. A greater exploration of these social and psychological functions is the focus of the following chapter.

Chapter Seven

Functional Interpretations

In his communications research, George Gerbner presents the basic elements of a communications perspective: A central concern of the study of communication is the production, organization, composition, structure, distribution, and functions of message systems in society.[1] While Gerbner refers to mass communication, we have shown how his first five elements relate equally well to home modes of communication. It remains for us to discuss his sixth point: the functional dimensions of the home mode.

We have seen how a model of sociolinguistics can be adapted to work with the systems, codes, and modes of visual-pictorial communication. One major contribution of sociolinguistic theory is the realization that functions of speaking vary across situational, social, and cultural contexts. People perform and engage in speech for a variety of culturally appropriate reasons. Dell Hymes reminds us that:

...the tendency to generalize about channels, such as speech and writing, as if they were everywhere uniform in function, must be overcome, and the specific roles allotted to various modalities of communication in a given culture carefully delineated.[2]

The concept of functional variability in the use of communication channels and modes can also be applied to society's use of photographic images.

Many questions regarding functional relationships are inevitably reduced to asking "why" people do what they do. But in this book, discussion of "why" questions has been relegated to a late chapter—for several reasons. One intention of this presentation strategy is to balance a common tendency to ask for psychological explanations first and foremost. People are generally more anxious to speculate on "why" rather than to explore questions related to how, what, when, or where.[3] But certain "why" questions cannot be addressed in a competent manner until we have a clearer understanding of the behavior under study. This is especially important in an area defined by stereotypes, or when the behavior is mistakenly thought to be so simple as to be beneath comment. Thus, considerable time and attention have been given to outlining and

illustrating the how, what, when, and where of behavior that we will now attempt to interpret in functional terms. In summary, we have prepared a groundwork for understanding the functions of symbols as described by Gerbner:

> Symbolic functions are the consequences that flow from a communication, regardless of intentions and pretensions. To investigate these functions one must analyze the symbolic environment and particular configurations of symbols in it. In this way one can obtain information about what the actual messages, rather than the presumed messages might be.... The human and social consequences of the communication can be explored by investigating the contributions that the symbolic functions and their cultivation of particular notions might make to thinking and behavior.... That is what culture does.[4]

In the home mode, this is what Kodak culture does.

The psychological, social, and cultural functions associated with home mode communication are considerably more complicated than most people initially expect. Stanley Milgram has suggested that photography "is a technology that extends two psychological functions: perception and memory."[5] But this statement addresses itself to the level of the psychology at the individual; since we have concentrated more on social and *cultural* levels, we should be able to add more. We should not be thinking in terms of single functions, but in terms of multiple ones. People do the same things, and "use" the same materials, for a variety of reasons—reasons which are best discovered by examining their social context. At the same time, we must avoid the infinite regression of "why" questions; for any type of reason or interpretive statement, another "why" can always be asked. The choice of certain cutoff points will satisfy some readers and frustrate others.

Functional questions can be studied through use of the "do for" dimension (mentioned in Chapter Six). What people expect their home mode collection to "do for" them can now be connected to what people "do with" their images. People will often be able to simply say what they expect photos to do—but there are other functions which operate in latent, unconscious, unacknowledged ways. These must be discovered through the analyst's observations, speculations, and conclusions. Thus, our functional interpretations must come from several sources, namely picturemaking informants, photography guides, *and* analysis. Using several sources counteracts any deficiency or limitation that might result from using only one kind of information.

Informants tend to limit their explanations to something like: "It's just a fun thing to do." Recognizing the limitations of "fun" as an explanatory principle and probing further, one is likely to hear at most: "They're nice to have," or "We keep them for our children," or "They

just remind me of the good old days." However, these descriptions of the manifest functions of the visual mode are insufficient, for snapshots, home movies, and home videotapes are most likely "doing" many things simultaneously to, and for, participants in the overall process of visual communication.

Documentation

Perhaps the most common and explicitly realized set of functions deals with needs to document and preserve a view of "the way things were." Gisele Freund references this perspective in her book *Photography and Society*.

> Millions of amateurs, both consumers and producers of photography, who imagine they have captured reality by snapping the shutter and rediscovering it in their negatives, do not doubt the truth of the photograph. For them, the photograph is irrefutable evidence.[6]

Tacitly agreed to values and acknowledged belief in the *evidentiary quality* of photographic imagery underlie and strengthen these reasons. As stated by one home moviemaker:

> It's for a record and they think because its moving it's more of a complete record than stills would be...(they) want to document what went on; no artistic impulse....

In another interview, these ideas were expressed as follows, in response to the question: "In general terms, why do you think people make snapshots and home movies?":

> I guess it would be just kind of a documentation, still, it's real if you've got a picture of it. And I do that too; I take pictures of weddings, birthdays, things like that. I don't think, maybe I'm wrong, that people take these pictures as, for lack of a better word, artsy stuff.... And I guess again, there's this kind of, 'put it on film and you've got it forever.' It might even be fun too. In part some of the reasons I take pictures are, I'm too lazy to keep a diary, and some of it is a conscious diaristic approach to still photography.

The notion of diary can be linked to the creation of personal *visual histories*,[7] as mentioned by the following husband-and-wife responses to the same question as above:

> Husband: It's more like a diary or I wouldn't say a diary-it's a history. Say, for instance, when my arthritis gets to the point...,an' I can't fish and I can't do nothin', I can always sit back, look back ten, fifteen twenty years and enjoy myself.

> Wife: An' you can see when people were active, like when you have still shots out— like my son, I have'em [pictures] from the time when they brought the twins home, an' they're eighteen now you know. An' then... when they come over sometime, I just give

'em the book [albums], and they can see what they looked like when they were small. . . .
We think of these pictures as history and entertainment.

Some of the relationships between making personal pictures and writing
or keeping a diary were mentioned briefly in Chapter Two. Whereas
a diary is considered personal, the visual home mode context is addressed
to more people. However, the recordkeeping functions are clear in both
cases. Again, in these statements, we see a relationship between verbal
and visual renditions. But going one step further to the selection of
topics found in diaristic intra-communication, we are likely to find the
mention of sad, difficult, or even tragic moments in life—topics that
will be selectively eliminated from the snapshot, slide, or home movie.
More work could be done on comparing and contrasting visualizations
in relation to verbalizations of personal moments in life.

The documentation idea reifies the value we place on using
technology to make accurate pictures of things and to provide conclusive
evidence for "the way things looked." Camera technology provides a
sense of security; while people may not be willing to trust their memories
as time passes, home mode photography seems to compensate for this
human shortcoming. The speculation is not generally acknowledged that
our information technologies and our image-crowded environment may
be teaching us to commit less to memory and more to photographic
images.

The perceived evidentiary qualities of home mode imagery foster
a sense of comfort with using pictures for validation purposes—validation
of various experiences, as testimony of interpersonal relationships, as
certification of achievements and pride-filled moments in life, and as
Sontag notes, as proof that the trip was taken and fun was had.[8] As
in many kinds of autobiographical accounts, the images provide a
statement of existence and an affirmation of the social self—less perhaps
of the idiosyncratic aspects of the individual, autonomous self, and more
of the conforming, corporate-family self.

In fact, exactly *what* kinds of existence and experience are being
documented and certified? The notion of documentation is inevitably
tied to a process of selection; not everything can be included. Any concept
of symbolic representation must acknowledge the presence of a structured
series of choices and meaningful decisions regarding inclusion and
exclusion.

However, several kinds of conceptual blocks or barricades seemingly
prevent a cultural acceptance of this perspective. Some of the problems
inherent in explicating the home mode interpretive framework are
revealed by the language ordinary people use to explain their behavior.

Makers and viewers of snapshots, family albums, and home movies frequently claim that they treasure their images because "they show what we looked like..." or people will say "they're important to us because this is *what we looked like.*" But home mode imagery reveals only a version of reality, one based on how people choose to look at a specific spectrum of their lives with cameras, and secondly, how they chose to present themselves in front of an operating camera. Thus, photos are not statements of reality, but of interpretations of reality.[9]

Another conceptual block results from the culturally accepted connection between interpretation and artistic renditions. The belief is that some special talent or artistic insight has produced an unusually sensitive way of seeing, evaluating, and understanding something. But this is only another elitist view of a phenomenon—interpretation—that exists in *all* symbolic behavior. This specialized connotation only serves to "culturally" separate and elevate one type of interpretation, while it simultaneously degrades other human capacities to make interpretive judgments and create significant renditions of life on an everyday basis. As the two last quotations indicate, home moviemaking and snapshot making are not outlets for artistic expression. Just as there would be little artistic motivation when making a home tape recording of something, there was little or no concern with making photographs in an "artistic" manner. As one home moviemaker stated: "No, no artistic impulse." It may be, in fact, that for home mode participants, "to make and do *art*" means to tamper with or alter personal images of reality. Results of this meddling activity do not reproduce the whole truth or an accurate rendition of reality—goals and appropriate motivations better suited to other genres of communication. Since the emphasis in the home mode is to truthfully duplicate reality in all its living color, an attempt to alter a faithful picture of reality with "art" somehow profanes the purpose of the medium and the communicative task. In short, the referential function is much more important than the expressive one, just as the phatic (or contact) function takes precedence over poetic ones.[10]

Closely related to the documentary theme is the value placed on *preservation.* Preferences for holding things still for later examination are expressed in manuals and advice columns as follows:

Few people enter upon movie shooting out of any fatal fascination with the photographic details of it. Usually the impetus is the single desire to preserve things... the entire event, unfrozen and continuous, exactly as it happens.[11]

What makes it [a home movie] worthwhile is seeing the event replayed on the screen, getting yourself hurled back to something you'd wanted to preserve.[12]

Promoting a theory of pictures-copy-life is very common to these statements, Comparative reference to a biologist's "slide" and ways these slides are microscopically examined seems appropriate.[13]

A preference for preservation in terms of *encapsulation* and packaged nostalgia was expressed by one articulate snapshooter as follows:

> I think that people try desperately to cling to moments—and time is elusive—and people try to capture in as real a form as possible the feelings and associations attributed to an experience that happens at a particular time in their lives with the people exactly as they were in that place, and that moviemaking is an attempt to bottle nostalgia, to encapsulate, to preserve a piece of the past....

Encapsulation is interesting because it exploits what pictures do well, namely reduce large amounts of information to manageable and convenient units for future reference.[14] The ideal is to "capture" a piece of experienced reality, a slice of time and possess it forever, to be able to retrieve it and re-experience it at any time:

> ...you'll find much to your pleasure, that you've captured a wonderful slice of childhood, complete and continuous....Inside your camera, imprisoned on the film and ready for processing, is a truly documentary film story of the cookout, just as it happened.[15]

In very cogent, persistent, and persuasive terms, the reader is led to believe that the primary function of the home movie enterprise is to capture and store a strip of reality. Probably the most extreme statement in this context comes from the avant-garde filmmaker of "home movies," Stan Brakhage:

> When an amateur photographs scenes of a trip he is taking, a party, or other special occasion, and especially when he is photographing his children, he is seeking a hold on time and, as such, is ultimately attempting to defeat death.[16]

Milder versions of this "defeating death" motivation[17] appear in observed tendencies to photograph times of rapid and favorable change. When home movies are viewed in a chronological order, the juxtaposition of each movie documents changing settings, fashions, peoples' looks, among others. For instance:

> They [home movies] spark the surprising and sometimes disturbing realization that a lot has passed without our having noticed; the gradual changes imperceptibly mounted upon one another.... We're reminded how we used to look, think, live, and behave....[18]

By increasing the frequency of picture-taking during times of change, people could be said to be slowing down the inevitable process of change and development. In the words of one home moviemaker:

One thing I've noticed about us is that these movies are taken less frequently when the kids get older, obviously because the kids don't change as fast. You want to preserve the babyhood because it goes away so quickly.

Memory Functions

Another closely related and frequently mentioned function is the *aide de memoire*. This function is intimately related to needs to create visual diaries which act as mnemonic devices. Home mode photographs are said to help people order their memories of people, events, and places, and aid in the retention of details. The photography manuals stress the idea of a memory bank:

There's just nothing that will recall all the color, fun, and reality of good times like a good home movie.[19]

These nine sequences were a beautiful story that will please you and your friends that see it for years to come. Why? Because you have recorded on film a story from beginning to end that tells who was there and what happened.[20]

Among the people interviewed for this book, general agreement was found on the importance of home movies to stimulate the memory. The most frequently mentioned was the "triggering of the memory" function:

Someone might say 'oh look at such and such doing such and such,' and the family would make general comments—'oh remember when we were driving past there.' It's almost as though the pictures would sometimes serve as a triggering device and then they'd come out with some incident that was associated with the trip....

In another husband and wife interview, triggering was more benignly expressed as jogging the memory:

Husband:...I've a full memory, you know, and [I like] to have it jogged every now and then by seeing pictures of things we did in the past: it's a memory jogger.

Wife: Yes, I think it makes us feel that we're back with our friends and our families again.

Husband: Yes, it does do that, yes. We've seen the shots numerous times and it's as if we were doing those things yesterday, because we are constantly visually reminded of them. And there are so many stimuli, as it were, that come out of the movie—ah, how can I say it? You do create a much fuller scene, much fuller memory than you can from prints, or the written word for that matter.

Other informants simply said, "It's good memorabilia, isn't it?"

Another example of the memory and storage function is clear in the following letter, which appeared as a newspaper clipping entitled, "Movies of Mother All Daughter Will Ever Know."

Dear Killing Me Softly—

...A bizarre and tragic accident took the life of my eldest daughter, 27, last summer. She left a husband and three young children, two boys, 8 and 6, and a new baby daughter, only 5 weeks old...I don't think our memories should be let go, unless they keep us from functioning among the living. I have some marvelous movies of my daughter, starting when she was 4 years old. This is the only way her little girl will ever know the kind of person her mother was. I am extremely thankful that I stuck to my movie-making so faithfully. It comforts me to bring back the happy memories.

Signed—Can't Help Singing[21]

We have seen that in almost all cases the memories are of good times, and support a preferred view of past occurrences. Pro-social behavioral examples far outnumber anti-social ones. One exception was mentioned in a newspaper clipping entitled "Crime: Stop or I'll Shoot a Picture." The clipping reports that an incarcerated bank robber named C. Alexander, wanted to hang a photograph of himself in his jail cell, but not for reasons of "vanity."

Alexander was one of three men who pleaded guilty last week to an attempted robbery of the Artisans' Savings Bank in Wilmington, Delaware, last summer. They were caught after an alert amateur photographer took pictures of them as they fled the bank. "He wanted to hang it in his cell to remind him that, no matter how carefully you plan, things can always go wrong," an assistant U.S. attorney said.[22]

Occasionally, the prescribed behavior for picture making combines the importance of having a pictorial memory with a pragmatic emphasis on making an investment. It is suggested that home mode images gain in *interest* when people make *investments* in creating a memory *bank*:

You've got an investment in every fifty feet you shoot. It's not only an investment in money...but one in memories. Every roll you shoot probably has a dozen things on it you'll want to remember... Actually that film is rather precious.[23]

Shooting home movies is like making a good financial investment—you give up something at the time, but you get a profitable return later. And like most good investments, this one grows as time passes.[24]

This brings us back to our emphasis on creating pleasure and being entertained—the hedonistic function. "Good times" frequently require some form of photographic recording. Not only should one have a good time making the movies, but viewers should be able to repeat and re-

experience these pleasurable times. The hedonistic function is often expressed in manuals:

> This is a book about movies. Not the LIGHTS-CAMERA-ACTION kind of movies, but the kind of personal movies that we make so that we can enjoy our good times over and over again, as often as we like.[25]

> ...your films will become a marvelously rewarding, continuing source of deep pleasure.[26]

Making "instant movies" or home videotapes seemed to change this perspective only slightly. Home picturemaking was valued in terms of long-term gain in pleasure rather than in instant gratification. As a father of two children stated:

> I don't sense that being able to look at it instantly would affect me that much. Because I think I know in the long-term experience of looking at all of our movies, the pleasure of the movies extends over a long period of time, years of time; in fact, they get in some ways more pleasurable after time has passed.... When I'm taking a movie, I'm sure I'm thinking that this is something I'm going to enjoy five, ten, fifteen, twenty years from now; it's going to last a very long time. So there doesn't seem to be any great need for me to see it five minutes from now.[27]

In another interview, the mother of two young girls said:

> I do feel we do this [make home movies] strictly for ourselves and for our kids. I see this as something for them later in life.... So it's nice for us as we go along to be able to get a historical feeling about how we've developed as a family and as a people. But basically, in terms of the future, I see these as for them, so that they can look back and understand a little more about themselves.[28]

Her husband added, "and have a concept of themselves.... "

Cultural Memberships

We can begin to sense the relevance of such themes as cultural stability, conformity to social and cultural norms, generational continuity, unacknowledged sources of socialization, and the maintenance of ethnocentric value schemes and ideology. We need to explore briefly how home mode imagery serves participants as a demonstration of cultural membership. Kodak culture promotes the visual display of proper and expected behavior, of participation in socially approved activities, according to culturally approved value schemes. People are shown in home mode imagery "doing it right," conforming to social norms, achieving status and enjoying themselves, in part, as the result of a life well lived. In short, people demonstrate a knowledge, capability, and competence to do things "right." In these ways, a sense of belonging and security is developed and maintained.

Basic to a notion of cultural membership is the ongoing process of socialization, though the socialization functions of home mode imagery are subtle and generally unacknowledged.[29] Children attend to their parent's collection of family snapshots and slides with intense curiosity; repeated viewings frequently include types of verbal questioning that are uncharacteristic of other visual genres. Children have a strong interest in family pictures that show "their people" and not unfamiliar "others" frequently seen in alternative visual sources such as television programming, comic books, and magazine photographs, among others. In metaphoric and literal senses, children, as well as relatives, newly acquired through marriage or fictive kin relations, are being introduced to family members and close personal relationships. Some deceased relatives will never be met in person; family friends may have moved away, emigrated, and may never be seen in-person again. In this sense, Michael Lesy notes: "Snapshots may not have the numinous power of Communion wafers, Sabbath candles, nor Eleusinian sheaves—but they are often used as relics in private ceremonies to reveal to children the mysteries of the incomprehensible world that existed before love and fate conjoined to breathe them into life."[30]

Children witness patterns of success, the accumulation of significant material culture, and an array of appropriate role behaviors. Children internalize views of past moments of achievement and happiness, with the unspoken expectation that this pattern should be repeated. This agenda-setting function provides a model of life with moments to strive toward, to brag about, and, in turn, to display in a conspicuous pattern of home mode representation. In these ways, home mode imagery contributes to the formation of a world view and ideology.

Cultural membership also involves demonstrating an adherence to appropriate models of social organization and kinship. The people who came together to be "in" a photograph stay together in a symbolic sense, in a symbolic form, for future viewing or exhibition events. Alan Coleman, a photography critic keenly sensitive to these ideas, mentions this issue when discussing another home mode artifact, the wallet photograph:

The photograph as a process and a product permits us to carry around on our very person a matrix of illusions which we all encourage each other to give credence to, a matrix which is a symbolic "genuine imitation" of the fabric of the past.[31]

When reviewing the work of photographer Emmet Gowin, Coleman adds: "It (the family album) is the closest we can come to concretizing the intangible experiences which compose the matrices of our lives."[32] The family album is a visual record of a network of social relationships,

preserving those relationships when people grow up, move away, or die.[33]

In addition, home mode activity serves to reify and strengthen previous and on-going social bonds. New photographs bring people together to maintain preferred and regulated social relationships.[34] While participants view their ties with the past, with deceased relatives, or with relatives living in other regions of the world, they proceed to produce new evidence of cross-generation and intrafamilial relationships. These occasions thus serve to review and renew patterns of kinship affiliation and group membership, to provide a continuity through time and space, and to revive and pass on personal histories.

Finally, we must acknowledge how functional interpretations of photographs reinforcing cultural membership and continuity, are related to the apparent paradox that they document *change*. The answer is that while home mode imagery documents repeated patterns of visible change and development, the parameters or "allowable" change are *not* unrestricted. These patterns of patterned change remain stable through time. And so, while photograph collections document changes, these changes are predictable, stable, culturally expected and approved. In this way photography maintains a culturally structured status quo. It does this through continuity in both subject matter *and* format: we have seen in Chapter Four that while albums of snapshots usually document or trace changes in the ways that people and things appeared over a period of years, the cast of characters remains much the same, and the *ways* in which people and things were looked at with cameras—the format— is quite stable and consistent.

The process of making and organizing sets of personal images may also be understood as a way of ordering the world. As anthropologist Nancy Munn suggests, "Culturally standardized systems of visual representations, like other sorts of cultural codes, function as mechanisms for ordering experience and segmenting it into manageable categories...."[35] It should be clear by this point that Kodak culture includes the production of a "standardized system of visual representation." Ordinary people are afforded a chance to order past experiences, making their travels, past adventures, and segments of life into a coherent order of events. As James Kaufmann notes: "... the ritual making of family photographs—like most strategies for ordering experience—... offer(s) soothing evidence that our lives are better and sometimes more coherent than we sometimes believe."[36]

A statement by Erving Goffman confirms this perspective in a different way, and helps us further understand an internal consistency of human symbolic behavior:

> . . . What people understand to be the organization of their experience, they buttress, and perforce, self-fulfillingly. They develop a corpus of cautionary tales, games, riddles, experiments, newsy stories, and other scenarios, which elegantly confirm a frame-relevant view of the workings of the world. . . . And the human nature that fits with this view of viewings does so in part because its possessors have learned to comport themselves so as to render this analysis true to them. Indeed, in countless ways and ceaselessly, social life takes up and freezes into itself the understandings we have of it. [37]

Home mode pictorial forms operate as "a frame-relevant view of the working of the world"—one that is repeated and duplicated with remarkable consistency. Ordered collections of home mode imagery are repeatedly telling the same "stories" according to some master scenario-stories based on the pictorial rendering and unfolding of an interpretation of experienced daily life and the "punctuation" of special experiences. There is a visual narrative style developed to deliver culturally significant tales and myths about ourselves to ourselves.[38]

In speaking about some "master plan" we are inevitably drawn back to the concept of culture. A family's collection of snapshots represents one of many constructions of a symbolic reality that has been tacitly agreed to and is shared by members of the same culture. The fact that people sharing the same culture will independently agree so well on their patterned choices of appropriate imagery and associated conventions makes many collections of personal pictures "look" so much alike. Ironically, this overwhelming sense of similarity and redundancy frequently prevents a sustained interest in someone else's collection of images.

Chapter Eight

Home Mode Imagery In Other
Communicative Contexts

We've precluded much discussion of how *mass* modes selectively borrow from the home mode, or how home mode imagery becomes incorporated into public, mass, or applied communication. However, we easily find many examples of "home movies" and "snapshots" that end up in these latter exhibition contexts. The majority of relevant examples fall into three categories: (1) contexts of artistic expression; (2) the commercial appropriation of home mode imagery in advertising; and (3) photo therapy. In almost all cases, knowledge and associated behaviors central to our concept of Kodak culture play important roles in explaining why and how this imagery is used.

Manipulation and Uses of "Home Movies"

Previous and on-going trends in professional film production have used home movies in a variety of ways. Several categories of these films either refer to home movies or are made to look like home movies. A major user of home movies is the art community, specifically members of the New American Cinema. The writings of Jonas Mekas and Stan Brakhage[1] illustrate this school quite well. In one instance, Mekas, a filmmaker, distributor, and critic for the *Village Voice*, states:

> The avant-garde film-maker, the home movie maker is here... presenting to you, he is surrounding you with insights, sensibilities, and forms which will transform you into a better human being. Our home movies are manifestoes of the politics of truth and beauty, beauty and truth. Our films will help to sustain man, spiritually, like bread does, like rain does, like rivers, like mountains, like sun. Come you people, and look at us; we mean no harm. So spake (sic) little home movies... I could tell you that some of the most beautiful movie poetry will be revealed, someday, in the 8mm home-movie footage...[2]

In addition to Mekas and Brakhage, we include such filmmakers as Ken Jacobs, Shirley Clarke, Gregory Markopoulas, Jack Smith, and, in his early films, Andy Warhol. These films may be understood as a kind of Dadaist reaction to Hollywood and to stereotypic Hollywood film products. Their films are "home movies" only in the sense of sometimes being shot "at home" with simple and comparatively inexpensive

filmmaking technology. Filmmakers' intentions and anticipated audience are unlike what is characteristic of authentic home movies.

A slight variation on the artistic model includes films that depict events of family life or life-at-home that are usually and purposefully excluded from most authentic home movie footage. Instead of glorifying and amplifying the positive aspects of family life, these filmmakers tend to "play on" unpleasant incidents and uncomfortable moments. Examples include Allen Ross' *X-Mas Home Movie* (1976) which documents the death and burial of "Blackie," the family cat; and Gregory Gans' *The Homecoming— Gary and Lynda Visit 1973*, shot when the filmmaker's brother and sister-in-law were considering divorce. Inexpensive Super-8 technology is used and common home movie "flaws" (scratches, flash frames) are left intact.

Another and much larger category of work includes professionally produced 16mm films on social events in family or home life, or films on topics and themes commonly found in authentic home movie footage, such as weddings, showers, birthday and anniversary parties. Examples include Deborah Franco's *Wedding in the Family* (1977), Miriam Weinstein's *We Get Married Twice* (1976), Abigail Child's *Mother Marries a Man of Mellow Mien* (1974), Jeff Kreines and Tom Palazzollo's *Ricky and Rocky* (1972)—among many others. Another example was produced by professional cameraman Ross Lowell. His 16mm sound film *Oh Brother, My Brother* (1980) was shot at home and includes his wife and two young children. The 14 minute film was nominated for an Academy Award in the short subject category and won the Cine Golden Eagle award.[3] These films contain no authentic home movie footage, and have been produced for distribution to large audiences as documentary films.

Another instance of ambiguous "home movie" status occurs when native generated films, made in research contexts, are called home movies. Examples here include sociodocumentary films made by teenagers,[4] children's filmmaking in general, or Navajo-made films produced as part of a research project.[5] The "primitive" and "inexperienced" qualities of movies made by novice filmmakers provokes a categorical reduction to the "home movie" status. However, social characteristics used to define home mode genres easily distinguish these products from authentic home movies.

In addition to these four kinds of "home movies" consideration should also be given to the diverse ways in which these and more genuine home movies are incorporated into, and presented as part of, other kinds of film productions. The following outline of nine categories summarizes this diversity by demonstrating how authentic home movies or the "look"

of this footage, have been used in artistic and mass communication contexts.

(1) Films that consist entirely of edited authentic home movie footage have begun to appear. In some cases, the filmmaker personally knows the home moviemakers, as in Sandy Wilson's *Growing Up At Paradise* (1977) and Frederick Becker's feature length film entitled *Heroes* (1974). Becker's film is an edited compilation of 25 years of movies made by three families. One reviewer describes *Heroes* as a film "fashioned out of that most maligned of media—the home movie.... At one and the same time it is an exercise in nostalgia: a record of generational growth and death; a piece of social history glittering with the popular artifacts of the post-war period (fashions, cars, toys, sporting equipment); an anthropological survey of American mores; a diary of affluence, and a slightly savage chronicle of innocence lost."[6] Sound tracks have been added to what was originally silent footage.

(2) A closely related category includes films made entirely or in part from found footage, that is, authentic home movies produced and discarded by people unknown to the filmmaker. These films are heavily edited, and individual shots may be radically transformed, manipulated, and creatively mutilated in a variety of ways. Examples include Barry Levine's *Procession* (1978) and *Photon Nights* (1982), and Victor Faccinto's *Sweet and Sour* (1976).

(3) Another group of films combines edited segments of authentic home movie footage with original footage shot by the filmmaker. In most cases, the filmmaker personally knows or may be related to the custodians of the original home movies. Summarizing the production of these "personal films" and "family portraits," Elizabeth Weis says, "now there is a trend among independent filmmakers to make documentaries about their own families, and these go further and deeper than anything in the typical home movie."[7] Examples include Jerome Hill's *Film Portrait* (1971), Martha Coolidge's *Old-Fashioned Woman* (1976), Jan Oxenberg's *Home Movie* (1973), Alfred Guzzetti's *Family Portrait Sittings* (1975), Amalie Rothschild's *Nana, Mama, and Me* (1974), among many others. Commenting on Rothschild's film, Margaret Mead stated: "It is the best example I have seen of the way home movies and old still photographs can be used to bring the past to life."[8]

(4) Closely related to category three are films made from home movies shot under unusual circumstances or conditions that are socially or politically significant. Filmmakers do not personally know the original moviemakers. A good example is Don and Sue Rundstrom's *Uprooted! A Japanese American Family's Experience* (1978), a film that uses home

movie footage shot by a Japanese American family before, during, and after their internment following Pearl Harbor. The planning of another film for this category appears in the following advertisement:

<div align="center">

"For Immediate Release" 7/10/78

DID YOU TAKE HOME MOVIES IN VIET NAM?

</div>

If so, BRANYA wants to see your footage. We are doing a documentary on the day-to-day life of American soldiers in Viet Nam. Shots of barracks, mess halls, medical facilities, leaves—anything, in short, which gives a sense of what it was like to be there—we want to see. The films selected will be shown to small groups of Viet Nam veterans, whose spontaneous reaction will form the core of the narrative.[9]

(5) Another category includes films produced for television presentation—films that use authentic home movies shot under *normal* circumstances during a particular time period. The best example would be the films televised on London's BBC 2 in a 13-part series cleverly titled "Caught in Time." James Cameron introduced the series and described it as follows:

The idea of 'home movies', on a serious programme seemed quite dotty, until we tried it. We advertised all over the country for any old amateur films taken in the 1920's and 1930's, possibly stored away in lofts and attics and long forgotten. We didn't ask what they were about. We felt that anything encapsulating our society of a generation ago couldn't fail to be absorbing. This is precisely how our fathers saw the world—not our ancestors; this is the world of the day before yesterday.

We haven't mucked around with the film or sent it up (sic); we haven't added any clever sound-track nor done any funny editing. As often as possible we have had the actual people involved to sit with me in the cutting-room and talk about their film.[10]

A more recent example comes from the making of *American Life* by P. J. O'Rourke, former editor of the *National Lampoon*. This film is described as a 90-minute feature consisting entirely of spliced segments culled from real home movies, with such themes as "people with their new cars," "prom night" and "baby's first steps"—narrated by the people who made the home movies.[11]

(6) Closely related to the last category are films produced for television that incorporate and comment on home movies originally made by a publically recognized celebrity. Examples include the televised home movies of Adolf Hitler shot by Eva Braun, and the six-part weekly series "A View of the White House," which includes home movies shot by Richard Nixon's former chief of staff, H. R. Haldeman,[12]

(7) A seventh category of relevance is made up of feature films which include sequences of *fabricated* home movie footage. These scenes usually comment on a traditional conventionalized look at life. Examples include the dinner scene in *Up the Sandbox* (National General Pictures, 1972), the bar mitzvah scene in *The Apprenticeship of Duddy Kravitz* (Paramount Pictures, 1974), and Jake LaMotta's home movies in *Raging Bull* (1981). The prime time television counterpart appears in M*A*S*H when Colonel Henry Blake shows a home movie, sent from Illinois, of his wife and children taken during a birthday party.

(8) Another use of home movies includes films that incorporate authentic footage for discussion, analysis or comparison to other styles and genres of film production. Appropriate examples include *Six Filmmakers in Search of a Wedding* (1972), which compares and contrasts the home movie view with other camera-made views of the same event, and Star and Zeitlin's *Home Movie—An American Folk Art* (1975).[13]

(9) A last category comprises films that are titled or advertised as "home movies" but contain no home movies whatsoever. The best example would be Brian DePalma's *Home Movies* (United Artists, 1980), in which Kirk Douglas directs a class in "Star Therapy" for people who are "extras in their own lives."

A tenth category might also be included, or at any rate, considered: as early as the 1930's, advertisements appeared for renting professionally produced movies to be *shown at home*.[14] A modern version is Castle Film's catalogue entitled "Home Movies," which contains 8mm, Super-8, and 16mm transfers of feature films previously shown in movie theatres and on television. Home video and videocassettes are now replacing the motion picture projector but the idea remains the same.

Contexts Of Snapshot Reference And Use

In comparison to home movies, snapshots are written about much more frequently. The popular and scholarly literature contains as many as eight separate yet interrelated contexts of references to snapshot photography. The following categorical outline has been developed from trying to understand better how different contexts for snapshots lead to different descriptions of their significance. The diverse and scattered collection of books, articles, and miscellaneous remarks on snapshots can be organized in the following manner:

(1) Instructions and advice for making better snapshots and family albums: here we include guides and manuals, as well as magazines and newspaper advice columns directed toward amateur photographers. Primary attention is given to improving camera use, "looking better"

in photographs, ordering picture collections into albums, creating new kinds of picture display, avoiding "mistakes", etc. Articles written by Moser,[15] McCluggage,[16] and O'Neill[17] are examples of this approach. Satirical articles, such as Russell Baker's "Negative Thinking"[18] are included also.

(2) Explaining the significance of amateur camera-use in the historical development of photography: attention here is given to the continuous tradition of snapshot-making and its relationship to parallel developments in other genres of photographic recording. Examples include Taft,[19] Halpern,[20] Kouwenhoven,[21] and Coe and Gates's book *The Snapshot Photograph* (1977).[22]

(3) Relating the snapshot tradition to alternative pictorial contexts such as fine art photography, photojournalism, and folk art production: attention is given to comparing styles of work and different contexts of appreciation. References include articles by Christopherson,[23] Downes,[24] Malcolm,[25] Holmes,[26] and Ohrn.[27]

(4) Integrating the significance of snapshot imagery into the emergence of the "snapshot aesthetic": attention focuses on how certain photographers have incorporated specific stylistic elements of snapshot form and familiar content into an art form. Photographers included are Emmet Gowin, Lee Friedlander, Mark Cohen, Robert Frank, among others.[28] Relevant articles have been written by Coleman,[29] Green,[30] and Malcolm.[31]

(5) Interpreting the content of snapshots in terms of psychological premises: pictures are treated as "psychic tableaux"[32] amenable to explication through a series of well established themes and relationships common to the writings of Freud and Jung. Snapshots are described from their dream-like qualities and through unconscious motives and compositions provided by amateur photographers. The best example here is Michael Lesy's book *Time Frames—the Meaning of Family Pictures* (1980).[33]

(6) Using snapshots in forms of psychotherapy: attention here is given to a growing field of photo therapy in which psychiatrists, psychologists, social workers, family therapists invite patients to bring personal family snapshots to therapy sessions. Photographs are used as stimuli for therapeutic discourse and as evidence of problematic interpersonal relationships hidden from the consciousness of the patient(s). Best known is Robert Akeret's *Photoanalysis* (1973);[34] other references include Zakem,[35] Loellbach,[36] Stewart,[37] Entin,[38] among others.

(7) Publishing a collection of "interesting" snapshots taken away from original family album contexts: a new kind of album, in the form of a picture book, is constructed from the author's own selection of snapshot photographs. The best example in this category is *American Snapshots* (1977) by Ken Graves and Mitchell Payne.[39] Other works include Silber,[40] Seymour,[41] and Stephens.[42]

(8) Using collections of snapshots as a visual chronicle of the same family through several generations: snapshots will accompany a written text that also includes studio photographs and other pictures produced by professional photographers. The best examples include Catherine Hanf Noren's *The Camera of My Family* (1976)[43] and Dorothy Gallagher's *Hannah's Daughters—Six Generations of an American Family: 1876-1976* (1976).[44]

(9) Discussing the social relevance of snapshot collections: authors speculate on the relationship of snapshot making to such themes as ritual, social documentation, family cohesion, socialization, personal identity, social functions, and the like. A recent example is Julia Hirsch's *Family Photographs—Content, Meaning and Effect* (1981).[45] Articles written by Sontag,[46] Hattersley,[47] Coleman,[48] Leary,[49] Ohrn,[50] Kaufmann,[51] and Milgram[52] begin to clarify the social and cultural significance of snapshots. As such, this last category is most important to themes that underlie our formulation of Kodak culture. All of the above references pertain to snapshot photography produced in Anglo-American cultural contexts. At this writing, it is possible to mention similar work done in several European countries. For instance, in France, we have the writings of sociologist Pierre Bourdieu,[53] Martine Segalen,[54] as well as a complete issue of *Le Nouvel Observateur*;[55] in Holland, Boerdam and Martinus;[56] in Germany, Meyer,[57] Kunde,[58] and Kallinich.[59] The existence of these articles and others[59a] recently discovered suggest many unexplored opportunities for cross-cultural studies.

And so authentic home mode imagery and related facsimiles have been absorbed into other communicative tasks and contexts, notably into mass communication. The "look of the snapshot" appears very frequently when one starts looking for it.

There are, particularly, three kinds of adoption, exploitation, and use of home mode imagery which deserve additional attention: first we will look at what groups of photographic artists have done; secondly, we will comment on two applied contexts, namely photojournalism and advertising; finally, we will review work done in the mental health context of photo therapy.

We know that professional fine art photographers make certain kinds of images, in patterned working conditions, for specific contexts of display such as exhibitions in galleries, picture books, photo essays.[60] These images are part of their public and professional lives. But what about their private and personal lives? Do they make photographs of members of their families—pictures that are not meant to "go public," pictures that are for the exclusive use and enjoyment of family members? If so, how similar are these private pictures to their professional ones? Are discernible differences immediately apparent? If so, can we say a "code-switch" is involved? Has a change in communicative intent and general context created a style that resembles non-artist-made snapshots? Or, does the artist bring his/her style and way-of-picturing to home mode participation and create "artistic snapshots?" In the case of people who make motion pictures, do camera operators, directors, or screenwriters of feature films or professional documentaries apply their aesthetic sensibilities to their personal home moviemaking? Do actors and actresses who regularly appear in film and television create home movies that are similar to or different from movies made by non-professionals?[61]

Very few of these questions have been asked before; none of them has been studied systematically. Christopherson, though, offers some relevant observations in his paper "Art is More than Snap-Shot":

One [fine art] photographer outlined the distinction between "snapshot" and "art" succinctly:

Q: Do you find that you and your colleagues are making family pictures? Snap-shots of your kids and what not?

A: I do, and I think that they do—in fact, I know that they do, but these are not photographs they would wish to show in a public sense.

Q: Why not?

A: Because they are not about ideas, they are about personalities, and I think that most photographers working today are into some kind of ideas. It could be a visual one, in terms of shape and forms, or it could be an intellectual one, conceptual in the generally accepted sense. Snapshots don't fall into this category.

Q: They don't ever fall into this category?

A: Historically, if you look back at something someone did back in 1890 say—then it becomes a whole different order of involvement, because you are looking back at something more than just personality, you are looking at era. You are looking at lots of things that aren't reflected in the moment or in the time that they are made.

> The essential point of difference seems to be that photographs which are nothing more than document are detached from a body of abstract knowledge which not only supports true professional activity, but supports the meaning of art itself.[62]

Christopherson reminds us of important principles that distinguish home mode communication from other models. Attention is given to choices of different exhibition events and audiences as well as to the intentions of the photographer.

When we study snapshot-like images made by professional art photographers two kinds of manipulation of snapshot conventions are immediately obvious. The first involves the choice of subject matter (participants, topics, settings): several artists have incorporated family members into their published images. For instance, Alfred Steiglitz photographed his young daughter; Edwin Steichen photographed his sister, wife, and daughter; Edward Weston included his wives and children; and Dorothea Lange chose to photograph her husband Taylor, her children, and grandchildren. In more recent examples, Harry Callahan has posed his wife Eleanor for many photographs; Emmet Gowin has used his wife and her family in various at-home settings; Ralph Meatyard has photographed his children "in his highly structured photographic allegories";[63] and Elliot Erwitt's photographs of his wife and newborn daughter appear in his published work. But all these artists transform snapshot conventions. Photojournalism scholar Karin Ohrn has summarized this use of family members as follows:

> ...we can say that professionals who select members of their families as subjects for a serious photographic study tend to use methods and equipment according to techniques they have developed in other work. Although they often use simplified lighting and equipment for family settings, the technical fluency and competence they have gained in their work clearly sets them apart from the average amateur.[64]

Motives for taking these pictures are quite varied. And the way that snapshots are transformed by artistic "treatments" remains generally unstudied.[65]

The photographers mentioned above turned their cameras on family members *after* they consciously decided to become professional imagemakers. In contrast, the case of Jacques Henri Lartigue is particularly interesting.[66] As early as 1901, when only seven years old, Lartigue was using a camera to record various moments of family life in France. Since that time, his snapshots have been recognized as fine art. Here we have an example of a few people (critics, art historians, museum curators) causing a change in modes of communication. Lartigue's pictures *of* his family, *for* his family, have been drawn into

public view and are now valued and evaluated as art images rather than as snapshots.

The relation between fine art photography and home mode photographs is complex. Content alone is not sufficient to define home mode communication, to make snapshots into fine art, or fine art photographs look like snapshots. A consistent artistic intent, and ability, is important too. One side of this issue has been suggested by John Szarkowski's critical anthology *The Photographer's Eye*.[67] Szarkowski juxtaposed art photographs with photographs made in other communicative contexts such as newspapers, museum identification, technical, and scientific as well as snapshots.[68] Readers and viewers are asked to compare and evaluate fine art images with "functional" ones, provoking a conclusion that artistic and non-art photographs share many similarities and seemingly cannot be distinguished. But while it is apparently possible to isolate specific images to illustrate this thesis, both Szarkowski and Malcolm[69] are temporarily willing to overlook another side of the question, namely the important characteristic of *consistency*. We are thankfully reminded by Margaret Weiss that:

> ...it is neither subject matter, basic technique nor photographic equipment that separates the professional cameraman from the snapshot boys.... The one all important distinction between the fulltime practitioner and the casual hobbyist is the former's ability to perform consistently...to produce good pictures any day of the year...with dependable frequency.[70]

Amateur photographers can't and don't regularly create images that resemble the work of fine artists.

Another source of some confusion derives from a second kind of manipulation of conventions. A growing number of art photographers are attempting to adopt, duplicate, and manipulate stylistic characteristics of vernacular forms such as snapshots. Here we have the interesting contributions made by members of the "snapshot school," variously labelled "snapshot chic" or the "snapshot aesthetic." As described by critic Janet Malcolm:

> Old and current snapshots are similarly being scrutinized and cherished for the inadvertent truths they reveal, and the most advanced photographers are painfully unlearning the art lessons of the past and striving to create an aesthetic out of the ineptitudes and infelicities of amateur snapshooting. As a result, haphazardness, capriciousness, and incoherence are everywhere emerging as photography's most prominent characteristics.... The central focus of this group's research, and the starting point, model, and guide of its artistic endeavors, is the most inartistic (and presumably most purely photographic) form of all—the home snapshot. The attributes previously sought by photographers— strong design, orderly composition, control over tonal values, lucidity of content, good print quality—have been stood on their heads, and the qualities now courted are

formlessness, rawness, clutter, accident, and other manifestations of the camera's formidable capacity for imposing disorder on reality...[71]

The snapshot aesthetic is particularly well illustrated in Jonathan Green's *The Snapshot* (1974).[72]

In this kind of work, photographers are having fun *with* while making fun *of* the amateur's snapshot.[73] Metacommunicative comment is being made on photographic activity as well as its style of representation. At one extreme there is a sense of mockery and exploitation of vernacular forms. At the other, photographers working in the snapshot school are asking viewers, and anyone interested in any form of photography, to realize and acknowledge the value of these structured and conventionalized ways of looking and showing with cameras. In this sense, these photographers have intuitively enacted a version of the analysis used in previous chapters and have applied these findings to their work. Our task becomes one of understanding which conventions have been selected (or eliminated) and subtly transformed into an artistic presentation.

While facsimile snapshots may be used as artistic images, this mode of communication never duplicates social characteristics of the home mode. Intentions are different; presentation or display characteristics are different; composition of audience is different; and finally, the artist's rendition and means of exhibition create different "readings" or interpretations of the images.

Mass Media Contexts

Our belief in the evidentiary, truthful qualities of amateur photographs allows them to be used effectively by the mass media. Daily newspaper items and feature expose articles will incorporate snapshots when professionally-made photographs are unavailable. When people are arrested, kidnapped, reported missing, or die, snapshots will be used in newspapers and magazines for identification purposes with the caption "as seen in a 1962 family photograph."[74] One war-time related example is described as follows:

In one of the finest pieces of conceptual art, and one of the high points of journalism, *Life* printed old snapshots of one week's American war dead in Vietnam, captioned them as news photos, and published them as virtually the sole content of a single issue: I am still haunted by their faces, so alive and secure.[75]

In other cases, magazine editors and photojournalists incorporate snapshots or single frames from home movies in their photo essays. The home movie footage made by Abraham Zapruder has become a famous

example. Zapruder, a dress manufacturer, filmed the 1964 assassination of President Kennedy quite by accident with his 8mm movie camera. *Life* magazine offered $50,000 for this important footage.[76] In a more recent example, Bernard C. Welch, professional burglar and accused murderer of Dr. Michael J. Halberstam, was asked to sell snapshots of himself and his family to *Life* magazine. *Life's* offer of $9,000 has caused considerable ethical debate in journalistic circles.[77]

Snapshots are often used by journalists when they are interested in portraying the private person behind a public image. For instance, Aurelia Schober Plath, mother of the late writer and poet Sylvia Plath, edited a book of Plath's letters including family snapshots. In this book she endeavored to "prove that her daughter was not a rebellious dark spirit but predominantly a sunny, bright, though rather extraordinary, American girl. Here is the other Sylvia...."[78] There are other examples in which a family member may work with a journalist to publish views of the personal, humanistic, and caring attributes of a relative who is recognized and publicly known for other characteristics. The newspaper article "My Father Angelo Bruno" reports how Bruno's daughter has a very different view of her father than "the public image... mirrored in myriad clippings in the libraries of newspapers." The father she knows, she says, is a "good man—not the notorious gangland leader the FBI talks about, nor the 'reputed underworld boss' [Cosa Nostra in Philadelphia] identified in the press."[79] This article is highlighted by snapshots of Bruno with his wife, children, and grandchildren taken at weddings, a christening, and similar family gatherings.[80]

The faith in the "authentic view" of the snapshot has lead to the emergence of fictive or fake snapshot imagery. "Behind-the-scene" photographs are taken for a view of the "human side" of celebrated public personalities in show business, professional sports, and politics. In such "behind-the-scenes" articles and reports, authentic snapshots may be combined with photographs professionally made to look exactly like snapshots. In contrast to home mode forms, these facsimile images are made for display in mass communication contexts. Viewers are tacitly invited and instructed to treat these images as if they were looking at a relative's or friend's snapshot collection—as if they now have access to personal information and visual accounts of a celebrity's private life. This technique fosters a sense of what Horton and Wohl refer to as "para-social interaction."[81] Its sense of false intimacy can be found on the record jackets of recording artists,[82] and, most recently, in music videos.

Sometimes an entire album of facsimile snapshots is created as a book for popular consumption. These books are artificial family albums of fictive families like the Ewing family of NBC's popular series *Dallas*.[83] Similar album-like displays of snapshot poses appear in popular magazines devoted to daytime soap operas and evening situation comedies; readers are persuaded to interpret these images as real-life extensions of televised family life. Here we find evidence of what might be referred to as "media extended families." The Nielsen television ratings indicate an enormous popularity of shows that focus on such families as the Bunkers, the Jeffersons, the Bradfords, the Cunninghams, the Huxtables, the Keatons, among others. The creation and publication of pseudo albums full of snapshot-like images depicting members of these families help audience members play out a sense of participation in extended family life. These examples provide us with yet another interaction between home modes and mass modes of pictorial communication.

Other attempts to usurp the look of the "real" through fake snapshot imagery are frequently found in magazine and newspaper advertisements. It is not surprising to find snapshot and home movie images as part of advertisements for camera equipment, photographic supplies, and film processing. Ads for inexpensive cameras, especially instant cameras, and even items used for framing or displaying photographs have been particularly rich in the use of fictive snapshots.[84] These advertisements are interesting in how they also serve prescriptive and "agenda-setting" functions by illustrating appropriate subject matter for snapshot photographs.

Another logical and popular use of snapshots is advertisements for travel. Facsimile tourist photography shows up in ads for travel agencies, airlines, charter trips, travelers' checks, specific tourist sites, vacation hotels, and the like (note Chapter Five). In one promotional ad designed by the Irish Tourist Board, Ireland is described as "A place that's worth a 1000 pictures."

Other advertisements stress a notion of change. Again, the evidentiary quality of the "naive" snapshot image plays an important role. The acknowledged power of photography to document authentic change is used notably in "before" and "after" views. Pictures of overweight men and women are juxtaposed with slimmer figures of the same people after they have participated in a particular weight reduction plan; "after-pictures" of full heads of hair are juxtaposed with "before-pictures" of receding hairlines and bald pates. In one ad for Ayds, a caption for two photographs reads: "Wasn't I klutzy-looking in these old snapshots? I was 150 pounds." Under a snapshot of the same woman taken after

the use of Ayds we read: "Here, I'm 101. My husband carries this one in his wallet."[85]

Another example takes the evidentiary function one step further. Advertisements for Zest soap have used two nearly identical snapshot images of the same person in a "Zestimonial."[86] James (Tex) Stokley "testifies" that Zest soap rinses clean while competitive brands leave a greasy film after a shower. The ad has us believe that the two photographs of Tex were "bathed" in his favorite soap and in Zest; results show that the Zest photograph of Tex is clearer than the "my soap" counterpart. In this example, the snapshots of Tex apparently "stand for" Tex as he actually showered or bathed and had used different brands of soap. We are not meant to consider the possibility that soap may or may not wash off a photograph in ways similar to or different from ways that soap washes off the skin of a living human body. The snapshots of Tex are meant to be Tex. Surely our beliefs about photographic representation are being played with and subtly manipulated. In this extraordinary example, viewers are asked to identify a photograph with a person, and secondly to believe the person is taking a bath.

And finally, we find facsimile snapshots used in advertisements for products or services that do not have any immediate connection to photography or needs for evidence. Examples include advertisements for automobiles, cologne, whiskey, sportswear, and various types of clothing, insurance companies, oil company sweepstakes, and telephone services, just to mention a few culled from a random selection.[87] When we start looking, variations of home mode imagery appear everywhere.

Many of these described uses and occurrences have usurped what we might call "the look of reality." In doing so, they indirectly request a stereotypic—"realistic"—pattern of interpretation. The home mode image seems to lend an air of authenticity, of certain reality, of unquestionable truth to forms of persuasive discourse. It is suggested that a conventionalized pattern of representation has been used to promote an untampered, unmediated (read "unstaged") view of reality which, in turn, helps readers/viewers believe they are gaining "an inside look." In short, we are witnessing an exploitation of home mode imagery in the construction of credibility.

Photo Therapeutic Contexts

Increasing interest is being directed toward how the viewing and making of authentic snapshots, family albums, and home movies can become an integral part of therapeutic discourse. Psychotherapists, psychologists, psychiatrists, social workers, family therapists, and

marriage counselors, among others, have been using home mode imagery with patients and clients as part of "photo therapy." Photo therapy has been defined as "the use of photography or photographic materials, under the guidance of a trained therapist, to reduce or relieve painful psychological symptoms and to facilitate psychological growth and therapeutic change."[88] Treatment goals are described as a greater awareness of self and an improved self-concept. Much of what is discussed as photo therapy has roots in forms of art therapy and various uses of projective techniques.

Here, our primary concern lies in how theories and principles of therapeutic practice are related to descriptions of home mode imagery given in previous chapters. What kinds of observation and data bases are photo therapists using for their work? What is known about how home mode artifacts "work" so they can become a meaningful part of a therapeutic process? And finally, how can our analyses of authentic of home mode imagery contribute to photo therapeutic theory, techniques, and practice?

Patients or clients may be asked to take original photographs, become subjects for photographs, or simply respond to photographic imagery. Techniques may involve a discussion of any of the following kinds of still or motion pictures:

1) Visual materials commonly found in magazines, newspapers, advertisements or any available source;

2) Photographs made by the therapist of either the patient/client or some other subject matter;[89]

3) Photographs made by the patient/client of him/her self (or family group),[90] of other patient/clients, or of specific subject matter as part of a series of therapeutic sessions;

4) Photographs made *by* or *of* the patient/client *before* therapy which are part of a snapshot collection, family album, or home movie archive.[91] This last category may also include photographs made by professional cameramen for weddings, yearbooks, passports, etc.

Any or all of these materials can be used as a projective technique, to stimulate memories, to provoke discussion of past events and interpersonal relationships, and for the clarification of personal feelings. Therapeutic techniques also include the use of family photographs to probe sensitive points of personality, interpersonal discord, or other kinds of problematic conflict or distress.[92]

Typically a therapist will ask patients/clients to bring a collection of home imagery to a counseling session. Less frequently, a selection of these materials may be shown and discussed during a home visit.

Assignments to clients may vary; each person may be asked to select only three of the most meaningful photographs of the nuclear family, or three photographs...

...from *each* of three generations, photos that contain more than two generations, or a large number of photographs of significant members of the extended family.... To study male/female roles and stereotypes, participants may be asked to choose photos that relate to how their family has worked out these issues over the years.... Another interesting variation is to request two photos, one that represents their ideal—how they wish the family was—and their reality—how the family is; this can help to clarify disappointment, disparities, and goals for the future.[93]

Psychiatrist Adrien Coblentz calls attention to the significance of this selection process: "A family in which the presenting symptom was the mother's phobias unwittingly revealed the extensiveness of 'her' symptom when they gave us a picture of themselves visiting a cemetery! It took three months to unearth the buried fears of dying from which they all suffered.:[94]

Other health care specialists have explored the potential of home imagery for diagnosis and therapy. Collections of family snapshots and home movies are being used to study abnormal child development and problems in parent-child relationships. Building on theory and research in kinesics initiated and developed by Birdwhistell (1970), Scheflen (1972), and Kendon (1967), research psychiatrist Henry N. Massie has performed intensive frame-by-frame analysis of family home movies depicting infancy and early childhood:

...The parents made these films before they realized their children were ill, and therefore before any diagnostic or therapeutic intervention...the films serve as a kind of prospective study documenting many aspects of... infancy. The movies show the children developing the first signs of psychosis in their first year, and its features toward the end of their first year and in their second and third years. The film analyses, coupled with the clinical investigation made when the cases came to professional attention, provide a rare opportunity to study the early natural history of childhood psychosis.[95]

In 1978, Massie reported on his study of ten cases of childhood psychosis, demonstrating how family home movies provided valuable data on neuromuscular pathology, psychomotor development, initial signs of psychosis, and maternal-infant interaction based on observations of eye gaze, holding, touching, feeding, and smiling from the first weeks of life.[96]

In a related study of home mode imagery, Sandra Titus studied the photograph collections of 23 families who had at least two children and whose most recent child was between 4 and 11 months old.[97] Titus was

interested in how home mode imagery reflected the "transition to parenthood."

It was predicted that there would be more photographs of the family with the first child than with any subsequent child(ren) on the following observable behaviors: 1) parental caretaker activities depicted via holding, feeding, bathing, and diapering the infant; 2) observing the child by taking pictures of the child posed alone; 3) developing an image as a family unit by posing together; and 4) participating with relatives and significant other relationships who were not coresident with the family by posing with the new child.[98]

Frequency counts of family photographs indicated that for the first child there were more photographs of parental activities, of the child alone; the same number of photos of the family unit; and actually less photographs of the first child with non-resident significant persons.

In summary, the photo therapy literature, especially the journal *Photo Therapy Quarterly*,[99] contains many fascinating accounts of how a variety of psychologists have used these techniques, and how patients and clients have benefitted from different kinds of applications. However, almost no studies systematically document the use of photos to produce beneficial change. Examples remain at the level of clinical anecdotes and illustrations.

Conclusions

Although photo therapists credit a paper by Dr. Hugh Diamond written as early as 1856[100] as the first significant contribution, there has been little accumulation of related work and literature that might provoke the emergence of a tradition. Therapists began to write about their approach only within the last decade. Though much of this literature is very suggestive, it is generally limited by repeated reference to anecdote, speculation, intuition, and an occasional brief case study.

For our study, this literature has several important shortcomings. We seldom find reference to visual communication theory; family album imagery and home movies are neither conceptualized nor treated as systems of pictorial communication. Pictures tend to remain in the status of helpful stimuli for enhancing forms of recall, confession, and discussion; the social significance of the imagery is generally circumvented. There is always the chance that the therapist will make too much of a particular image without knowing certain normative standards or original circumstances surrounding the original production of the image.[101]

It becomes clear that many practicing photo therapists are working from intuitive knowledge and understandings of what constitutes a "normal" collection of snapshots or home movies. Alan Entin is one of the few writers who acknowledges the need for additional information on what we might call the ethnography of home mode communication:

> As a family therapist, I am interested in who, what, where, when and how the family chooses to document their existence as a family. This includes a myriad of questions concerning the boundaries of the family system, the events and ceremonies chosen to be preserved, recorded and remembered, and who is the family historian.... Therefore, the need for knowledge of typical picture taking behavior in families is apparent...knowledge of these patterns of picture taking behavior is important because departures from the expected patterns may provide important clues for the therapist and the family about the emotional processes operating in the family.[102]

A similar need is mentioned by Titus. After discussing the results of her transition-to-parenthood research, and after speculating on various explanations, she calls for "more research both on the content and the occasions of family picture taking. In order to further understand the signfiicance of family picture taking, it would be useful to know how these correlate with marital adjustment, family intimacy, sibling rivalry, transitional behaviors, and time together and apart."[103]

These comments by Entin and Titus are extremely significant to this book: each chapter has addressed the questions and needs they mention. We have attempted to outline and describe normative patterns and some of the reasons for "normal" on-going picturemaking behavior. Photo therapy provides an outlet for applying our results.

Chapter Nine

Conclusions And New Questions

Toward the beginning of this book, we noted that the human condition is reliant on several kinds of support systems—systems that are separate, yet interdependent. To the acknowledged significance of physical, biological, and social support systems, we are adding the symbolic environment, as a fourth support system. Within our symbolic environment are many symbolic worlds; we need to ask how these worlds are made and what they look like. When Howard Gardner comments on the work of Nelson Goodman, he notes:

> ...it is misleading to speak of the world as it is, or even of a single world. It makes more sense to think of various versions of the world that individuals may entertain, various characterizations of reality that might be presented in words, pictures, diagrams, logical propositions, or even musical compositions. Each of these symbol systems captures different kinds of information and hence presents different versions of reality. All we have, really, are such versions; only through them do we gain access to what we casually term "our world."[1]

Our notion of Kodak culture and pictorial symbol systems finds a home in Goodman's constructivist philosophy. We have concentrated on how Kodak culture captures a certain kind of information and presents a particular version of reality.

The previous chapters have been organized to demonstrate how one type of social scientist, interested primarily in the social context of visual representation and image communication, would study the most popular forms of photography. A home mode model of interpersonal pictorial communication has been outlined, developed, and applied to the production and use of a collection of imagery. Concepts of Kodak culture, Polaroid people, and an event/component framework of description have been offered to understand how members of a society participate in, and interact with, a number of related pictorial genres in organized and systematic ways. We have suggested that photographic representations must be understood as cultural artifacts surrounded by social and cultural contexts. A unity of several image genres or contexts has been found in the patterned, social use of pictures and picturetaking. Persistently treating photographs as symbolic forms, we have developed the

perspective of "world" and "reality constructions" through photography and filmmaking.

Illustrating this perspective with many examples from a broad and previously unassociated collection of references, we can now understand better two important facets of our social and cultural selves. We have a better view of human participation in one of many on-going processes of image communication: The home mode of communication. This book has focused on only one of our many kinds of involvement with visual communication systems. In this sense, only a small portion of our unacknowledged communicative talent and competence has been discussed. But it is an important part. Moreover, our examination of this small portion also describes certain general relationship between individuals, human society, and the symbolic environment. We have seen specifically how the making of snapshots and home movies can be treated as the creation of a symbolic world—a world of symbolic representations that both reflects and promotes a particular look at life. We concluded that the immense popularity and ubiquity of home mode imagery can be explained by emphasizing the diversity of personal, social, and cultural functions, some of which are rooted in covert and implicitly realized layers of cultural understanding. Continued examination of specific functional relationships surrounding home mode imagery will bring into focus other hidden dimensions of social and cultural significance.

But where do we go from here? This book was not written as a definitive study. Its objective has been to provide a useful starting point for many related kinds of speculation, observation, research, and hopefully, application. In order to understand better the relationship between sociocultural factors and home mode activity, comparative work is much needed. A discussion of several possible starting points might be useful.

Staying within the borders of the United States for a moment— what can be said of the subcultural diversity in American society?[2] Descriptions here have been limited to the home mode habits of white middle class Americans. Some perspectives would ask what people do who are not members of the dominant social class.[3] How do home mode images reflect differences when they are made by people who participate in different sectors of the socio-political scheme? Do alternative choices in settings and topics manifest differences in the consumer ethic? Do images made by people who occupy different positions in the labor force demonstrate various notions of leisure and freedom from work activities? Are there significant differences in the home mode views of the world among affluent versus low-income imagemakers? What role does ethnicity

or recent immigration play? Does religious affiliation, or urban, suburban, or rural residence make a difference? Do different patterns exist for large families, small families, and childless families? Or, do similarities far outnumber differences in all cases?

We have touched briefly on the possible influence of previous training in the arts, and only in reference to photography and filmmaking. Does some form of art training at the secondary school level or during college or graduate school make a difference in home mode activity? Does experience in other symbolic modes or in communication arts and sciences influence the emergence of alternative patterns? What about people who undertake long periods of training in certain professions? For instance, does being an architect, a family therapist or counselor, an airplane pilot, or even an anthropologist make any difference in the way people look at the world through cameras?

Using another set of reference points: what happens in home mode activity when people dramatically change their intimate personal relationships, their social affiliations or occupational roles, or even their place of residence? For instance, how does home mode communication change when people emigrate to another country? What are the dynamics of the process of divorce and possibly remarriage?[4]

Extend our inquiry beyond the confines of this country: what kinds of comparisons can be made with other nations of the world?[5] Do members of other Western cultures or Eastern cultures participate in Kodak culture in similar and familiar ways? For instance, Germany and Japan are known for their quality and quantity of camera production and use; do members of these "high-camera cultures" demonstrate different or similar patterns as outlined in previous chapters? In addition, we know that members of Third and Fourth World nations are making their own home mode imagery. Are patterns of participation significantly different from those of Western cultures? What models for choices of appropriate subject matter are being used? Are alternative psychological and social functions emerging?

Additional research in these areas will clarify further the diversity of human participation in personal pictorial symbol systems. We should be careful, however, that a zeal for difference does not blind us to the existence of similarities and the possibility of some pan-cultural behavior patterns. If we find that similarities outnumber trivial differences for all groups studied, we should be prepared to take the construct of Kodak culture even further. Speculation and consideration must be given to the fact that inexpensive camera equipment, produced for non-professional use in contexts of home mode communication, carries with

it some form of "operating instructions"—instructions that somehow provide a model for appropriate behavior on a cross-cultural basis.

A culture and communications approach would also have us investigate certain cross-media comparisons. One such area worthy of future study is the introduction of videotape technology as a replacement for home moviemaking and even snapshot making.[6] Little has been said in past chapters regarding the growing frequency and popularity of home videotaping. In comparison to home movies and snapshots, there is much less material to be examined at the moment. However, there is a growing sense of agreement that 8mm and Super-8 equipment will be phased out by videotape technology.[7] A brief review of the current situation may set the stage for future research.

Several forecasters have predicted a gradual decline in the use of celluloid film as a home mode medium paralleled by an increase in videotape.[8] The change appears to be occurring quite rapidly. Previous predictions claimed that portable videocassette recorders would make some movies obsolete, and that everyone "will have a video recorder because they're so easy to use and their uses are unlimited."[9] Richard Leacock, professional filmmaker and head of the Film/Video Section of the Massashusetts Institute of Technology, suggests that video will replace the use of Super-8 in the home market within two to five years.[10]

Marketing reports and sales data are quite revealing in these predictions. The sales of movie cameras dropped from 609,000 in 1977 to 180,000 in 1981 with the simultaneous increase of video cameras from 73,000 in 1979 to 115,000 in 1980.[11] Eastman Kodak no longer produces either 8mm or Super-8 movie cameras or projectors; the Polaroid Corporation discontinued production of its instant movie system in 1979 (only three years after it began).[12] Other reports indicate that most manufacturers of Super-8 equipment (mostly by Japanese firms) now have some form of video camera in production.

Not surprisingly, we also find advertisements for video technology enthusiastically endorsing a switch from film to video for home mode uses. These ads promote a standard fare of home movie settings and topics. For instance, in one Panasonic ad we read: "The little games with all those big moments. Your kid's first birthday. Your parents' 50th anniversary. Tape them now on the new Panasonic portable VHS so you can relive them years from now." From RCA we find: "There's never been a better time to videotape your little girl's birthday, New Year's Eve, a beautiful woman, or any of the once-in-a-lifetime events you live. RCA's new CCOIO video camera lets you capture them live and in color...." In an ad for Quasar equipment: "Shoot your own

videotape 'family album' in color and sound, show it easily anytime through your TV set. No hassle with projector and screen....Instant replay. Instant enjoyment. Instant check to be sure you got that once-in-a-lifetime shot. You just can't do it with ordinary 8mm film."[13] The Fotomat Corporation supports the use of videotape not by selling hardware, but by offering to transfer previously made movies and slides to video cassettes: "Every night across the face of America, families gather 'round to relive happy memories with their home movies and slides. Only to wish they'd gone bowling instead. Projector malfunctions, collapsing screens, tangled film, jumbled slides, impatient tots...all contribute to the nagging question: is it really worth it? The answer is simple. Fix it with tape." Of course, this assumes that people own video decks to make replay possible.[14]

We may be seeing another case of the same old wine in new bottles. Most of the video ads reviewed for this report do not deviate significantly in suggested lists of participants, topics, or settings; a continuity is maintained in choice of events and activities for video recording. One exception was noted in a 1975 *Penthouse* advertisement for the AKAI 1/4-inch video tape recorder. A bathrobed man lying in front of a fireplace is shown shooting a nude woman who is kneeling beside him; the caption reads: "Play and *instant* replay. You'll wrack your brain to think of a place where you can't use a video tape recorder. We're showing only one of thousands of ways to get it on...on video tape."

The question remains: will new equipment dramatically alter event/component patterns established with previous technology? Will non-professional use of video promote and produce a distinctly different pattern of topics, settings, and participants? Will conventionalized code characteristics, familiar to the home movie, be altered with the use of video cameras and different capabilities of video recorders? Will the instant feedback qualities of video technology alter fundamental relationships between shooting events and exhibition events? How will home movie viewers react to small screen images?

We must keep in mind that technological change has not determined different use patterns in the home mode in the past. Home moviemakers generally copied what snapshooters did. With minor exceptions, even instant camera technology—such as Polaroid cameras and even the Polavision instant movie system—did not radically transform traditional camera use;[15] nor did the addition of sound recording capabilities to home moviemaking equipment create radically different patterns. We have seen that home mode camera users do not take advantage of technological potential on any regular basis. While the potential for

creating an alternative scheme of settings, topics, participants, and code conventions exists, the possibilities are generally not exploited.[15] [a] Thus, even with the introduction of video, traditional patterns of appropriate subject matter and view of the world may continue to remain relatively stable.

The event/component framework can be used to describe and analyze what will happen as video technology becomes popularly accepted as part of home mode communication. We have developed a social perspective to observe and study the effects of video adoption—which may produce meaningful changes in home mode patterns, but will more likely merely add much more of the same.[16] And so, speculations like the following may be too extreme:

> The video recorder, in other words, has been responsible for bringing huge new pile of information into our home. No one yet is laying odds whether it will bring us closer and enhance our lives, or blow us all off the face of the map. It could just as easily go either way.[17]

Our finding is different. It is that technological innovations are, and will continue to be, less important than *culture*'s contribution to providing a continuity in a model and pattern of personal pictorial communication.

In 1959, the renowned science fiction writer Arthur C. Clarke, wrote an entertaining short story entitled "History Lesson."[18] Clarke tells the story of how a group of explorers from Venus came to earth long after glaciers recovered the planet, forcing the end of human experience. The Venusian team of scientists studying "the Third Planet" was led by a historian, who reviewed their lack of knowledge regarding Planet Three's language systems, reasons for the collapse of civilization, or any information on the physical features of former inhabitants. Then he announced a major breakthrough: they had discovered "a flat metal container holding a great length of transparent plastic material, perforated at the edges and wound tightly into a spool.... Along the surface of the material...are literally thousands of tiny pictures."[19] The historian proudly announced that "after hundreds of years of research, we have discovered the exact form and nature of the ruling life on the Third Planet.... These pictures apparently form a record of life...at the height of its civilization.... They show a complex civilization, many of whose activities we can only dimly understand."[20] The scientists realized that they needed many more years of research and analysis to understand what they were seeing. Clarke continued his story by describing how "... The psychologists of Venus would analyze its [a character in the

pictures] actions and watch its every movement until they could reconstruct its mind. Thousands of books would be written about it. Intricate philosophies would be contrived to account for its behavior."[21] While the team of Venusians temporarily concluded that this important record was "a work of art, somewhat stylized, rather than an exact reproduction of life as it actually had been on the Third Planet;"[22] Clarke's narrator stated that the images would continue to symbolize the human race. But an enigma remained for interpreters; without adequate decoding of Planet Three speech, the final words that appeared at the end of the transparent tape could never be understood, namely, "A Walt Disney Production."

The fictional tale may serve as an encouragement—and warning— to future ethnographic studies of pictorial forms. While Clarke was not, in fact, describing a home movie, we find similar mistakes reflected in less fictional contexts of advice columns and general commentary:

> When made in familiar environments, home movies are a form of social game.... But a few years from now, your social game has become a social document. It's a genuine form of folk art that shows how people lived in those days. The archaeologist scratching through the dust of time—don't you think he'd like to see home movies made in Sparta? One day, sociologists might seize upon your reels with glee to see how people actually prepared and consumed those old organic substances they called food, made ready in those primitive contrivances called microwave ovens, and devoured by means of that quaint and ancient ritual known as chewing. Ours are the most fully documented private lives ever led on this earth...[23]

This author may be confusing a home movie with an anthropologically produced ethnographic film on American culture. A more cautious perspective is offered by Margery Mann:

> Few of today's amateur snapshots would provide a future anthropologist with any insight into the culture that produced them. The people are isolated in space and captured at an artificial instant in time.... A future anthropologist might learn something of our architecture from the photographs of our houses, but I am sure that he would be bewildered by our quaint tribal custom of having our photographs made in front of our national landmarks.[24]

Of all forms of photographic and filmic recording that in any way present, illustrate, or illuminate the human and sociocultural condition, home mode images are stereotypically thought to show the most accurate and realistic picture of everyday life. And this may be the case on a relative scale. However, if Martians or Venusians should study our home movies long after we have ceased to exist, they would be studying a carefully contrived and biased view of everyday life. Observers could not

make valid inferences about the behavior shown on film without knowing how home movies function as a specific product of symbolic manipulation, how this product is used within a specific process of visual communication, and what the significance of this process is within a cultural context. This is true for any form of visual representation from which we try to gain knowledge about the state of the human and social condition.

The material presented in previous chapters should clarify the Venusian dilemma and the comments made by Sutherland and Mann. We can understand better the naive and genuine popular appreciation of home mode imagery as depicting and preserving "things as they really are." We have attempted to provide evidence for the multidimensional connections between related genres of photographic imagery and the social and cultural contexts that make a particular mode of visual communication work. Knowledge of social and cultural contexts provides a basis for interpreting how home mode imagery "means" a world, constructs a reality for part-time participation, and functions as part of a symbolic environment. Establishing patterns of these relationships should increase our sensitivity to interpreting the significance of other genres and modes of pictorial communication used in contemporary times as well as examples used by people in different spatial and temporal contexts. We are now better "armed" for when we "discover" other people, or, as Clarke suggests, for when other "people" discover us.

Notes

Chapter One

[1]Paul Byers, "Photography in the University," no reference, 1965, files of the author.

[2]Smith suggests a three by three matrix for integrating culture and communication: "The three investigators—mathematicians, social psychologists, and linguistic anthropologists—and the three divisions—syntactics, semantics, and pragmatics—form an organizational matrix for the study of human communication." *Communication and Culture*, Alfred G. Smith (ed.) (New York: Holt, Rinehart and Winston, 1966), p. 7.

[3]Ernst Cassirer, *An Essay on Man* (New Haven: Yale University Press, 1944).

[4]Ibid, p. 25.

[5]Sol Worth, "An Ethnographic Semiotic," unpublished paper (1977), files of the author.

[6]Nelson Goodman, *Ways of Worldmaking* (Indianapolis: Hackett Publishing Co., 1978), p. 1.

[7]Sol Worth, "Doing the Anthropology of Visual Communication," *Working Papers in Culture and Communication* 1(2):2-20(1976), published by the Department of Anthropology, Temple University, Philadelphia, Pa., p. 9.

[8]In a similar perspective, art critic John Berger emphasizes that all images are man-made: "An image is a sight which has been recreated and reproduced. It is an appearance, or a set of appearances, which has been detached from the place and time in which it first made its appearance and preserved—for a few moments or a few centuries. Every image embodies a way of seeing. Even a photograph. For photographs are not, as is often assumed, a mechanical record. Every time we look at a photograph, we are aware, however slightly, of the photographer selecting that sight from an infinity of other possible sights. This is true even in the most casual family snapshot." See *Ways of Seeing*, John Berger *et al.* (New York: Viking Press, 1972), pp. 9-10.

[9]Sol Worth, 1976, p. 18.

[10]For an explicit statement of this perspective, see Paul Byers, "Cameras Don't Take Pictures," *Columbia University Forum* 9(1): 27-31 (1966).

[11]Other studies that have used this perspective include "Film Communication: A Study of the Reactions to Some Student Films" by Sol Worth, *Screen Education* (July/August, 1965), pp. 3-19; *Through Navajo Eyes* by Sol Worth and John Adair (Bloomington: Indiana University Press, 1972); "A Sociovidistic Approach to Children's Filmmaking: The Philadelphia Project" by Richard Chalfen, *Studies in Visual Communication* 7(1): 2-32 (1981).

[12]Introducing a sensitive integration of phenomenology and semiotics, communication scholar John Carey addresses this problem as follows: "A cultural science of communication then views human behavior, or more accurately human action, as a text. Our task is to construct a "reading" of the text. The text itself is a sequence of symbols—speech, writing, gestures—that contain interpretations. Our task, like that of a literary critic, is to interpret the interpretations. We are challenged to grasp hold of the meanings people build into their words and behavior and to make these meanings, these claims about life and experience, explicit and articulate. We have to untangle...the meanings...." See "Communication and Culture," *Communication Research* 2(2):187 (1975).

[13]References that come immediately to mind include *Life on Television* by Bradley S. Greenberg (Norwood, NJ: Ablex Publ. Corp., 1980); *The Soap Opera* by Muriel G. Cantor and Suzanne Pingree (Beverly Hills, CA: Sage Publ., Inc., 1983); *The TV Establishment* edited by Gaye Tuchman (Englewood Cliffs, NJ: Prentice-Hall, Inc., 1974).

[14]Examples here include *The Cartoon—Communication to the Quick* by Randall P. Harrison (Beverly Hills, CA: Sage Publ., Co., 1981); *Gender Advertisements* by Erving Goffman, *Studies in the Anthropology of Visual Communication* 3(2), 1976.

[15]Sol Worth, "Pictures Can't Say Ain't" *Studying Visual Communication*, L. Gross (ed), (Philadelphia, PA: Univ. of Pennsylvania Press, 1981), p. 165.

[16]The proposed examination of private pictures will not follow Freudian or Jungian models of interpretation as suggested by historian Michael Lesy. See *Time Frames—The Meaning of Family Photographs* (New York: Pantheon Books, 1980).

[17]Contrast is made to a "public message system" as discussed by George Gerbner (see "Communication and Social Environment," *Scientific American* 277 (3): 152-160) and a "public symbol system" as described by W. Lloyd Warner (see "Mass Media: A Social and Psychological Analysis," *American Life* (Chicago: Univ. of Chicago Press, 1962)).

[18]For instance, snapshot makers do not consider "publishing" their pictures in popular magazines, daily newspapers, as postcards or posters nor in such exhibition contexts as museums, photo galleries, or in photo contests. For a dissenting view, see Jon Holmes' "Pictures without Exhibition," *The Village Voice*, November 29, 1976, pp. 67, 69; for agreement, see Michael Lesy's "Snapshots: Psychological Documents, Frozen Dreams," *Afterimage* 4(4): 12-13.

[19]In addition, this use of the word "mode" is related to neither statistical "mode" nor to "mode of production," which commonly suggests a Marxist orientation—a perspective that may prove useful in relation to other kinds of questions.

[20]Readers should understand that people may refer to "Kodak" and "Polaroid" in a generic sense rather than as a specific reference to two brands of photographic equipment and supplies. I have interviewed young children who could talk about their parent's "Polaroid" or "Instamatic" but didn't know the meaning of the word "camera."

[21]Stanley Milgram, "The Image-Freezing Machine," *Psychology Today* (January, 1977), p. 52. In another instance, the author of a guidebook on home videomaking confesses: "I would not be writing this book had I not served a long (and generally unwitting) apprenticeship in the home-movie culture under my mother. She bought an 8-mm camera in 1950 and for the next three decades, never missed a trip, birthday, or significant family event." See *Making Home Video* by John M. Bishop and Naomi H. Bishop (New York: Wideview Press, 1980), p. 3.

[22]Here I am borrowing selectively from Ward Goodenough's notion of culture as a system of knowledge and standards: "A society's culture consists of whatever it is one has to know or believe in order to operate in a manner acceptable to its members.... It is the form of things that people have in mind, their models for perceiving, relating, and otherwise interpreting them. (See "Cultural Anthropology and Linguistics," *Report of the Seventh Annual Round Table Meeting on Linguistics and Language Study*, Paul Garvin (ed.) (Washington, D.C.: Georgetown University Monograph Series, 1957), p. 522.) However, we will explore the operationalization of this knowledge system. For critical comment see Clifford Geertz, *The Interpretation of Cultures* (New York: Harper Colophon Books, 1973), p. 10-13. For a response from Goodenough, see *Culture, Language, and Society* second edition (Menlo Park, CA: The Benjamin/Cummings Publishing Co., Inc., 1981), pp. 53-54. Goodenough's 1981 statement is: "We shall reserve the term *culture* for what is learned, for the things one needs to know in order to meet the standards of others. And we shall refer to the material manifestations of what is learned as *cultural artifacts*" (1981:50).

[23]For a novelist's treatment of these questions, see *A Family Album* by David Galloway (New York: Harcourt Brace Jananovich, 1978).

[24]For a controversial overview, see E. Richard Sorenson, "Visual Evidence—An Emerging Force in Visual Anthropology," *Occasional Papers, National Anthropological Film Center*, No. 1, December, 1975. Several problems associated with the "evidence" question are suggested by the following observation: "Future anthropologists, if they studied

our culture from home photo albums alone, would probably conclude that this breed of man lived mostly at Christmas, indulged in a ritual with colored eggs at Easter, graduated from institutions frequently, celebrated birthdays mostly while young and had lots of small animals. Further, they would conclude, children were usually fresh scrubbed, and spent a great deal of time standing around squinting into the sun." See Denise McCluggage, "How to Make the Merriest Photographs Ever," *American Home* (December) 1972.

[25]Sol Worth, "Margaret Mead and the Shift from Visual Anthropology to the Anthropology of Visual Communication," *Studies in Visual Communication* 6(1): 18 (1980).

[26]The relative importance of "serious" photography is mentioned by critic Alan D. Coleman as follows: "...to take a long hard look at the role of photography in our culture, it becomes apparent that a radical redefinition of our concept of the photography community is necessary. For too long we have assumed that it included only "serious" or "artistic" photographers, curators, and that small public specifically interested in viewing, purchasing, and reading the works of these three groups. . . In light of the omnipresence of photographic imagery and the medium's manifold offshoots in our culture today, the elitist parochialism of this concept is painfully obvious." See *Light Readings* (New York: Oxford Univ. Press, 1979), p. 90.

[27]For examples, see *The Snapshot Photograph—The Rise of Popular Photography, 1888—1939* by Brian Coe and Paul Gates (London: Ash and Grant Ltd., 1977): *The Instant Image* by Mark Olshanker (New York: Stein and Day, 1978); *Images and Enterprise: Technology and the American Photographic Industry, 1839-1925* by Reese V. Jenkins (Baltimore, 1976).

[28]Magazine advertisement for Kodak products.

[29]*The 1983-84 Wolfman Report on the Photographic Industry in the United States* by Augustus and Lydia Wolfman (New York: ABC Leisure Magazines, Inc.). This annual report, used by retail outlets, contains figures on estimated sales of photographic equipment, film and supplies, photofinishing services, general buying trends, and tabulations of the "Gross National Photo Product."

[30]Lisette Model, no title, *The Snapshot*, J. Green (ed.) (Millerton, NJ: Aperture), p. 6. Model goes on to explain why professional photographers can never make snapshots because of a loss of "innocence...the quintessence of the snapshot...."

[31]Mihaly Csikszentmihalyi and Eugene Rochberg-Halton, *The Meaning of Things—Domestic Symbols and the Self* (New York: Cambridge University Press, 1981), p. 67. Also see p. 95, Table 4.1.

Chapter Two

[1]Bronislaw Malinowski, *Argonauts of the Pacific* (New York: E.P. Dutton & Co., 1961 (1922)), p. 25.

[2]Dell Hymes, "Introduction: Toward Ethnographies of Communication," *The Ethnography of Communication*, John Gumperz and Dell Hymes (eds.), *American Anthropologist* 66 (2, Pt. 2): 1-34 (1964). Other publications by Hymes that are immediately relevant to this perspective include: "The Ethnography of Speaking," *Anthropology and Human Behavior*, Gladwin and Sturtevant (eds.), (Washington, D.C.: Anthropological Society of Washington, 1962), pp. 15-53; "Models of the Interaction of Language and Social Life," *Directions in Sociolinguistics*, Gumperz and Hymes (eds.), (New York: Holt, Rinehart and Winston, 1972), pp. 35-71.

[3]Dell Hymes, "The Anthropology of Communication ," *Human Communication Theory*, Frank Dance (ed.), (New York: Holt, Rinehart and Winston, 1967), p. 25.

[4]Sol Worth, "Doing Anthropology of Visual Communication," *Working Papers in Culture and Communication*, Temple University, Philadelphia 1 (2):2-21 (1976).

[5]Sol Worth, "An Ethnographic Semiotic" unpublished paper, 1977, files of the author. A revision of this paper "Toward an Ethnographic Semiotic" was given during a UNESCO

conference entitled "Utilisation de L'ethnologie par le Cinema/Utilisation du Cinema par L'ethnologie," Paris, 1977.

[6] I am indebted to Dell Hymes for suggesting this line of questioning in reference to research in sociolinguistics and, specifically, in the ethnography of speaking. Hymes' original statement appeared as follows: "The question as to relations implies determination of the way in which rules of proscription and prescription constitute a system in the community by providing that it is not the case that anyone can say anything to anyone in any form by any channel in any code in any setting of time and place." (1967:26).

[7] Other statements of the hypothetical freedom of picture-taking choice have been made by several authors. From a legalistic point of view we read the following: "Right now, suppose you, the photographer, are walking down 42nd Street in New York City. You want to take pictures of everything you see: trees, cars, buildings, derelicts, theatres, ladies of the night, men of the day, snack bars, etc. Can you do it? Of course you can. Take whatever you want. Ah, generally, that is. We have to add a few qualifications. There are certain restrictions...but understand first that you can take all the pictures you want. Later on we will discuss whether you can use them" (Robert M. Cavallo and Stuart Kahan, *Photography: What's The Law?* New York: Crown Publishing, Inc. 1976, p. 1). In another context Michael Lesy notes that after looking through thousands of individual examples of snapshots from many different collections, "you begin to lose track of the idea of people's individuality and freedom of choice as guaranteed by the U.S. Constitution and the Bill of Rights" (*Time Frames—The Meaning of Family Pictures* (New York: Pantheon Books, 1980) p. xii). And in another articulation of a similar idea, social psychologist Stanley Milgram notes: In principle, the camera could be used to record any visual event: stars, lakes, garbage, loaves of bread. But overwhelmingly, what people wanted to record were images of themselves and their loved ones ("The Image-Freezing Machine" *Psychology Today*, Jan., 1977, p. 50). And for an additional statement of frustration regarding the amateur photographers failure to leave a more complete source of visual history, see *The Snapshot Photograph—The Rise of Popular Photography* by Brian Coe and Paul Gates (London: Ash and Grant, Ltd., 1977) p. 11.

[8] This event/component organization has been referred to as a "sociovidistic framework" in several previous publications by the author.

[9] Evidence and application of this integrated perspective appear in the following papers by the author: "Reactions to Socio-Documentary Filmmaking Research in a Mental Health Clinic," (with Jay Haley), *American Journal of Orthopsychiatry* 41(1):91-100 (1971); "How Groups in Our Society Act when Taught to Use Movie Cameras" (with Sol Worth), *Through Navajo Eyes*, Sol Worth and John Adair (Bloomington: Indiana University Press, 1972), pp. 228-251; "Film as Visual Communication: A Sociovidistic Study in Filmmaking," unpublished Ph.D. dissertation (Philadelphia: University of Pennsylvania, 1974); "A Sociovidistic Approach to Children's Filmmaking: The Philadelphia Project," *Studies in Visual Communication* 7(1):2-32 (1981).

[10] In non-home mode contexts, we may be describing such activities as learning to use equipment, organizing a film production in terms of contracting a director, camera operators, lighting crew, sound recordists, grips, etc., auditioning acting personnel, making pre-production agreements for on-location shootings, doing historical research, preparing and editing a script, among other examples.

[11] Denise McCluggage, "How to Take the Merriest Photographs Ever," *American Home*, December (1972).

[12] Ralph Hattersley, "Family Photography as a Sacrament," *Popular Photography*, June (1971), p. 106-108.

[13] According to this formulation, various methods of coloring, painting, scratching, or puncturing pieces of unexposed celluloid or light sensitive paper are not included. However, these techniques may be included as part of "editing activity."

[14]The relationship of on-camera performance to image management is discussed by Boerdam and Martinus in "Family Photographs—A Sociological Approach" *The Netherlands' Journal of Sociology* 16(2): 95-119 (1980).

[15]Personal thanks to Jim Linton for sending me this clipping from the *Windsor Star* (Ontario), July 17, 1979.

[16]No author, *Woman's Day*, January (1979).

[17]For a discussion of the "mise en scene" of family photography—as kinds of "arranging, directing, and posing" (determined by the photographer)—see Boerdam and Martinus (1980). Their mention of "compulsory casualness" may, in fact, differ across social groups (class, age, ethnicity).

[18]*The Globe* (Ontario), July 5, 1980. Again, thanks to Jim Linton.

[19]*The Evening Bulletin* (Philadelphia), September 30, 1975.

[20]Christopher Musello adapted this framework for his MA thesis study of family albums. He suggested the addition of one editing related event namely "Processing events" which he describes as "all methods and activities through which photographs are developed and/ or printed" (1979: 105). I have not found this additional event particularly helpful and prefer to incorporate this activity into "editing."

[21]Myron A. Matzkin, *Family Movie Fun for All* (New York: American Photographic Book Publishing Co. Inc., 1964), p. 79.

[22]Robert Fanelli, "The Practice of Popular Still Photography: An Ethnography of the Home Mode of Visual Communication," unpublished Senior Honors Thesis, Department of Anthropology, Temple University (1976).

[23]An extreme example is provided by family therapist Jack Friedman who reports that "one of the things people do when they get very angry is rip up photographs and destroy movies, as though they're saying 'the things we treasured, I don't acknowledge any more' " (Janet Gardner, "Family Photographs," *Glamour*, November (1979), p. 308).

[24]In this formulation, "public" contexts do not include the viewing of rushes or edited work prints on a viewer or projector by the filmmaker or editor alone. These activities are classified as "private" showings and are better categorized as editing events. Exhibition events (in non-home mode contexts) may occur in many settings such as a downtown movie theatre, a classroom, a drive-in theatre or a livingroom.

[25]Leonard S. Bernstein, "How to Stop Them—After They've Photographed Paris," *House Beautiful*, October, 1972, pp. 171-172.

[26]Gardner, 1979, p. 308.

[27] *Philadelphia Inquirer*, April 20, 1981.

[28]David Jacobs argues that the selection of participants from the nuclear family and their "remarkably enclosed and discrete set of interrelationships is...the major defining characteristic of most snapshots." See "Domestic Snapshots: Toward a Grammar of Motives" *Journal of American Culture* 4(1):100 (1981).

[29]*Philadelphia Inquirer*, no date.

[30] *The New Mexican*, January 10, 1982.

[31]Taken from "Homemode Photography," an unpublished paper by Juanita Lavalais, 1980.

[32]*Evening Bulletin* (Philadelphia), March 25, 1973.

[33]See "Utilization of Family Photos and Movies in Family Therapy," *Journal of Marriage and Family Counseling*, January, 1977. Further discussion in later chapters will show that Kaslow and Friedman are generally correct about the relationship between photography and sickness. However, their comment on casts is questionable because people in various states of repair can be photographed, especially people with non-permanent injuries. People feel more comfortable photographing the repair and recovery views than the damaged ones.

[34]Gene Thornton, "Four Who Are Battling the British Establishment," *New York Times*, September 20, 1970. The letter originally appeared in *Punch Magazine* in 1855.

[35]See Christopher Musello, 1980, p. 41 (figure 13).

[36]Stanley Milgram, "The Image Freezing Machine," *Psychology Today*, January, 1977, p. 54.

[37]John Collier, Jr., "Photography and Visual Anthropology," *Principles of Visual Anthropology* (Chicago: Mouton/Aldine, 1975), p. 216.

[38]For an overview of how the snapshot, as a message form, gets "used" in other contexts for other communicative tasks, see Chapter Eight.

[39]Jonathan Green (ed.), *The Snapshot*, (Millerton, N.Y.: Aperture, 1974), p. 15.

[40]From a statement made by Peter Clagdon found in Alan D. Coleman, *Light Readings* (New York: Oxford University Press, 1979), p. 86-87. Emphasis in the original.

[41]For another description of code and the way that Sol Worth and John Adair chose to structure a notion of cinematic codes for their analysis of Navajo filmmaking, see their book *Through Navajo Eyes* (Bloomington: Indiana University Press, 1972), p. 140-141.

[42]For instance, in studying behavioral codes associated with the home mode, we would ask if changes occur when tourist photographers take pictures of non-family members.

[43]In other contexts and non-home mode genres of filmmaking, we might be talking about juxtaposing an establishing shot with a medium shot followed by a close-up; or, we might be describing the use of reaction shots or problems of matching action and continuity, specialized use of pans, tilts, tracking or dolly shots, the use of fades, dissolves, zooms, super-impositions, double exposure, single framing, pixilation techniques, and the like. Most of this is not relevant to the analysis of home mode codes.

[44]James Potts, "Is There an International Film Language?" *Sight and Sound* 48(2):74 (1979).

[45]Ibid., p. 79.

[46]Jonathan Green, "Photography as Popular Culture," *Journal of the University Film Association* 30(4):15 (1978).

[47]Other code characteristics are mentioned by Karin Ohrn as she summarizes some of the aesthetic features that characterize the amateur-made snapshot; "A subject may be slightly off-center, movement may be blurred, someone may be bisected by the edge of the frame. Harsh contrasts between light and shadow often are included, even on a subject's face. The horizon may be off-kilter, and unintended objects often intrude.... The subjects often appear in stiffly formal poses or ludicrously off guard. Although all of these aspects would seldom characterize any single photograph, together they represent the conventional forms which appear repeatedly in amateur's home photographs," See "The Photoflow of Family Life: A Family's Photograph Collection," *Folklore Forum* 13:8 (1975).

[48]Don Sutherland, 1977, p. 40.

[49]Tony Galluzzo, "What is happening to the 'home movie'?" *Modern Photography*, January (1975), p. 52.

[50]In part, this explains why so many snapshots leave a lot of space above people's heads, as seen in photographs 3, 4, 6, 10, 19, 20.

[51]George A. Theodorson and Achilles G. Theodorson, *A Modern Dictionary of Sociology* (New York: Barnes and Noble, 1969), p. 276-277.

[52]G. Chernoff and H. Sarbin, *Photography and the Law*, Fourth Edition (New York: Amphoto, 1971); R. M. Cavallo and S. Kahan, *Photography: What's the Law?* (New York: Crown Publishing, Inc., 1976).

[53]Chernoff and Sarbin, 1971, p. 11-12.

[54]Sarah Ryder, "A Teacher Tells Ups and Downs of Soviet Tour," *New York Times*, no date.

[55]Gary Haynes, *Philadelphia Inquirer*, September 17, 1978.

[56]Chernoff and Sarbin, 1971, p. 79. Other problems associated with legal definitions of obscenity and "hard core pornography" would require lengthy discussion and be out of place at this point. In summary, a trend that condones behavior "occurring between

consenting adults, behind closed doors" appears to be regulating behaviors associated with photographic imagery.

[57]Charles Lally, "Home pornography's dirt-cheap—And now processors will print it." *Philadelphia Inquirer* no date.

[58]Gary Haynes, 1978.

[59]Letter appeared in *Popular Photography*, November, 1968.

[60]Erving Goffman notes that theatrical actors cope with such audience disturbances as coming in late, and noises such as coughing, sneezing, premature clapping, and the like, but will "often be unwilling to tolerate being photographed. So, too, sometimes concert artists." He goes on by offering the following account: "But the crowning stupidity occurred during Andres Segovia's recital, when a nut in the audience actually stood up and tried to photograph him—at which the Master stopped playing and called out in a touching misuse of the language: 'Impossible, please!' " (*Frame Analysis* (New York: Harper and Row, 1974), p. 208).

[61]Chernoff and Sarbin, 1971, p. 136.

[62]See "I Can Shoot You Any Time I Want" by Jeanie Kasindorf (*TV Guide*, April 27, 1974, p. 24-26) for a discussion of how the Hollywood paparazzi circumvent certain legal restrictions.

[63]For instance, Boerdam and Martinus remind us that selection criteria for photographic norms started very early in the history of photography: "These norms and applications now strike us 'given' or 'obvious,' but in effect they are in considerable part the results of unplanned social process in which it has been established what aspects of community life it is appropriate to photograph" (1980:99).

Chapter Three

[1]Examples include a series of Eastman Kodak publications, with such titles as *How to Make Good Home Movies* (1966), *Better Movies in Minutes* (1968), *Home Movies Made Easy* (1970). Other examples include Myron A. Matzkin's *Family Movie Fun For All* (New York: American Photographic book Publishing Co., Inc., 1964), Bob Knight's *Making Home Movies* (New York: Collier Books, 1965) among others. Another category of books offers instructions on making "professional" films at home or making home "movies" look like "films," or, even better, "cinema." Titles include *How to Make Exciting Home Movies and Stop Boring Your Friends and Relatives* by Ed Schultz and Dodi Schultz (Garden City, N.J.: Doubleday, 1973), *Make Your Own Professional Movies* by Nancy Goodwin and James Manilla (New York: Collier Books, 1971), and *The Family Movie-Making Book* by Jay Garon and Morgan Wilson (Indianapolis: Bobbs-Merrill, 1977).

[2]Richard Hill and Kathleen Crittenden (eds.), *Proceedings of the 1968 Purdue Symposium on Ethnomethodology* (Institute Monograph Series No. 1, 1968), p. 55.

[3]Weston La Barre, "Comment on Hall," *Current Anthropology* 9(2-3):101-102; for a short discussion of the relationship between glances used in everyday life and posing for a still camera, see "Temporal Parameters of Inter-personal Observation" by David Sudnow, *Studies in Social Interaction*, D. Sudnow (ed.), (New York: The Free Press, 1972), pp. 259-279.

[4]Edmund Carpenter, *Oh, What a Blow That Phantom Gave Me!* (New York: Holt, Rinehart and Winston, 1972), p. 59-60.

[5]David MacDougall, "Prospects of the Ethnographic Film," *Film Quarterly*, 23(2): p. 16-30 (1969-70).

[5a]However, home movies may become more important as they are slowly replaced by home videotape. For instance, I have recently learned that a special issue of the *Journal of Film and Video* will be published in 1987 on the subject of home movies. Editor Patricia Erens has solicited papers from such film scholars as Chuck Kleinhans, B. Ruby Rich, Laura Mulvey, and Pat Zimmermann.

[6]Nicholas Pileggi, "The Making of 'The Godfather'—Sort of a Home Movie," *New York Times Magazine*, August 15, 1971.

[7]Jonas Mekas, *Movie Journal* (New York: Collier Books, 1972).

[8]Edward S. Small, "The Diary Folk Film," *Film Library Quarterly* 9(2):35-39 (1976).

[9]J. Hoberman, "There's No Place Like Home Movies," *The Village Voice*, April 24, 1978.

[10]Elisabeth Weis, "Family Portraits," *American Film* 1(2):54-59 (1975).

[11]John Stuart Katz, "Autobiographical Film," *Autobiography—Film/Video/Photography*, J.S. Katz (ed.), (Ontario: Art Gallery of Ontario, 1978), p. 5.

[12]Anonymous, "How You Can Make Better Home Movies," *Better Homes and Gardens*, November, 1968, pp. 132-4. In fact, one entire home movie manual was organized and written around the notion of planning. An introductory statement reads as follows:

No one can produce a successful film without planning it. The only question is *when* we are going to do the planning. At first, we may leave it until editing, so the first section is devoted to Planning After Filming. Then we see the advantages of Planning During Filming.... Finally, we become sufficiently experienced to attempt Planning Before Filming, and this is discussed in the third and main section.

(Philip Grosset, *Planning and Scripting Amateur Movies* (London: Fountain Press, 1963), p. 6.) This short quotation mentions three of the four types of communication events, namely planning, filming, and editing. The neglect of exhibition activity is not an uncommon characteristic of the HTDI manuals.

[13]Schultz and Schultz (1973), Goodwin and Manilla (1971) and Uwe Ney, *How to Shoot Home Movies* (New York: Crown Publishers, 1978).

[14]Schultz and Schultz, 1973, p. 38.

[15]Anonymous, 1968, p. 134.

[16]Schultz and Schultz, 1973, pp. 97-98.

[17]Kodak, 1966, p. 26.

[18]Matzkin, 1964, p. 24.

[19]Kodak, 1966, p. 18; see also p. 54.

[20]Anonymous, 1968, p. 132.

[21]Don Sutherland, "A Good Home Movie is Not Necessarily 'Well Made'," *Popular Photography*, October, 1971.

[22]Matzkin, 1964, p. 25; see also Kodak, 1966, p. 18.

[23]Smith, 1975.

[24]Schultz and Schultz, 1973, p. 106.

[25]Don Sutherland, "You Ought'a Be in Pictures and So Should Your Whole Family," *Invitation to Photography* (published by *Popular Photography*), Spring, 1977, p. 42.

[26]Sutherland, 1971, p. 123.

[27]Schultz and Schultz, 1973, p. 14.

[28]Kodak, 1966, p. 72.

[29]Kodak, 1968, p. 39, 23. See also Kodak, 1966, p. 8.

[30]For examples of representative statements, see Matzkin, 1964, p. 5; *Now That You're in Show Business* (A Bell and Howell publication, no date), p. 1; Kodak, 1968, p. 9; Kodak, 1966, p. 9.

[31]Bell and Howell, n.d., p. 9.

[31a]Kodak, 1966, p. 36.

[32]Camera advertisements clearly foster this attitude, presenting an image of the helpless picturetaker who needs the totally automatic and, in some cases, computer programmed camera.

[33]Kodak, 1968, p. 9.

[34]As one advertisement for GAF products suggests: "How much would it be worth to you...to keep a complete filmed record of your family's life together?"

[35]Kodak, 1966, p. 54; also see Anonymous, 1968, p. 134.

[36]Sutherland, 1971, p. 122. Jonas Mekas, avant-garde filmmaker and film critic for *the Village Voice*, praises the film *Man of the House*, made in 1924 by Carl Dreyer, for his attention to everyday things and activities:

...the film is full of most precise and most beautiful details from the daily life at the beginning of the century. All the little things that people do at home, in their livingrooms, in their kitchens, you can almost smell and touch every smallest activity, detail. In a sense one could look at it as an ethnographic film. (*The Village Voice*, April 2, 1970). This extreme attention to everyday detail may, in fact, belong to another film genre, either that of the "art" film or the "ethnographic" film, but not home movies.

[37]This distinction is important in some but not all genres of film communication. For instance, in a Hollywood production, the setting of a filming event may be a studio or a studio lot, but the setting for action in the film might be a Western saloon, a livingroom, an airplane interior, and the like.

[38]Moviemakers may feel awkward when their private images are shown in public places. One example is provided by Harry Dawson, Jr. who entered his home movie entitled *Dawson Family Album* in the first annual Oregon Filmmakers Festival. The film was given "first place and sparked a very lively local controversy. I was chagrined; here's my private home movie up in front of everyone, some identify with it, others cry hoax! I was very upset.... To me it's still mostly for family..." [personal communication].

[39]Article appeared in *the Toronto Star*, August 18, 1975. Personal thanks to Jim Linton.

[40]Schultz and Schultz, 1973, p. 91; emphasis in the original.

[41]Schultz and Schultz, 1973, p. 101.

Chapter Four

[1]Recent radio and television commercials end with the line: "...the great American storyteller is Kodak and you."

[2]Readers are reminded that claims are not being made for *all* white middle class members of American society. Generalizations are offered as a characteristic pattern of this display of life.

[3]Alan D. Coleman, "Autobiography in Photography," *Camera 35* 19(8):34 (1975).

[4]Steven Halpern, "Souvenirs of Experience: The Victorian Studio Portrait and the Twentieth Century Snapshot," *The Snapshot*, J. Green (ed.), (Millerton, N.Y.: Aperture, 1974), p. 64. See also Mark Silber, *The Family Album* (Boston: David R. Godine Press, 1973), p. 15-16.

[5]Paul Strand, "Interview," *The Snapshot*, J. Green (ed.), (Millerton, N.Y.: Aperture, 1974), p. 47, 49.

[6]Lisette Model, no title, *The Snapshot*, J. Green (ed.), (Millerton, N.Y.: Aperture, 1974), p. 6.

[7]For a short discussion of the "aesthetic organization" of the snapshot in comparison to the studio portrait, see Judith Gutman's comments in "Family Photo Interpretation" by Joan Challinor (*Kin and Communities—Families in America*, Allan J. Lichtman and Joan Challinor (eds.), Washington, D.C.: Smithsonian Institution Press, (1979), p. 240-246).

[8]Jonathan Green, "Introduction," *The Snapshot* (Millerton, N.Y.: Aperture, 1974), p. 3.

[9]John Kouwenhoven, "Living in a Snapshot World," *The Snapshot*, J. Green (ed.), (Millerton, N.Y.: Aperture, 1974), p. 106-107.

[10]Ibid., p. 106.

[11]Willard Morgan, "Snapshot Anniversary," *Popular Photography*, October, 1974, p. 28. Bruce Downs has also attempted to understand "snapshooting" as an inseparable part of American life: "In less than sixty years we have become a nation of photographers—snapshooters most of us, yes, but photographers none the less, producing a folk art of

our own. It is an art born of personal affection for people and things." See "Human Interest—Snapshots," *Popular Photography* 4(5):38 (1944).

[12]Richard Christopherson, "From Folk Art to Fine Art," *Urban Life and Culture* 3(2): 127 (1974).

[13]Ken Graves and Mitchell Payne, *American Snapshots* (Oakland, CA: The Scrimshaw Press, 1977), p. 9. For additional comment see Richard Chalfen, "Exploiting the Vernacular: Studies in Snapshot Photography," *Studies in Visual communication* 9(3):70-84 (1983).

[14]Henry Glassie, *Pattern in the Material Folk Culture of the Eastern United States* (Phila.: Univ. of Penna. Press, 1971) p. 2.

[15]An extreme example of such photo-identification includes "Blacks being photographed for 'registration books,' or passes they need to enter white areas of South Africa" (*New York Times*, January 21, 1973). The Polaroid Corporation had to make some serious decisions regarding the sale and use of their instant film for these purposes (see "South Africa: Polaroid Pulls Out," *Newsweek*, December 5, 1977).

[16]See Sontag's *On Photography* (1977) for unacknowledged reference to Pierre Bourdieu's similar finding in French rural society that 64% of the households with children have at least one camera against only 32% of the childless households. The reverse situation, namely a decline in childbearing frequency, is one reason given for the recent reduction in sales and use of home moviemaking equipment (see Ann Hughey, "Sales of Home-Movie Equipment Falling as Firms Abandon Market," *Wall Street Journal*, March 17, 1982). See Chapter Nine for additional comment.

[17]Personal thanks to Eric Michaels for sending me a newspaper article entitled "Camera Angles" by Irving Desfor (AP Newsfeatures, no date). After Desfor described how he had to surreptitiously photograph his grandson with a camera hidden in a gift box, he added: "Hospitals should know that our blessed events are matters of public record but they also deserve a place in the permanent archives of family albums.

[18]Lonnie Schlein, "Photographing the Birth of Your Own Celebrity," *New York Times*, October 31, 1976.

[19]For several examples of this image, see Photograph 3 of Christopher Musello's "Family Photography," *Images of Information*, Jon Wagner (ed.), (Beverly Hills, CA: Sage, 1979), p. 107.

[20]William M. Ivins, Jr., *Prints and Visual Communication* (Cambridge, MA: Harvard University Press, 1953), p. 180.

[21]Personal thanks to Barbara Lankford.

[22]I am reminded here of a statement made by anthropologist Edmund Carpenter: "A photographic portrait, when new and privately possessed, promotes identity, individualism: it offers opportunities for self-recognition, self-study. It provides the extra sensation of objectivizing the self. It makes the self more real, more dramatic. For the subject, it's no longer enough to be: now HE KNOWS HE IS. He is conscious of himself." (See "The Tribal Terror of Self-Awareness," *Principles of Visual Anthropology*, Paul Hockings, ed. (The Hague: Mouton Publishers, 1975), p. 458.

[23]Augustus Wolfman, *The 1978-1979 Wolfman Report on the Photographic Industry in the United States* (New York: Modern Photography Magazine, 1979).

[24]For a selection of a Christmas photo card collection, spanning a 40-year period, see Photograph 6 of Christopher Musello's "Family Photography," *Images of Information*, Jon Wagner (ed.), (Beverly Hills, CA: Sage, 1979), p. 114, and for an album page of Christmas photographs, see Figure 2 of Musello, 1980, p. 27.

[25]An exaggerated example of such continuity appeared when *Life* magazine once published two pages of yearly photographs of the same girl; the article was entitled "Twenty Years on Santa's Knee."

[26]For several examples, see Christopher Musello's "Studying the Home Mode: An Exploration of Family Photography and Visual Communication," *Studies in Visual Communication* 6(1):26-27 (1980).

²⁷For a book entitled *American Dream Cowboy*, authors Robert Heide and John Gilman solicited "actual photographs of children dressed up as cowboys in the 1920s, '30s, '40s, '50s, or '60s. They may be costumed either in complete regalia or as a more higgledy-piggledy buckaroo." (Howard Smith and Lin Harris, "Six-Gun Geegaws," *Village Voice*, November 25 December 1, 1981), p. 25. Thanks to Glen Muschio for the reference.

²⁸Several insights were gained from Helen Schwartz's paper "Our Bas and Bar Mitzvah" (1974), files of the author.

²⁹For the significance of reciprocity and gift-giving as important themes in social anthropology, see *The Gift* by Marcel Mauss (London: Cohen and West, 1925).

³⁰Taken with gratitude from an unpublished paper by Debbie Friedenberg, entitled "A Study of Family Photography," (1976), files of the author.

³¹Mentioned in an unpublished paper by Joan Kling entitled "The Ethnographic Study of the Kling Family—A German/Irish Catholic Family," (1978), files of the author.

³²Thanks to Jeffrey Rosenberg's unpublished paper entitled "Army Life or a G.I. in Germany: 179 Still Photographs," (1976), files of the author.

³³For a view of how snapshots get taken and looked at during a wedding shower, see the film "Ricky and Rocky" directed and produced by Jeff Krienes and Tom Palazollo (1974).

³⁴For the best published account of how weddings get looked at with cameras in a variety of professional and non-professional contexts, see Barbara Norfleet's *Wedding* (New York: Simon and Schuster, 1979).

³⁵For an interesting comparison of the snapshot view of a wedding placed alongside other camera generated views (by professional filmmakers, home moviemakers, etc.), see "Six Filmmakers in Search of a Wedding" (Pyramid Films, no date, distributed by The National Film Center, Finksburg, MD, 21048).

³⁶For a series of examples of inappropriate snapshots made by a precocious teenager during a wedding reception, see the French film *Cousin, Cousine* (1975).

³⁷"Snapshots" of nudity may find their way into contexts of mass communication such as snapshot contests sponsored by magazines as *Gallery* and *Penthouse*. As such, these images are not created for home mode communication. According to some film processing companies, snapshots of nudity are becoming more popular; see "More nudes are showing up among family snapshots," Gary Haynes (*Philadelphia Inquirer*, September 17, 1978).

³⁸Lisl Dennis, *How to Take Better Travel Photos* (Tucson, AZ: Fisher Publishing Inc., 1979).

³⁹For examples, see Christopher Musello, 1980, p. 28.

⁴⁰For an interesting review of how pictures made at work, called "occupational portraits," have changed through three eras (daguerrian, wet plate, and snapshot/amateur), and how these changes reflect differences in basic cultural values, see Richard Oestreicher's "From Artisan to Consumer: Images of Workers 1840-1920" *Journal of American Culture* 4(1): 47-64 (1981). For instance, Oestreicher notes:

. . . the snapshots which the amateurs took of themselves did not replace the professional occupational portraits. The occupational genre did not survive. If work appeared in the snapshot, it was usually by accident: the farmer with his new thresher was displaying the machine, not his work; the man fixing his car was probably a proud car owner, not an auto mechanic; the man in a new army uniform was recording an event much like a graduation or a bar mitzvah, and not a career as a professional soldier (1981: 51).

⁴¹Several examples appear in Musello, 1980, p. 36, especially Figures 9A and 9B.

⁴²One advice column reminds us once again of the importance of "newness:"

Be different. Be personal. Send a photo-greeting card. Get started now.

If you send photographs of a new baby, a new house, a new spouse, a new cat—some expression of you—the recipient will appreciate the photograph more than a commercial card.

Gary Haynes, "Now's a good time to draft your photo Christmas cards," (*Philadelphia Inquirer*, September 14, 1980).

[43]Robert Fanelli, "The Practice of still Photography: An Ethnography of the Home Mode of Visual Communication," 1976, p. 78, unpublished paper, files of the author. For visual examples of the naughty shot, see Figure 9, Musello, 1980, p. 37.

[44]Personal thanks to Karin Ohrn of the University of Iowa for sending me Linda Peterson's unpublished paper "The Photographer in Our Family" (1975), files of the author.

[45]For an extensive and unusual example of combining past snapshots with original photographs of a grandfather slowly dying at home, see Mark and Dan Jury's *Gramp* (New York: Grossman, 1976).

[46]Personal thanks for Ken Persing's unpublished paper "No Photographs in the Bathroom: A Survey of Home Mode Imagery" (1976), files of the author.

[47]Taken from an unpublished paper by Paula Broude and Kathy Morton entitled "Three Case Studies in Home Mode Visual Communication" (1975), files of the author.

[48]Dell Hymes has offered the following example of graveside photography observed at an Indian reservation in Warm Springs, Oregon:

...then, as people began to leave, the bereaved parents were stood at one end of the mound, facing each other, where their friends gathered to photograph them across it. That picture, of manifestations of solidarity and concern on the part of so many, evident in the flowers, might be welcome. ("On the Origins and Foundations of Inequality among Speakers" *Daedalus* 102(3):71(1973)).

Observations such as this beg many interesting questions regarding the cross-cultural use of snapshots and snapshot communication.

[49]Thanks are acknowledged for James Brennen's unpublished paper "A Sociovidistic Analysis of Home-Mode Photography Based on *Les Rites du Passage*" (1974), files of the author.

[50]I have not included examples of either people putting snapshot photographs on grave markers, or people being buried with photographs: "In keeping with a custom still to be found among some country people, to place great stock in photographs, she was buried with a snapshot of her favorite grandchild," Howell Raines, "Let us Now Revisit Famous Folk," *New York Times Magazine*, May 25, 1980, p. 38.

[51]Nelson Goodman's constructivist philosophy becomes relevant once again; in worldmaking, he discusses the processes of composition and decomposition, repetition, weighting, ordering, deletion and supplementation and deformation. Consider how Goodman's descriptions of "deletion and supplementation" may be related to decisions on including or excluding the making of specific snapshot images:

Also the making of one world out of another usually involves some extensive weeding out and filling—actual excision of some old and supply of some new material. Our capacity for overlooking is virtually unlimited, and what we do take in usually consists of significant fragments and clues that need massive supplementation.... That we find what we are prepared to find (what we look for or what forcefully affronts our expectations), and that we are likely to be blind to what neither helps nor hinders our pursuits, are commonplaces of everyday life....

See *Ways of Worldmaking* (Indianapolis: Hackett Publishing Co., 1978), p 14. We will repeatedly see how conscious and unconscious aspects of selective perception are central to the home mode of pictorial communication.

[52]For instance, aspects of our economic and/or political lives may *not* appear: "It is striking to note, for example, how Netherlands' family albums containing photographs from the years 1940 to 1945 contain almost no references whatsoever to the German occupation or to the war situation in general" (Boerdam and Martinus, "Family Photographs—a Sociological Approach," *The Netherlands' Journal of Sociology* 16(2):95-110 (1980)).

[53]Edgar Williams, *Philadelphia Inquirer*, February 27, 1976. In a related article, divorce album maker, Louie Grenier, gives examples of photographs that he would include:

. . .-Husband and wife arguing with each other.

-Shots of the husband and wife dividing up material possessions.

-Close-ups of the faces of the children while the husband and wife are fighting.

-Shots of the husband and wife conferring with respective lawyers.

-Scenes inside the courthouse prior to going before the judge.

-Shots of the departing partner packing.

-Shots of the departing partner waving good-by to the children.

-Pictures of the departing partner living alone in a hotel room, or with a sympathetic friend. . . .

Bob Green, "Divorce Photo Album," (*The Bulletin*, Philadelphia, February 27, 1976).

[54]Jeffrey Rosenberg, "Army Life or a G.I. in Germany: 179 still photographs," (1976), unpublished paper, files of the author.

[55]Personal thanks to Catherine Wisswaesser and Ida Liberkowski for their interesting paper "When Poppa Gets the Camera," (1974), files of the author.

[56]Robert Fanelli, 1976.

[57]For many interesting examples of these groups—groupings of people *not* commonly found in snapshots or family albums, see either Bill Owens' *Our Kind of People—American Groups and Rituals* (San Francisco: Straight Arrow Books, 1975) or Neal Slavin's *When Two or More Gather Together* (New York: Farrar, Strauss & Giroux, 1976). For additional comment, see Richard Chalfen's review, *American Anthropologist* 81:475-476 (1979).

[58]Fanelli, 1976, p. 89.

[59]Florence W. Kaslow and Jack Friedman, "Utilization of Family Photos and Movies in Family Therapy," *Journal of Marriage and Family Counseling*, January, 1977, pp. 20, 23.

[60]Readers are reminded that we have not been describing all items that may comprise any one family album. Photography albums frequently include such non-photographic materials as pressed flowers, ribbons, locks of hair, newspaper clippings, printed invitations and announcements, name tags, identification cards, driver's licenses, and the like. In fact, our discussion has barely touched on other closely related genres of personal imagery that are also included. Examples would include passport photos, various wallet photographs including the "4-for-50cent" machine made pictures, portraits made for other people's wedding albums, portraits from summer camp, class pictures, and the like. These images provide alternative and parallel views of people, times, and places that may also have been represented in snapshot form.

[61]Margaret Weiss, "Honoring the Amateur," *World*, March 27, 1973.

[62]Stanley Milgram, "The Image Freezing Machine," *Psychology Today* (January, 1977), p. 54.

[63]James Kaufmann, "Learning from the Fotomat," *The American Scholar* 49(2):244 (1980).

[64]Julia Hirsch, *Family Photographs—Content, Meaning and Effects* (New York: Oxford Univ. Press, 1981), p. 118.

[65]John A. Kouwenhoven, "Living in a Snapshot World," *The Snapshot*, J. Green (ed.), (Millerton, N.J.: Aperture, 1974), p. 107.

Chapter Five

[1]Susan Sontag, *On Photography* (New York: Delta Books, 1977), pp. 9-10.

[2]Mark Olshaker, *The Instant Image* (New York: Stein and Day, 1978), pp. 255-256.

[3]Alan Dundes, "Seeing is Believing," *Natural History Magazine*, May, 1972.

[4]Iris Posner, "Covering China with a 110," *Popular Photography*, 84(2): 104 (1979).

[5]I wish to thank Martha Chahroudi for sharing these advertisements with me.

[6]Ken Graves and Mitchell Payne, *American Snapshots* (Oakland, CA: The Scrimshaw Press, 1977), p. 8.

[7]Norbert Nelson, "Collector's Corner," *Camera 35*, (October), pp. 30-31 (1978).

[8]Brian Coe and Paul Gates, *The Snapshot Photograph* (London: Ash and Grant Ltd., 1977), p. 18.

[9]Complete references are: Dean MacCannell, *The Tourist—A New Theory of the Leisure Class* (New York: Schocken Books, 1976); Louis Turner and John Ash, *The Golden Hordes* (New York: St. Martin's Press, 1976); Valene Smith (ed.), *Hosts and Guests* (Philadelphia: University of Pennsylvania Press, 1977).

[10]Jafar Jafari, "Tourism and the Social Sciences—A Bibliography: 1970-1978," *Annals of Tourism Research*, 6 (April-June):149-194 (1979).

[11]Complete references are: Samuel E. Lessere, *What You Must Know When You Travel With a Camera* (Greenlawn, N.Y.: Harian, 1966); Hugh Birnbaum, *Photo-Guide for Travelers* (New York: Rivoli Press, 1970); Lisl Dennis, *How to Take Better Travel Photos* (Tucson: Fisher Publishing Co., 1979).

[12]Readers are reminded that "being-on-vacation," "travel" and "tourism" are not synonymous. Vacation is a designated period of time; travel is an activity; and tourist is a social role. Only some people on vacation choose to travel; some travelers choose to be tourists; neither all kinds of vacations nor all kinds of travel necessarily include tourist activity.

[13]For examples of material that comprise the first two categories, see Richard Chalfen, "Tourist Photography," *Afterimage* 8(1&2):26-29.

[14]For a differentiation of "travellers" and "tourists," see John Forster, "The Sociological Consequences of Tourism," *International Journal of Comparative Sociology*, Vol. 12, 1964, pp. 217-227. Sociologist Erik Cohen has suggested a four part scheme of "organized mass tourist," "individual mass tourist," "explorer," and "drifter" in "Toward a Sociology of International Tourism,"*Social Research* 39(1):164-182 (1972). And anthropologist Valene Smith contributes a more elaborate seven part scheme labelled "explorer," "elite," "off-beat," "unusual," "incipient mass," "mass," and "charter" in *Hosts and Guests* (Philadelphia: Univ. of Pennsylvania Press, 1977), pp. 1-14.

[15]Smith, 1977, p. 9.

[16]Another source of analytic confusion could be derived from Sontag's suggested relevance of a class-differentiated scheme: "Taking photographs fills the same need for the cosmopolitans accumulating photograph-trophies of their boat trip up the Albert Nile or their fourteen days in China as it does for lower-middle-class vacationers taking snapshots of the Eiffel Tower or Niagara Falls" (1977:9). However, for purposes of this discussion, the tentative claim is that tourist-type cuts across socio-economic and class distinctions, or that social class and tourist-type may coincide in some patterned way.

[17]Nelson E.E. Graburn, "Tourism: The Sacred Journey" in *Hosts and Guests*, V. Smith (ed.) (Philadelphia: University of Pennsylvania Press, 1977), p. 31.

[18]Valene Smith, "Eskimo Tourism: Micro-Models and Marginal Men" in *Hosts and Guests*, V. Smith (ed.), (Philadelphia: University of Pennsylvania Press, 1977), p. 59.

[19]Dean MacCannell, "Staged Authenticity: Arrangements of Social Space in Tourist Settings," *American Journal of Sociology*, 79:597 (1973).

[20]MacCannell, 1973, p. 592.

[21]Daniel J. Boorstin, *The Image: A Guide to Pseudo-Events in America* (New York: Harper Colophon Books, 1961), pp. 108-109.

[22]Edmund Carpenter, *Oh, What a Blow That Phantom Gave Me!* (New York: Holt, Rinehart and Winston, 1972), p. 6.

[23]Byers, 1964, p. 80.

[24]MacCannell, 1976, p. 104.

[25]Howard Becker, "Photography and Sociology," *Studies in the Anthropology of Visual Communication*, 1(1):18 (1974).

[26]Sontag, 1977, pp. 41-42.

[27]Leon Gersten, "Use with Discretion," *New York Times*, June 26, 1977.

[28]Jack Manning, "Putting Poetry Into Travel Photos," *New York Times*, March 18, 1979.

[29]Allan Rokach and Ann Millman, "On Photographing People in Foreign Countries," *New York Times*, May 18, 1980.

[30]Janet Kealy, "Shooting on the Run: How to Make a Vacation Film," *Popular Photography*, August, 1977, pp. 126-127, 136-137.

[31]Title 18, United States Code, Section 795-797, says that "whenever in the interests of national defense the President of the United States declares that certain vital military and naval installations or equipment shall be privileged, then it is unlawful to take any photographs of such installations or equipment without permission of proper authorities." (See *Photography: What's the Law?* by Robert M. Cavallo and Stuart Kahan (New York: Crown Publishing, Inc., 1976, p. 4.

[32]Editors of Time-Life, *Travel Photography*. New York: Time-Life Books, 1972, p. 84.

[33]*New York Times*, April 10, 1977; April 24, 1977. The tourist was detained by local police for this activity.

[34]For an interesting if not somewhat bizarre turn of events, William Ecenbarger has suggested that the crippled nuclear plant at Three Mile Island might "replace the Eiffel Tower as a background for tourist snapshots." (*Philadelphia Inquirer*, April 12, 1979).

[35]Smith, 1977, p. 59.

[36]Ximena Bunster B., "Talking Pictures: A Study of Proletarian Mothers in Lima, Peru," *Studies in the Anthropology of Visual Communication* 5(1):38 (1978).

[37]John Hostetler, *Amish Society* (Third Edition, Baltimore: Johns Hopkins Press, 1980). Hostetler goes on to explain a tourist photographer's dilemma:
... Objections of the Amish to the camera are widely known. The reasons given are based on religious grounds, ranging from the prohibition of the graven images (Exodus 20:4-5) to a variety of other biblical teachings against a show of personal pride and vanity. To take photographs or pose for pictures is strictly forbidden in Amish law. The tourist who wishes to capture some of the scenery, people, and lore of the Amish community is confronted with a dilemma. If he asks Amish persons for permission to photograph, they are obliged to decline politely (1980:311).

[38]Parry C. Yob, "Tips for the Travel Photographer," *Photo Graphic*, May, 1978, p. 80.

[39]Avon Neal, "It's a Big Deal Posing for Camera in Guatemala," *The Smithsonian*, March, 1975, p. 68.

[40]Leon Gersten, "Use with Discretion," *New York Times*, June 26, 1977.

[41]Stanley Milgram, "The Image Freezing Machine," *Psychology Today*, January, 1977, p. 54.

[42]Carly Mydans, "An Expert's Advice to the Tourist-Photographer," *Travel Photography* (New York: Time-Life Books, 1972), pp. 15-16.

[43]Gersten, 1977.

[44]*New York Times*, March 19, 1980.

[45]David Seaman, "Culture Behind the Lens: Learning from the Photographer's Experience," paper presented during the 1981 Conference on Culture and Communication, Temple University, Phila., Pa., files of the author.

[46]Ralph Blumenthal, "If You Are Caught in a Coup...," *New York Times*, February 24, 1980.

[47]Milgram, 1977, p. 52.

[48]Lois B. Bastian, "Instant Pictures, Instant Response," *New York Times*, June 23, 1974.

49Robert Kornfeld, "Morocco from a Fresh Viewpoint," *New York Times*, December 11, 1977.

50John Collier, Jr., *Visual Anthropology: Photography as a Research Method* (New York: Holt, Rinehart and Winston, 1967), p. 15.

51Jules Farber, "No Snap for Photographers," *New York Times*, April 24, 1966.

52Michael Bruno and Lynn Tiefenbacher, "The Impact of Tourism and Media on the Highlands of Chiapas, Mexico: A Preliminary Analysis," unpublished paper, 1979, files of the author.

53Laurence Salzmann, "Photography in Rumania: from studio professionals to village amateurs, the craft's the thing," *Afterimage* 4(4):11 (1976).

54Turner and Ash, 1976, p. 241.

55*New York Times*, July 19, 1981.

56Sontag's version of this phenomenon is as follows: "Faced with the awesome spread and alienness of a newly settled continent, people wielded cameras as a way of taking possession of the places they visited. Kodak put signs at the entrances of many towns listing what to photograph. Signs marked the places in national parks where visitors should stand with their cameras" (1977:65).

57Mydans, 1972, p. 16.

58Emil Bix, personal communication, 1980.

59Taken from a photographic exhibition, Conference on Visual Anthropology, Temple University, Philadelphia, PA, 1978.

60*Travel Photography* (New York: Time-Life Books, 1972), p. 179.

61Smith, 1977, p. 70.

62Max E. Stanton, "The Polynesian Cultural Center: A Multi-Ethnic Model of Seven Pacific Cultures," *Hosts and Guests*, V. Smith (ed.) (Philadelphia: University of Pennsylvania Press, 1977), p. 196.

63MacCannell, 1976, p. 167.

64Davydd J. Greenwood, "Culture by the Pound: An Anthropological Perspective on Tourism as Cultural Commoditization," *Hosts and Guests*, V. Smith (ed.) (Philadelphia: University of Pennsylvania Press, 1977), p. 130.

65Boorstin, 1961, p. 108.

66MacCannell, 1976, p. 13.

67Ibid.

68Ibid., p. 15.

69Salzmann, 1976.

70Galen Cranz, "Photography in Chinese Popular Culture," *Exposure* 16(4):24-29 (1978).

71Stephen Sprague, "How I See the Yoruba See Themselves," *Studies in the Anthropology of Visual Communication*, 5(1):9-28 (1978).

72Neal, 1975.

73Benedict Tisa, "Photographers have begun to interpret their culture for themselves," *American Photographer*, June, 1980.

74MacCannell, 1976, p. 589.

75Forster, 1964, pp. 226-227.

Chapter Six
1Pictures may be formally organized in the sense of framing, hanging, album-making, editing, titling, captioning, etc., or simply brought forth from a wallet, drawer, or shoebox to be shown to people.

2Reference will consistently be to interpretation rather than to the "reading" of imagery. Even at its metaphorical best, "reading" implies a taken for granted process of symbol decoding that should remain problematic and not be tied to written forms.

[3]Nelson Goodman's view of this problem makes the case even clearer when he suggests we reconsider our accepted beliefs about the various methods we use to describe or depict the world "as it is":

We need to consider our everyday ideas about pictures for only a moment to recognize...(how) we rate pictures quite easily according to the approximate degree of realism. The most realistic picture is the one most like a color photograph; and pictures become progressively less realistic, and more conventionalized or abstract, as they depart from this standard. The way we see the world best, the nearest pictorial approach to the way the world is, is the way the camera sees it. This version of the whole matter is simple, straightforward, and quite generally held. But in philosophy as everywhere else, every silver lining has a big black cloud—and the view described has everything in its favor except that it is, I think, quite wrong.

See "The Way the World Is" *Problems and Projects* (Indianapolis: Bobbs-Merrill Co., Inc., 1972) p. 27.

[4]Sol Worth, "Toward an Ethnographic Semiotic." Unpublished paper presented during a UNESCO conference entitled "Utilisation de L'ethnologie par le Cinema/Utilisation du Cinema par L'ethnologie," Paris, 1977, p. 1-3.

[5]Allan Sekula "On the Invention of Photographic Meaning" *Artforum* 13 (5):37(1975).

[6]Sekula covers a lot of ground when he describes this opposition:

The misleading but popular form of this opposition is "art photography" vs. "documentary photography." Every photograph tends, at any given moment of reading in any given context, toward one of these two poles of meaning. The oppositions between these two poles are as follows: photographer as seer vs. photographer as reportage, theories of imagination (and inner truth) vs. theories of empirical truth, affective value vs. informative value, and finally, metaphoric signification vs. metonymic significance (Sekula 1975:45).

[7]Sol Worth 1977, p. 4.

[8]Many examples of these evidentiary functions may be found in *Evidence* by Mike Mandel and Larry Sultan (Santa Cruz, CA: Clatworthy Colorvues, 1977). For an interesting review by Drew Moniot, see *Studies in the Anthropology of Visual Communication* 5(1): 73-76 (1978). In another applied context we find circulars from insurance companies advocating the taking of snapshots of all personal possessions—making a complete set of pictures of every room, wall, and object in the household, and storing the pictures in a safety deposit box (see "Snapshots can benefit homeowner" *Philadelphia Inquirer*, July 1, 1980).

[9]See Andre Bazin, *What is Cinema?* (Berkeley: University of California Press, 1967).

[10]Allan Sekula, 1975, p. 37.

[11]Even in the case of tourist photography, the belief holds that the tourist's camera gets "what is there." Questioning the fact that what is there for the tourist to photograph may have been mediated by members of the host society or tourist site professionals is a secondary issue that is often conveniently dismissed or overlooked by home mode participants.

[12]See Sol Worth's "Pictures Can't Say Ain't," *Versus* 12:85-108 (1975).

[13]For additional comment, see Richard Chalfen's 1975 review of *Photoanalysis* by Robert U. Akeret (*Studies in the Anthropology of Visual Communication* 1(1):57-60).

[14]Christopher Musello, "Studying the Home Mode: An Exploration of Family Photography and Visual Communication," *Studies in Visual Communication* 6(1):41 (Figure 13), 1980.

[15]See *The Family Album* by David Galloway (New York: Harcourt Brace Jovanovich, 1978), p. 22. The letter was written by Necephore Niepce to his son Isidore, July 20, 1832.

[16]Margery Mann, "The Snapshot: Family Record or Social Document?" *Popular Photography* (September) pp. 29-30 (1970).

[17]In fact, it is when people cannot recognize people in their pictures that they get thrown away—but this is not very common.

[18]I am not referring here to a recent trend to create "instant" relatives or family by buying elaborately framed, large photographic portraits found in antique shops, junk shops, or flea markets. These images are valued as examples of representation rather than as pictures of specific relatives.

[19]Margery Mann, 1970, pp. 29-30.

[20]Jean Shepherd, "Introduction" *American Snapshots* selected by Ken Graves and Mitchell Payne (Oakland, CA: Scrimshaw Press, 1977), p. 5.

[21]Many parents have reported that their children willingly spend hours looking through their albums or snapshot collections. My own children regularly ask to see our slides stored in carousel trays. They have a pattern of image curiosity about which we know very little. See Chapter 7 for additional comment.

[22]My first serious treatment of home movies was a seminar paper written for Erving Goffman entitled "Home Movies are the Closest Thing to Life Itself: A Study of the Home Movie Key" (1970). Professor Goffman's comments stimulated an expanded treatment of the subject matter; acknowledgement is given here for his valuable insights and sustained encouragement.

[23]Erving Goffman, *Frame Analysis—An Essay on the Organization of Experience* (New York: Harper Colophon Books, 1974), pp. 43-44. Both Goffman and Nelson Goodman reference the philosophy of William James. For instance, when Goffman traces the intellectual heritage of "frame analysis" through a generalized theme best understood as "the organization of experience," he notes the following:

Instead of asking what reality is, he (James) gives matters a subversive phenomenological twist, italicizing the following question: *Under what circumstances do we think things are real?* The important thing about reality, he implied, is our sense of its realness in contrast to our feeling that some things lack this quality. One can then ask under what conditions such a feeling is generated, and this question speaks to a small manageable problem having to do with the camera and not what it is the camera takes pictures of.

See *Frame Analysis* (New York: Harper Colophon Books, 1974), p. 2. We are here exploring how members of Kodak culture go about operationalizing the conditions that generate a belief in the real on both sides of the camera.

[24]Ibid, p. 560.

[25]See Joan Challinor, "Family Photo Interpretation" *Kin and Communities—Families in America*, Allan J. Lichtman and Joan Challinor (eds.) (Washington, D.C.: Smithsonian Institution Press, 1979), p. 246.

[26]For a discussion of how pictorial information is interpreted in different ways by people of various cultures, see Jan B. Deregowski, "Pictorial Perception and Culture" *Scientific American* 277(5):82-89 (November, 1972). With specific reference to photographic representation see E. H. Gombrich, "The Visual Image," *Scientific American* 227(3):82-97 (1972).

[27]For a discussion of natural and artificial contexts of observation as well as "the induced natural context", see *A Guide for Field Workers in Folklore* by Kenneth S. Goldstein (Hatboro, Pa.: Folklore Associates, Inc., 1964), pp. 80-90. It became increasingly clear that people made certain adjustments and offered seemingly protective qualifiers when they knew that a "sociovidistician" was monitoring what would otherwise have been a spontaneous flow of judgements and other comments.

[28]Cultural historian David Jacobs calls attention to a comment by Wilson Hicks who argues that in snapshots, the subject matter is much more important than technical proficiency: "Even though little Alice's face is chalked out by the sun, or half lost in a shadow, it is still little Alice. The viewer, knowing her so well, by a trick of the imagination sees the real little Alice whenever he looks at her image, which he deludes himself into believing is much better than it actually is." See "Domestic Snapshots: Toward a Grammar

of Motives," *Journal of American Culture*, 4(1):95(1981). The Hicks quotation appeared originally in "Photographs and the Public" *Aperture* 2 (1953), p. 4.

²⁹Taken from an unpublished paper by Juanita Lavalais entitled "Homemode Photography" (1980), files of the author.

³⁰For additional comment, see Amy Kotkin's "The Family Album as a Form of Folklore," *Exposure* 16(1):4-8 (1978). Michael Lesy also makes this point very well in his book *Time Frames* (New York: Pantheon Books, 1980), in which he states: "By itself, an ordinary snapshot...is as bland and common as a tea biscuit; but as a goad to memory, it is often the first integer in a sequence of recollections that has the power to deny time for the sake of love" (p. xi). Most of this book consists of verbatim stories told by his friends as they looked through their photograph albums and snapshot collections. For additional comment, see Richard Chalfen's "Exploiting the Vernacular: Studies in Snapshot Photography," *Studies in Visual Communication* 9(3):70-84 (1983).

Chapter Seven

¹George Gerbner, "Mass Media and Human Communication Theory" *Human Communication Theory—Original Essays*, Frank E. X. Dance (ed.), (New York: Holt, Rinehart and Winston, 1967), p. 52.

²Dell Hymes, "The Anthropology of Communication," *Human Communication Theory—Original Essays*, Frank E. X. Dance (ed.), (New York, Rinehart and Winston, 1967), p. 27.

³In six of seven interviews I have done for radio shows and newspaper articles, reporters consistently began by asking me a *"why* do you think people do this so much" type of question. I have respectfully requested patience while we reviewed what was meant by "this."

⁴George Gerbner, "Communication and Social Environment," *Scientific American* 227(3):158 (1972).

⁵Stanley Milgram, "The Image-Freezing Machine," *Psychology Today* (January, 1977), p. 50.

⁶Gisele Freund, *Photography and Society* (Boston: David R. Godine, 1980), p. 216.

⁷For short contrasts between historical accounts and family albums, see David Jacobs, "Domestic Snapshots: Toward a Grammar of Motives," *Journal of American Culture* 4(1):93-105 (1981), and James Kaufmann, "Learning from the Fotomat," *The American Scholar* 49(2):244-246 (1980).

⁸Susan Sontag, *On Photography* (New York: Delta Books, 1977). Following a religious metaphor, James Kaufmann collaborates by noting that people have "observed the requisite pieties, performed the obligatory acts" (1980:244).

⁹In another study, Boerdam and Martinus note: "Photographs constitute unmistakable evidence in the negotiation process of how their own past should be seen." See "Family Photographs—A Sociological Approach" *The Netherlands' Journal of Sociology* 16(2):116 (1980).

¹⁰I am borrowing from two sources which discuss these language functions—Roman Jacobson's "Closing Statement: Linguistics and Poetics" *Style and Language* (Cambridge: MIT Press, 1960) and Dell Hymes' "Models of the Interaction of Language and Social Life," *Directions in Sociolinguistics*, Gumperz and Hymes (eds.) (New York: Holt, Rinehart and Winston, 1972), pp. 35-71.

¹¹Eastman Kodak Company, *How to Make Good Home Movies* (1966), p. 18, 7.

¹²Don Sutherland, "A Good Home Movie is Not Necessarily 'Well Made'," *Popular Photography* (October, 1971), p. 123.

¹³An interesting difference emerges between home movie making and ethnographic film on the issue of preservation. This motive is praiseworthy with respect to "us" but filmmakers who focus on "primitive" or simple societies are sometimes accused of

"preserving the primitive" in the sense of inhibiting change or reifying a view that these people cannot move into the modern world.

[14]Clive James in a review essay on the current popularity of photography books cites an important characteristic relevant to the home mode: "The photographs do what photographs best can—they give you some idea of what the reality you already know something about was like in detail." See "The Gentle Slope of Castalia," *New York Review of Books* (December 18, 1980), p. 30.

[15]Eastman Kodak Company, 1966, p. 9, 23.

[16]Stan Brakhage, "In Defense of the 'Amateur' Filmmaker," *Filmmakers Newsletter* (Summer, 1971), p. 24.

[17]Discussion of negative reasons such as "defeating death" seem to be more common to novelists and short story writers than home mode participants. For instance, Tess Gallagher writes:

Even the stopped moment of a photograph paradoxically releases its figures by holding them because the actual change, the movement away from the stilled moment, has already taken place without us, outside the frame of the photograph, and the moment we see ourselves so stilled, we know we have also moved on. This is the sadness of the photograph: knowing, even as you look, it is not like this, though it was. You stand in the "was" of the present moment and you die a little with the photograph.

"The Poem as Time Machine," *Atlantic Monthly* (May, 1980), p. 74. From John Fowles, we read: "All pasts shall be coeval, a back world uniformly not present, relegated to the status of so many family snapshots. The mode of recollection usurps the reality of the recalled." (*Daniel Martin* [New York: Signet, 1977], p. 90.) Personal thanks to Karen Donner for these references. Novelist David Galloway refers to a family album as "a chronicle of death.... But ultimately photographs are morbid objects, and the making of photograph albums is the assembling of books of the dead.... Tuck the book carefully away, well screened by mothballs, and slowly it becomes a litany of death" (*A Family Album* [New York: Harcourt, Brace, Jovanovich, 1978], p. 224).

[18]Don Sutherland, 1971, p. 180.

[19]Eastman Kodak Company, *Better Movies in Minutes* (1968), p. 1.

[20]Bell and Howell, p. 4.

[21]Letter appeared in the *Boston Glove*, June 6, 1975.

[22]Taken from the *Philadelphia Inquirer*, March 6, 1978.

[23]Myron A. Matzkin, *Family Movie Fun For All* (New York: American Photographic Book Publishing Company, Inc., 1964), p. 73.

[24]Don Sutherland, 1971, p. 123.

[25]Eastman Kodak Company, 1968, p. 1.

[26]Ibid., 1966, p. 8.

[27]Richard Chalfen, et al., unpublished interviews, Polavision Project, Polaroid Corporation, files of the author.

[28]Richard Chalfen, et al., unpublished interviews, Polavision Project, Polaroid Corporation, files of the author.

[29]Sociologists speak of mass media as a powerful agent of socialization working alongside traditional sources such as the family, peer group, and school. Here, home mode media acts as another input in a more generalized notion of media socialization.

[30]Michael Lesy, *Time Frames—The Meaning of Family Pictures* (New York: Pantheon, 1980), p. xv.

[31]Alan D. Coleman, "Introduction" *First Class Portraits* by Robert Delford Brown (The First National Church of the Exquisite Panic Press, 1973).

[32]Alan D. Coleman, "Artist of the Snapshot," *New York Times* December 30, 1973.

[33]In a public application of this point:

Believing that taking family pictures promotes family togetherness, a private social service agency in Hartford is going to provide families in poor neighborhoods with free cameras, film and processing.

A spokesman for Child and Family Services of Connecticut says he hopes the $50,000 program will help "instill a sense of family pride." (*Philadelphia Inquirer*, January 7, 1976).

[34]Even when relatives cannot meet in person or gather for important moments, cameras may be used to maintain relationships:

In 1952, I mailed the camera to our son in Minneapolis for pictures of his first child, our first grandson. And in 1953 I mailed it to our daughter in Albany for pictures of her first child, our first granddaughter. Until our son and daughter had movie cameras of their own, our camera made a number of such trips to keep us in touch with our children and grandchildren.

Letter to the Editor, *Temple University Alumni Review*, Fall, 1978.

[35]Nancy Munn, "Visual Categories: An Approach to the Study of Representational Systems," *American Anthropologist* 68:936 (1966).

[36]James Kaufmann, "Learning from the Fotomat," *American Scholar* 49(2):244 (1980). Another expression of ordering comes from a novel by David Galloway:

For the husband and wife, the taking of the photograph is more significant, since it records the last moments of their second honeymoon, and they place considerable stress on the keeping of records, even if neither one could say that this interlude in Hot Springs was all they had wanted or hoped it would be. Perhaps a neat, crisp photograph, something suitable to be mounted in an album, could order the days and give them significance, if only as a record to be appreciated in decades to come.

A Family Album (New York: Harcourt, Brace, Jovanovich, 1978), pp. 130-131.

[37]Erving Goffman, *Frame Analysis—An Essay on the Organization of Experience* (New York: Harper Colophon Books, 1974), p. 563.

[38]Reference here is made to Clifford Geertz, "Deep Play: Notes on a Balinese Cockfight," *Daedalus* 101(1):1-38 (1972).

Chapter Eight

[1]Stan Brakhage, "In Defense of the 'Amateur' Filmmaker," *Filmmakers Newsletter*, Summer, 1971, pp. 20-25.

[2]Jonas Mekas, *Movie Journal* (New York: Collier Books, 1972), p. 352, 131.

[3]Leendert Drukker, " 'Oh Brother, My Brother': How a Pro Cameraman Made a Home Movie," *Popular Photography* 88(1):190 (1981).

[4]See Richard Chalfen, "A Sociovidistic Approach to Children's Filmmaking: The Philadelphia Project," *Studies in Visual Communication* 7(1):2-32.

[5]Sol Worth and John Adair, *Through Navajo Eyes—An Exploration in Film Communication and Anthropology* (Bloomington: Indiana University Press, 1972).

[6]Lawrence Van Gelder, " *Heroes*: Ode to the Home Movie," *New York Times*, December 15, 1974.

[7]Elizabeth Weis, "Family Portraits," *American Film* 1(2):54 (1975).

[8]Taken from a promotion sheet for *Nana, Mama, and Me* by Amalie Rothschild.

[9]Taken from a project promotion sheet; thanks to Janice Essner for calling it to my attention.

[10]*Radio Times* (London), January 1, 1978. Personal thanks to Peter Moller and Garry Mirsky.

[11]*The Philadelphia Inquirer*, June 16, 1981. Personal thanks to Julie Compologno for pointing this out to me.

[12]See John W. Dean's "Haldeman is no More Innocent than I am," *New York Times*, April 6, 1975. It was reported that Dean (a "home movie buff") shot approximately 20,000 feet of Super-8 film of President Nixon's activities including plans for Tricia Nixon's

wedding, the return of former secretary of State Henry Kissinger from a 1972 secret trip to China, and Nixon giving the White House piano to former President Harry Truman ("Haldeman to broadcast Nixon Films" *The New Mexican*, January 17, 1982). The Super-8 films are being transferred to videotape in preparation of six hour-long television specials.

[13]For a short review by Richard Chalfen, see the *Journal of American Folklore* 93(368):245-246.

[14]See an advertisement for "Home Film Libraries, Inc." in *Newsweek*, February 17, 1933.

[15]Linda Moser, "The Family Album: A Worthwhile Project," *New York Times*, June 15, 1975.

[16]Denise McCluggage, "How to Take the Merriest Photographs Ever," *American Home*, December, 1972.

[17]Jeanne Lamb O'Neill, "All in the Family Album," *American Home*, August, 1972.

[18]Russell Baker, "Negative Thinking," *New York Times Magazine*, July 14, 1974.

[19]Robert Taft, "The Family Album," *Photography and the American Scene* (New York: Dover, 1964), pp. 138-152.

[20]Steven Halpern, "Souvenirs of Experience: The Victorian Studio Portrait and the Twentieth Century Snapshot," *The Snapshot* J. Green (ed.) (Millerton, N.Y.: Aperture, 1974), pp. 64-67.

[21]John Kouwenhoven, "Living in a Snapshot World," *The Snapshot*, J. Green (ed.) (Millerton, N.Y.: Aperture, 1974), pp. 106-108.

[22]Brian Coe and Paul Gates, *The Snapshot Photograph—The Rise of Popular Photography, 1888-1939* (London: Ash and Grant, Ltd., 1977).

[23]Richard Christopherson, "Making Art with Machines: Photography's Institution-alized Inadequacies," *Urban Life and Culture* 3(1):3-34 (1974); "From Folk Art to Fine Art," *Urban Life and Culture*, 3(2):123-158 (1974).

[24]Bruce Downes, "Human Interest—Snapshots," *Popular Photography* 4(5):38-49 (1944).

[25]Janet Malcolm, "Diana and Nikon," *New Yorker*, April 26, 1976, pp. 133-138. This article also appears in Malcolm's book *Diana and Nikon—Essays on the Aesthetic of Photography* (Boston: David R. Godine, 1980).

[26]Jon Holmes, "Pictures without Exhibition," *The Village Voice*, November 29, 1976.

[27]Karin B. Ohrn, "Prodigal Photography: Professionals Returning to the Home Mode," paper presented during the 1975 Conference on Culture and Communication, Temple University, Philadelphia, files of the author.

[28]We should also include the childhood photographs made by Jacques-Henri Lartigue—photographs that have subsequently been classified as fine art.

[29]Alan D. Coleman's articles appear in collected form in *Light Readings—A Photography Critic's Writing 1968-1978* (New York: Oxford University Press, 1979).

[30]Green, 1974.

[31]Malcolm, 1980.

[32]See Michael Lesy's "Snapshots: Psychological Documents, Frozen Dreams" *Afterimage* 4(4): 12-13 (1976).

[33]Michael Lesy, *Time Frames—The Meaning of Family Pictures* (New York: Pantheon, 1980); other articles by Lesy include " 'Mere' Snapshots, Considered," *New York Times*, January 16, 1978; "Fame and Fortune: A Snapshot Chronicle," *Afterimage* 5(4):8-13 (1977)

[34]Robert U. Akeret, *Photoanalysis* (New York: Wyden, Inc., 1973); for a critical statement, see Richard Chalfen's review, *Studies in the Anthropology of Visual Communication* 1(1):57-60 (1974).

[35]Brian Zakem, "Photo Therapy: A Developing Phototherapeutic Approach," unpublished paper (1977), files of the author. Zakem is editor of the journal, *Photo Therapy Quarterly*.

[36]Marcia Loellbach, "The Uses of Photographic Materials in Psychotherapy: A Literature Review," unpublished paper (1978), files of the author.

[37]Doug Stewart, "Photo Therapy: Theory and Practice," *Art Psychotherapy* 6(1):41-46 (1979).

[38]Alan D. Entin, "Photo Therapy: Family Albums and Multigenerational Portraits," *Camera Lucida* 1(2):39-51 (1980).

[39]Ken Graves and Mitchell Payne, *American Snapshots* (Oakland, CA: Scrimshaw Press, 1977).

[40]Mark Silber, *The Family Album* (Boston: David R. Godine, 1973).

[41]Daniel Seymour, *A Loud Song* (New York: Lunstrum Press, 1971).

[42]Lilo Stephens, *My Wallet of Photographs* (Ireland: Dolman Editions, 1971).

[43]Catherine Hanf Noren, *The Camera of My Family* (New York: Alfred A. Kopf, 1976). The motivation for organizing these books is best summarized by a statement by Noren:

I came to this project via the photographs. One afternoon during the summer of 1972, I was visiting my maternal grandmother at her home in Lime Rock, Connecticut. We were drinking coffee and talking, and she mentioned another of those names which were so familiar to me and bored me so much. Saying that she had a photograph of the person she was talking about, she directed me to a chest of drawers, and in it were hundreds of photographs, some in albums, some in old wooden boxes, some loose. I admired them, appreciated their beauty as any photographer would. But more, I was awed by the strange and alien time, flavor, place they evoked. I had no sense of identification with the photographs, but I knew almost at once that I wanted to make a book (1976, forward).

[44]Dorothy Gallagher, *Hannah's Daughters—Six Generations of an American Family: 1876-1976* (New York: Thomas Crowell, 1976).

[45]Julia Hirsch, *Family Photographs—Content, Meaning, and Effect* (New York: Oxford University Press, 1981).

[46]Susan Sontag, *On Photography* (New York: Delta Books, 1977).

[47]Ralph Hattersley, "Family Photography as a Sacrament," *Popular Photography*, June (1971), pp. 106-108. A number of Hattersley's articles have been collected for his *Discover Yourself through Photography* (New York: Morgan and Morgan, 1971).

[48]Coleman, 1979.

[49]James P. Leary, "Folklore and Photography in a Male Group," *Folklore Forum* 13:14-50 (1975).

[50]Karin B. Ohrn, "The Photoflow of Family Life: A Family's Photograph Collection," *Folklore Forum* 13:27-36 (1975a).

[51]James Kaufmann, "Learning from the Fotomat," *The American Scholar* 49(2):244-246 (1980).

[52]Stanley Milgram, "The Image-Freezing Machine," *Psychology Today*, January, 1977, pp. 50-54, 108.

[53]Pierre Bourdieu et al., *Un Art Moyen—Essai sur les usages sociaux de la photographie* (Paris: Les Editions de Minuit, 1965).

[54]Martine Segalen, "Photographie de noces: mariage et parente en milieu rural," *Ethnologie Francaise* 11(1-2):123-40 (1974).

[55]Special Photo No. 4, December, 1978.

[56]Jaap Boerdam and Warna Oosterbaan Martinus, "Family Photographs—A Sociological Approach," *The Netherlands' Journal of Sociology*, 16(2):95-119 (1980).

[57]Werner Meyer, " 'Als Erinnerung sollte das sein . . . als Selbstbestatigung...' Bricht uber den Amateurfotografen Rudi Stemmwadel," *Asthetik und Kommunikation* 28:25-32 (1977).

[58]Wolfgang Kunde," '...halb kunst...' Zu Pierre Bourdieus' 'Versuch zum gesellshcaftlichen Gebrauch de Fotographie'" *Asthetick und Kommunikation*, 28:34-52 (1977).

[59]Joachim Kallinich, "Fotographieren—Probleme der empirishen Untersuchung einer popularen aethetischen Praxis," *Asthetic und Kommunikation*, 28:19-24 (1977). Personal thanks to Anja Dalderup for helping me with these references.

[59a]For instance, I do not want to overlook the work of Andras Ban and Peter Forgacs from the Research Institute for Culture, Budapest, Hungary, as well as recent papers by Mihaly Hoppal and Erno Kunt (see "Lichtbilder und Bauern—Ein Beitrag zu einer visuellen Anthropologie" in *Sonderdruck fur Volkskunde*, 11:216-228 (1984).

[60]For a field study of working conditions of several kinds of professional photographers, see Barbara Rosenblum's *Photographers at Work* (New York: Holmes & Meier, 1978).

[61]Film Scholar Calvin Pryluck has mentioned in passing that "Charlie Chaplin's home movies look like everyone else's" (personal communication).

[62]Christopherson, 1974, p. 139.

[63]Karin B. Ohrn, *Dorothea Lange and the Documentary Tradition* (Baton Rouge, La.: Louisiana State University, 1980), p. 199. Personal thanks to Karin Ohrn for this and other references in this section.

[64]Ohrn, 1975b. p. 27.

[65]In one rare example, Ohrn examined the work of documentary photographer Dorothea Lange and attempted to characterize and compare her family photography in relation to her professional work. Ohrn initially notes:

Lange became impressed with the power of family photographs during her first job in San Francisco, working behind the counter of the photography store in 1919. There, she said, "I got interested in the snapshots and I realized at that time something that's never left me, and that is, the great visual importance of what's in people's snapshots that they don't know is there.... They never see them in any way but personal." (Ohrn 1980:196)

[66]See *Jacques-Henri Lartigue* (Millerton, N.Y.: Aperture, 1976), or *Boyhood Photos of J.H. Lartigue: The Family Album of a Gilded Age* (New York: Guichard-Time-Life Books, 1966), or *Diary of a Century* (New York: Penguin, 1978).

[67]John Szarkowski, *The Photographer's Eye* (New York: Museum of Modern Art, 1966).

[68]For the best example of mixed context imagery, see the book *Evidence*, by Mike Mandel and Larry Sultan (Greenbrae, CA: Clatworthy Colorvues, 1977).

[69]Malcolm, 1980, pp. 59-73.

[70]Margaret R. Weiss, "Honoring the Amateur," *World*, March 27, 1973, p. 61.

[71]Malcolm, 1980, p. 82, 68.

[72]Green's book contains small portfolios by such relevant photographers as Emmet Gowin, Lee Friedlander, Garry Winogrand, Robert Frank, among others.

[73]One example is discussed in Alan Coleman's review of photographer Leslie Krims:

Krims is a sardonic documentarian who is blending the snapshot and grotesque traditions into a unique vehicle for psycho-social commentary.... It is no small accomplishment to take pictures which could have come from the pages of a middle-class family album, yet which simultaneously reveal the hallucinatory absurdity of normalcy with such cheerful and merciless accuracy (Coleman, 1979, p. 59).

For an example of making art out of fake snapshots, see David Tipmore's review of William DeLappa's exhibition, "Memories of Time Fake," *Village Voice*, April 11, 1977.

[74]In one such article, a woman is shown looking at snapshots of her husband—pictures that were developed immediately after he was killed in an accident. Included is mention of their child's reactions to seeing the last pictures of his deceased father. See "The Cruel Cost of Offshore Oil," *Life*, April, 1982, pp. 85-90.

[75]Holmes, 1976, p. 69.

[76]See Kathryn Livingston, "Photographing Armageddon," (*American Photographer*, January, 1980), for this and other examples of how "great news photos" have been made by amateur photographers. The Zapruder footage has subsequently been used as legal

evidence in several court cases; it has also become part of Bruce Conner's avant garde film entitled "Report."

[77]See "Crime Pays," *The Philadelphia Inquirer,* January 15, 1981. "A Slice at Life," *Newsweek,* January 28, 1981, contains information on public reaction.

[78]Maureen Howard, "Review of *Letters Home—Correspondence 1950-1963* by Sylvia Plath" (*New York Times Book Review,* December 14, 1975).

[79]Susan Stranahan, "My Father, Angelo Bruno," *Today Magazine, The Philadelphia Inquirer,* August 21, 1977, p. 10, 12.

[80]In another ploy to create a behind-the-scenes look at someone before she emerged into "star quality," see *Playboy Magazine's* use of snapshots on their "Playmate Data Sheets" where the monthly pinup will be shown as a one year old, ten year old, seventeen year old, etc.

[81]Richard Horton and David Wohl, "Mass Communication and Para-Social Interaction," *Psychiatry* 19:215-229 (1956).

[82]This was learned from an interesting unpublished paper by Mitchell Feldstein entitled "Home-Mode Material in a Public Context: An Introduction" (1980), files of the author.

[83]*The Dallas Family Album* by Robert Masello (New York: Bantam, 1980).

[84]Several examples used in this report come from advertisements for Eaton's Photo Displays; for Burns "group picture organizer" called "The Arrangement"; for Sylvania flashbulbs (even a "would-be" Mona Lisa has not escaped a "would-be" snapshot in one Sylvania ad); for film processing by the Fotomat Corporation; and many advertisements for inexpensive cameras.

[85]Advertisement appeared in *Look* magazine, June 10, 1969, p. 91.

[86]Advertisement appeared in *People* magazine, December, 1978.

[87]Facsimile snapshot images have been used in the following examples: a Volvo ad captioned "Love Letters to a Car Company?" included snapshots of cars attached to several letters; Christian Dior Cologne incorporates snapshots in a "Rose Dior Memory Box"; Old Forester Whiskey ad captioned "And in the past 100 years there's been a lot of them"; Campus Sweater and Sportswear Co. ad captioned "Capture the moment in Campus Expressions"; Klopman Mills, Inc., ad captioned "Remember your first uniform?"; an advertisement for the Walter K. Sackol State Mutual Insurance Co. and Marsh and McLennan Insurance Co. shows a snapshot of "Aunt Meg" in a rumble seat roadster captioned " 'Hi there!' Aunt Meg sure keeps her car looking like new"; and the Bell Telephone Company of Pennsylvania has an ad captioned "From our family to yours"

[88]Doug Stewart, "Photo Therapy: Theory and Practice," *Art Psychotherapy* 6(1):42 (1979).

[89]Kenneth Poli and Joel Walker, "Photoprobes," *Popular Photography* 85(3):91, 134 (September, 1979).

[90]An example is provided by photo therapist Doug Stewart:

. . .when a client and I are working with problems of self-concept and/or distortions and uncertainties as to how the client is perceived by others, I will sometimes suggest that the client make the following self-portraits: 1) "How I think I'm seen by others"; 2) "How I see myself"; 3) "How I want to be seen by myself." These images can often be done in the passport photo machine (Stewart 1979:45).

[91]Most examples and discussion deal with still photographs. However, for an early use of home movies in psychoanalytic practice see Herman M. Serota's "Home Movies of Early Childhood: Correlative Development Data in the Psychoanalysis of Adults" (*Science* 143(3611):1195, March 13, 1964). Serota stresses how "photographic evidence, combined with the patient's accompanying verbal associations, sheds additional light on evolving behavioral patterns such as affective expression, communication with others, and motility and its mastery, as well as early social interactions, and serves to correlate with reconstructions made from psychoanalytic data" (1964:1195).

[92]For a summary of nine reasons for using home mode materials in marriage and family therapy, see the discussion of "family photo reconnaissance" in Florence W. Kaslow and Jack Friedman, "Utilization of Family Photos and Movies in Family Therapy," *Journal of Marriage and Family Counseling*, January, 1977, pp. 21-24.

[93]Carol M. Anderson and Elaine S. Malloy, "Family Photographs: in treatment and training," *Family Process* 15(2):264 (1976).

[94]Adrien L. Coblentz, "Use of Photographs in a Family Mental Health Clinic," *American Journal of Psychiatry* 121:602 (1964).

[95]Henry N. Massie, "The Early Natural History of Childhood Psychosis," *Journal of the American Academy of Child Psychiatry* 14(4):683 (1975).

[96]Henry N. Massie, "The Early Natural History of Childhood Psychosis—Ten Cases Studied by Analysis of Family Home Movies of the Infancies of the Children," *Journal of the Academy of Child Psychiatry*, 1978, pp. 29-45. The study of interaction patterns between family members and the household pet(s) has been initiated at the University of Pennsylvania's Center for the Interaction of Animals and Society. Drs. Sharon Smith and Alan Beck have been studying videotapes and films made in research subjects' homes. (See Jane Biberman, "Companion Animals," *Pennsylvania Gazette*, June, 1981, pp. 18-25).

[97]Sandra Titus, "Family Photographs and Transition to Parenthood," *Journal of Marriage and the Family* 38(3):525-530 (1976).

[98]Ibid., p. 526.

[99]Edited by Brian Zakem, published through the Ravenswood Hospital Community Mental Health Center, Chicago, Illinois.

[100]Hugh Diamond, "On the Application of Photography to the Physiognomic and Mental Phenomena of Insantia," *The Face of Madness*, S. Gilman (ed.) (New York: Brunner Mazel, 1976).

[101]See Richard Chalfen's review of Robert Akeret's *Photoanalysis* (New York: Wyden, Inc., 1973) for further discussion, *Studies in the Anthropology of Visual Communication*, 1(1):57-60 (1975).

[102]Alan D. Entin, "Photo Therapy: Family Albums and Multi-generational Portraits," *Camera Lucida* 1(2):43-44 (1980).

[103]Titus, 1976, pp. 529-30.

Chapter Nine

[1]Howard Gardner, "Gifted Worldmakers," *Psychology Today* (September, 1980), pp. 92-94.

[2]For instance, photo therapists Kaslow and Friedman note:

People from all strata of society value and take photos and it is often a family activity. This generalization is based on our experience with white and black families spanning from a variety of ethnic backgrounds such as Italian, Jewish, Puerto Rican, Chinese, and Irish. We have seen a wide range of difference in competence, mood, equipment, and photographic preference; but we have not yet found any families who have not taken, kept, and treasured their photos.

See "Utilization of Family Photos and Movies in Family Therapy," *Journal of Marriage and Family Counseling* (January, 1977), p. 21.

[3]For instance, Ralph Bogardus asks: "Is there a class-based sense of propriety or lack of it that could emerge in photographs?... Might a class analysis of snapshots show that the middle-class is more conscious of "propriety" and reveals this in its family albums?" See "Their 'Cartes de Visite to Posterity': A Family's Snapshots as Autobiography and Art," *Journal of American Culture* 4(1):132-133 (1981).

[4]In Mary Hazzard's novel *Sheltered Lives*, she describes what Anne would have to do with certain jointly-owned materials when and if she divorced her husband Nat:

... Or the photographs I have always meant to put into an album—N's childhood pictures that his mother gave me (the one of N, aged ten months, sitting in a stream in diaper-swollen overalls and gloating over his first fishing pole; the one of him standing solemn and too tall, saluting, with the other boys in his Cub Scout den, etc.). All our camp and school pictures, the snapshots of H's children, the wedding pictures and the ones we took in Europe. No one else knows their chronological order. If N and I are not together in the future, surely he will want some of the pictures, and if I sort them now, they must be put into two stacks instead of one....

See *Sheltered Lives* (New York: Pinnacle Books, 1980), p. 237.

[5]Consider the following two comments that appeared in the popular press:

To filmmakers, "home movies" are dirty words, snapshots in motion (perchance) that drag on and on into inescapable boredom. Weddings, birthday parties for the kids, beach picnics, family reunions—how trite they seem to the sophisticates. Yet, too, how revealing these commonplace recordings would appear to those of other cultures—say Africans and Asians. Don't you just wish you could see their home movies?

See "Make Your Home Movies Keep People Awake," by Leendert Drukker, *Popular Photography*, May, 1977, p. 74.

A year ago I was approached by a Deputy Director of Antenne 2, one of the French TV networks. He wanted American home movies for broadcast in France so the French could see how we really live... Would Americans watch French home movies? Will the average John, Jean, and Johann contribute to a worldwide cultural-exchange program, achieving mutual understanding through the universal language of vision?

See "Super 8 for 'Para-Professional' Filmmakers" by Don Sutherland, *New York Times*, November 12, 1978.

[6]In recent years we've seen the introduction (and demise) of Polaroid's Polavision, its instant home movie system; Agfa Corporation is now marketing a Super-8 "family" system which includes a projector (or "player") that can make an enlarged print of a movie frame on Kodak instant color film; Sony Corporation has introduced Mavica, a video still camera that looks like a traditional 35mm camera. The Mavica can record 50 images on a flat rotating magnetic disc that is "played back" on a television monitor.

[7]For a short review and comparison of using video and film for home moviemaking, see Janet Kealy, "Will Videotap (sic) Systems Replace Home Movies?" *New York Times*, July 12, 1981. For a more comprehensive view see "The Uses of Home Video," *Making Home Video*, John Melville Bishop and Naomi Hawes Bishop (New York: Wideview Books, 1980), pp. 125-152.

[8]Even the potential obsolescence of the snapshot in favor of video technology is mentioned by David Jacobs (see "Domestic Snapshots: Toward a Grammar of Motives," *Journal of American Culture* 4(1):101 (1981).

[9]Jane Wollman, "A Family Album," *Video* (June, 1980), p. 84.

[10]Barry Levine, Center Screen, Boston, MA (personal communication, 1980). Leacock has developed and used synchronous sound Super-8 technology in his professional work.

[11]See Ann Hughey, "Sales of Home-Movie Equipment Falling as Firms Abandon Market, Video Grows," *Wall Street Journal*, March 17, 1982.

[12]The Polaroid Corporation took a $68.5 million dollar write-off on the failure of Polavision as a home medium (see Hughey, 1982).

[13]Two examples of technological differences are interesting. Some advertisements for videotape stress the capability to erase tapes for reuse. However, we know that home moviemakers are usually reluctant to throw away any of their footage, even when it is technologically flawed. Thus, the erase function of video may not be very important. On the other hand, editing problems with video may not bother amateurs because we know that most home moviemakers ignore the editing potential of the film medium.

[14]In comparison, Goko, a leading manufacturer of Super-8 editors, has designed an ingenious "Video Album" for combining films, slides, postcard images, and prints on videotape (see Leendert Drukker,) "Can Super-8 Survive Video Fever?" *Popular Photography* (no date), pp. 70-74.

[15]Richard Chalfen, "A Study of Polavision and Home Moviemaking," a report prepared for the Polaroid Corporation, 1979).

[15a]For instance, Bob Hanke found that users of instant cameras rarely took advantage of corrective opportunities offered by this technology that features instant "feedback." See *Instant Record, Instant Memory: Instant Photography and Visual Communication in the Home Mode* by Robert J. Hanke, unpublished MA thesis, Annenberg School of Communications, Univ. of Pennsylvania, Phila., PA 198.

[16]For instance, what was formerly recorded on three minutes of motion picture film may now take 30 minutes of videotape.

[17]Judy Oppenheimer, "Video Verities—The Machine that Ate My Family," *Village Voice*, May 26, 1981, p. 24. Personal thanks to Glen Muschio for sharing this reference with me.

[18]Arthuc C. Clarke, *Across the Sea of Stars* (New York: Harcourt, Brace and Co., 1959), pp. 54-62.

[19]Ibid., pp. 59-60.

[20]Ibid.

[21]Ibid., p. 62.

[22]Ibid., p. 61.

[23]Don Sutherland, "You Ought'a Be in Pictures And So Should Your Whole Family," *Invitation to Photography* (New York: Popular Photography Publishers, 1977), p. 39.

[24]Margery Mann, "The Snapshot: Family Record or Social Document?" *Popular Photography* (September, 1970), p. 20.

Appendix:

Home Mode Questionnaire

The following questionnaire has been used in several projects that comprise this report. Use of the questionnaire begins to satisfy some quantitative needs. However it is best used as a starting point; questions can serve as a stimulus to elicit discussion on home mode activity. Discussion might begin by making reference to specific responses recorded on the questionnaire. Or answers may serve as an introduction to additional interviews, discussions, and viewings of home mode imagery. Future studies may want to adapt parts of the questionnaire to address specific rather than general questions.

A Study Of Family Photography

Respondent's Name _____

Address _____
 (Street) (APT.)

(City) (State) (Zip)

The following questionnaire has been designed to learn how and when people use their cameras and the kinds of photographs, and videotapes that people make for their own personal enjoyment. If there are questions which are not applicable to you either because you do not own a camera or do not have many photographs, please mark NA in the appropriate space.

Please comment on any question that you feel is not clear.

Section A

This section of the questionnaire must be completed by either *male head* of household or *female head* of household. Please indicate who is responding to this questionnaire:

_____ Male head of household_____ Female head of household

AI. In the spaces and columns provided on the following page, please fill in all the names of your family members and supply the following kinds of information:

In Column A: please list the *names* of your family members. List the male head of household *first*, and the female head of household *second*. Include all children and any relatives that may be living with you at the present time.

In Column B: please indicate the *place of birth* of each family member.

In Column C: please indicate the *age* of each family member.

In Column D: please indicate the *relationship* of each family member to you.

In Column E: please indicate whether or not each person is *living in your household* at the present time.

In Column F: please indicate the *highest grade* or *level of school* reached by each family member. If a family member is presently in school, list the present grade.

In Column G: please indicate the *occupation* (or type or work) of each family member at the present time. Include "student," "housewife," "retired," "unemployed" etc. when applicable, or NA for pre-school children.

A2. Please indicate the *religious affiliation* or affiliations of your family, if any.

Male head of household _____

Female head of household _____

A3. How would you best describe the *nationality* or *ethnic composition* of your family?

Male head of household _____

Female head of household _____

Family Members	Place of Birth	Age	Relationship to You	Household (Yes/No)	Level of School	Occupation

A4. Please indicate which of the following categories best characterizes your *total family income*, before taxes, *for the past year*:

() below $4,000 () between $20,000 & 35,000
() between $4,000 & 11,000 () between $35,000 & 60,000
() between $11,000 & 20,000 () above $60,000

Section B

This section of the questionnaire concerns your ownership or use of various kinds of photographic equipment, such as still cameras, movie cameras, video cameras, projectors, and/or darkroom equipment for developing and printing photographs.

IF YOU DO *NOT* OWN, POSSESS OR USE ANY TYPE OF PHOTOGRAPHIC EQUIPMENT, DISREGARD THIS PART AND GO DIRECTLY TO *SECTION D.*

B1. Does any member of your family currently own, possess or use a camera for making either photographs or slides?

() YES () NO ------ IF NO, GO TO QUESTION B2.

For any type of *still* camera that you do have, please fill in the following information. Please list the camera that is used most of the time *first*.

NAME OF CAMERA AND MODEL	EXTRA LENSES (if any)	WHO IN YOUR FAMILY USES THIS CAMERA MOST OF THE TIME?

1.

2.

3.

4.

5.

B2. Does any member of your family currently own, possess or use a movie camera of any kind?

() YES () NO ------ IF NO, GO TO QUESTION B3.

Please fill in the following information regarding the motion picture cameras that are used by family members. Again, list the camera that is used most frequently first.

NAME OF CAMERA AND MODEL Gauge WHO IN YOUR FAMILY
(8mm,16mm USES THIS CAMERA
Super-8) MOST OF THE TIME

1.

2.

3.

B3. Do you currently own or possess video equipment?

() YES () NO ----- IF NO, GO TO QUESTION B4.
A video cassette recorder (VCR)? () YES ()NO
A video camera? () YES () NO
NAME OF CAMERA BETA or VHS WHO IN' YOUR
FAMILY USES THIS
CAMERA MOST OF THE
MOST OF THE TIME?

B4. Do you currently own or possess a projector or a screen?

Slide projector	() YES	() NO
Movie projector	() YES	() NO
Projection screen	() YES	() NO

B5. Do you ever use any type of sound recording equipment in conjunction with making either still pictures or movies?

() YES () NO ------ IF NO, GO TO QUESTION B5.
If you do record sound, please indicate briefly the type of equipment you use and how you use it.

B6. Do you currently own, possess or regularly use any type of film processing equipment or photograph enlarging equipment (such as developing tanks, an enlarger, etc.)?

() YES () NO ------ IF NO, GO TO QUESTION B6.
If YES, please describe this equipment and indicate how frequently it is used at the present time. Also indicate which family member is most likely to use your darkroom equipment.

B7. Where do you presently take most of your pictures to be developed?

() CAMERA SHOP () DRUG STORE () MAILERS
() FRIENDS () OTHER (specify)

Section C

This section of the questionnaire attempts to determine how photographs are taken by family members.

C1. Which family members generally take most of your photographs?

C2. If you take still photographs, movies, and videotapes, will the same person use the camera in all cases?

C3. Please list the last three (3) occasions in which a camera was used by a family member, and indicate which family member used the camera.

OCCASION	APPROXIMATE DATE	CAMERA USER
1.		
2.		
3.		

C4. Please try to estimate the number of photographs that have been taken by members of your family *during the past month*:

() NONE AT ALL () BETWEEN 50 & 80
() BETWEEN 1 & 20 () BETWEEN 80 & 100
() BETWEEN 20 & 50 () 100 OR MORE

C.4 Please try to estimate the number of photographs that have been taken by family members *during the past year:*

() NONE AT ALL () BETWEEN 100 & 150
() BETWEEN 1 & 50 () BETWEEN 150 & 200
() BETWEEN 50 & 100 () 200 OR MORE

Please estimate the number of videotapes that have been made by family members *during the past year:*

() NONE AT ALL () BETWEEN 5 & 15
() BETWEEN 1 & 5 () 15 OR MORE

Section D.

In this section, the questions concern how you keep your photographs and how often you show your photographs to other people.

D1. Please indicate if you have any of the following types of *photograph collections*:

Albums of Photographs
 Family album () NO () YES --- IF YES, HOW MANY?
 Baby album () NO () YES --- IF YES, HOW MANY?
 Travel album () NO () YES --- IF YES, HOW MANY?
 Wedding album () NO () YES --- IF YES, HOW MANY?
 Scrapbook () NO () YES --- IF YES, HOW MANY?
 Other (specify)

Slide Collections () NO () YES

Other Collections of Photographs.
 Miscellaneous accumulations in boxes () NO () YES
 Miscellaneous accumulations in drawers () NO () YES
 Other (specify)
Framed photographs hanging on your household walls or placed
 on pieces of furniture, bookshelves, etc.
 () NO () YES --- IF YES, HOW MANY?
Wallet Photographs carried by family members:
 Male head of household () MANY () A FEW () NONE
 Female head of household () MANY () A FEW () NONE
 Male children () MANY () A FEW () NONE
 Female children () MANY () A FEW () NONE
Home Movie collections: () NO () YES
Home Videotape collections:() NO () YES

If you have a *family album* of any kind, please answer the following
 questions.
IF YOU DO NOT OWN A FAMILY ALBUM OF ANY KIND, GO
 TO QUESTION D10.

D2. Did your parents or your spouse's parents keep a collection of
photographs? () No () Yes
 If YES, please describe the nature of this collection (a box of pictures,
an album, several albums, framed pictures, etc.), and who has this
collection at the present time?

D3. Who in your family started your family album, and when was it
 started?

D4. Who in your family generally maintains this album (that is, who selects what pictures should be in the album and keeps it up to date)?

D5. Who do you expect will inherit this album?

D6. How often do you estimate that this album is looked at?

D7. Is there any person to whom you would prefer *not* to show this album if he or she asked to see it? () NO () YES. If YES, please explain to whom you would not show it and why.

D8. Have you ever removed a photograph from your family album?
() NO () YES
If YES, please describe the photograph and the reasons for its removal.

D9. Please list the last three (3) times this album was shown to someone and indicate to whom it was shown.
OCCASION VIEWERS

1.
2.
3.

If your photograph collection consists mostly of *slides*, please answer the following questions.
IF YOU DO NOT HAVE ANY SLIDES, PLEASE GO TO QUESTION D12.

D10. Please estimate the number of times during the last year that you have shown and looked at some or all of your slide collection.
_____times last year

D11. Please list the last three (3) times these slides were shown and indicate who was in the audience.

OCCASION VIEWERS

1.
2.
3.

If you have a collection of *home movies* or *home videotapes*, please answer the following questions.
IF YOU DO NOT HAVE ANY HOME MOVIES, GO TO QUESTION D14.

D12. Please estimate the number of times during the last year that you have looked at some or all of your home movies or videotapes.
 _____times last year

D13. Please list the last three times these movies or videotapes were shown and indicate who was in the audience.
 OCCASION VIEWERS

1.
2.
3.

If you carry photographs in your *wallet*, please answer the following question.

D14. How many photographs do you presently carry with you in your wallet (photographs of any kind, including Identification photographs)?
 _____photographs

D15. How many of these photographs are attached to an identification card?

 _____photographs

THANK YOU VERY MUCH FOR YOUR COOPERATION IN RESPONDING TO THIS QUESTIONNAIRE.

Index